Healthy Eating for Life to Prevent and Treat Diabetes

PHYSICIANS COMMITTEE FOR RESPONSIBLE MEDICINE

John Wiley & Sons, Inc.

Menus and recipes by Jennifer Raymond

Published by John Wiley & Sons, Inc., New York
Published simultaneously in Canada

Design and production by Navta Associates, Inc.

This publication is designed to provide accurate and authoritative information in regard to the subject matter covered. It is sold with the understanding that the publisher is not engaged in rendering professional services. If professional advice or other expert assistance is required, the services of a competent professional person should be sought.

Library of Congress Cataloging-in-Publication Data

Healthy eating for life to prevent and treat diabetes / Physicians Committee for
Responsible Medicine.
 p. cm.
 Includes index.
 ISBN 0-471-43598-8 (pbk.)
 1. Diabetes—Diet therapy. I. Physicians Committee for Responsible Medicine.

RC662 .H435 2002
616.4'620654—dc21 2001046891

Printed in the United States of America

10 9 8 7 6 5 4 3 2 1

Physicians Committee for
Responsible Medicine Expert Nutrition Panel

Healthy Eating for Life
to Prevent and Treat Diabetes

Neal D. Barnard, M.D.

Suzanne Havala, M.S, R.D, L.D.N, F.A.D.A.

Jennifer Keller, R.D.

Amy Joy Lanou, Ph.D.

Gabrielle Turner-McGrievy, M.S., R.D.

Vesanto Melina, M.S., R.D.

Kristine Kieswer

Martin Root, Ph.D

with Patricia Bertron, R.D.

Contents

Part II: Making It Work for You

Part III: Lifelong Health

List of Recipes

Foreword

Many people with diabetes—and their doctors—think of the condition as a one-way street. Once it has been diagnosed, we begin a never-ending series of blood sugar tests, medication adjustments, and gradually worsening symptoms. But happily, that has begun to change. In a research study at the Physicians Committee for Responsible Medicine, in cooperation with doctors at Georgetown University, a group of people with Type 2 diabetes, the kind that typically begins in adulthood, tested a new diabetic diet. They found that their blood sugar levels got better and better and their need for medication quickly fell. And many others have found that, as the improvements continue, the disease sometimes simply disappears.

Of course, this does not often happen with the old-fashioned diets still used by most practitioners. But if you or a loved one has diabetes, you will want to put this wonderful program to work today.

We also have better means than ever for managing Type 1 diabetes, the kind that starts in children and young adults, and even some surprising clues as to its *causes* that could help us prevent it in the first place.

In this book you will find the keys to a healthy, vibrant life. The latest and very best nutritional guidelines have been carefully drafted by diabetes experts, and are presented with delicious recipes that put them to use.

I wish you the best of health.

Neal D. Barnard, M.D.
President, Physicians Committee
for Responsible Medicine

PART I

Essentials

1

Understanding Diabetes

Diabetes is a two-way street. For too many people it has presented serious health challenges, but we know that it can improve and, in some cases, even disappear with the right diet and lifestyle changes. This book will give you the information you need to prevent, manage, or even reverse diabetes.

In the early 1980s, evidence began to emerge showing that Type 2 (sometimes called adult-onset) diabetes could be dramatically improved by diets that stepped beyond the usual regimens doctors often prescribed. And new research also has shown striking links between diet and Type 1 (or childhood-onset) diabetes. Fortunately, the most effective diet for people with diabetes isn't really a diet at all. It requires simple substitutions that are a breeze to make—once you know what to look for.

If you or someone you care about is facing diabetes, you will soon have powerful new tools at your disposal—many of which are as close as your supermarket—to make your life simpler. This book will provide you with a comprehensive, user-friendly guide to nutrition and fitness for people with diabetes, including the impact of diet on Type 1, Type 2, and gestational diabetes. We will see how to

use a low-fat, high-fiber diet for controlling, improving, and even reversing the disease. We will explore carbohydrate-counting, analyze the nutritional content of easy recipes, and learn about diabetic exchanges. Powerful methods for weight management; controlling blood glucose levels, blood cholesterol levels, and blood pressure; and preventing diabetes are all tucked into these pages. And, if you are a health professional working in this area, you will find cutting-edge, proven techniques for changing its course.

Diabetes Basics

Diabetes mellitus has been recognized since ancient times. In 1552 B.C., the Egyptian journal *Ebers Papyrus* described this painless disease that caused body wasting and loss of large amounts of urine. Aretaeus, a Greek physician in the first century A.D., gave the condition its name. Noting that it caused increased urination, he called it "diabetes" from the Greek word for *siphon.* In the seventeenth century it was renamed "diabetes *mellitus.*" The word mellitus, which means "honey" in Latin, referred to the sweetness of the urine.

In the nineteenth century, scientists learned that the pancreas, an organ located behind the stomach, produces hormones and enzymes that are important in the digestion and uptake of nutrients in the body. German pathologist Paul Langerhans discovered clusters of cells (now called the islets of Langerhans) in the pancreas that produce insulin, a hormone that helps sugars and the building blocks of protein enter the cells of the body.

People with diabetes are either not able to make or not able to properly use insulin. Because insulin is affected by every meal we eat, healthy nutrition is key to improving diabetes. A range of dietary recommendations from fasting and very-low-calorie diets to high-carbohydrate diets and high-protein diets have all been tested in the treatment of this disease. Through scientific study and trial and error, we have learned about the special advantage of complex carbohydrates and the detrimental effects of dietary fat for people with diabetes. But only in the past few years have we come to understand what is the optimal diet for managing diabetes.

Hormones and Sugar

The starchy part of many foods—breads, potatoes, and beans, for example—is made up of many molecules of a natural sugar called "glucose," bonded together. When food enters the digestive tract, these sugar molecules come apart, and glucose passes from the small intestine into the bloodstream. In response to this influx of sugar, the pancreas releases insulin into the blood so it can carry the glucose into the cells of the body. Normal, healthy blood sugar levels are important for keeping your body working properly. When this system is not functioning as it should and blood sugar levels are generally too high, then diabetes results.

Insulin plays many important roles in the body in addition to helping glucose get into cells. Because insulin is released when you have recently eaten, insulin also discourages the breakdown of fat from your fat stores. This makes perfect sense. You don't need to pull energy out of your storage sites when you have new energy coming in from food. And insulin helps your muscles take up new amino acids—the building blocks of protein—for use in muscle repair and growth.

Types of Diabetes

Diabetes generally occurs when the body does not produce insulin (or not enough to be effective) and glucose builds up in the blood. Alternatively, sometimes diabetes results even when the pancreas is making enough insulin, but your body cells are resistant to its effects. Insulin is there, glucose is available, but the cells don't open up and let it in the way they should. In either case, some of the built-up glucose in the blood ends up passing through the kidneys, carrying water along with it, resulting in the increased urination that is often the first tip-off that something is amiss. When this happens, dehydration, increased thirst, blurred vision, and fatigue can occur. Prolonged, elevated blood glucose levels wreak havoc over the long term, so it is important to take the simple steps outlined in this book to keep it under control.

The three most common types of diabetes—Type 1, Type 2, and gestational diabetes—are described below.

Type 1 Diabetes

Type 1 diabetes, sometimes called insulin-dependent, childhood-onset, or juvenile-onset diabetes, accounts for 5 to 10 percent of diagnosed cases. It can occur at any age, but is diagnosed more frequently in younger people and is more common in Caucasian than in non-Caucasian populations. At onset, Type 1 diabetics are usually lean and often have recently experienced weight loss.

In Type 1 diabetes, the cells in the pancreas that produce insulin can no longer do their job. The most common cause of Type 1 diabetes is an autoimmune response in which the insulin-producing cells of the pancreas have been destroyed by the body's own immune system. Scientists are investigating why some people's immune systems attack their own pancreatic cells. It appears that a combination of genetic and environmental factors conspire to trigger this disease. Some of the culprits under investigation are cow's milk proteins and viruses in genetically susceptible individuals.

If you have Type 1 diabetes, you'll need insulin injections to keep your blood sugar under control. Injected insulin acts the same way as it does in a person without diabetes, by bringing blood glucose to the cells of the body. However, medication alone is not enough to successfully manage Type 1 diabetes. Diet and exercise make all the difference in whether you stay healthy and vibrant throughout life or succumb to the problems diabetes can cause.

Type 2 Diabetes

The vast majority of people with diabetes—90 to 95 percent—have the Type 2 form, also known as non-insulin-dependent or adult-onset diabetes. The pancreas is able to produce insulin, but the cells of the body are resistant to it. The problem appears to be that the insulin receptors on the cells don't recognize insulin and won't allow the glucose to enter. This "insulin resistance," as it is called, is often a consequence of carrying excess body fat. Over time, some people with Type 2 diabetes also make too little insulin to get their resistant cells to respond. If this occurs, they may also be given insulin.

Unfortunately, diabetes is on the rise, a serious consequence of the growing numbers of overweight and obese people in many

countries. Although most people with Type 2 diabetes develop it as adults, children are not entirely immune. As more kids lead sedentary lifestyles and put on extra weight, the number developing Type 2 diabetes continues to rise.

If you have Type 2 diabetes, you are not likely to have any symptoms for the first several years of its development. In fact, only about 50 percent of the people with Type 2 diabetes are aware they have it. However, there are some clues that indicate who is at increased risk for the disease. People who develop Type 2 diabetes tend to be:

- adults
- overweight
- from a family with a history of diabetes
- mothers with a history of gestational diabetes
- inactive
- diagnosed with impaired glucose tolerance
- on diets high in meat, dairy products, and other fatty foods

Gestational Diabetes

Gestational diabetes mellitus occurs during pregnancy, affecting about 4 percent of all pregnant women. The problem develops when a pregnant woman is not able to use insulin properly, possibly because pregnancy hormones counteract its actions. The condition usually goes away at the end of the pregnancy, but it is often a sign that Type 2 diabetes is around the corner unless you take steps to prevent it. Normally, more than 50 percent of women with gestational diabetes go on to develop Type 2 diabetes, but this is often because they did not receive proper information about *prevention*. See chapter 11 for more information.

Symptoms and Diagnosis

But how do I know if I have it? And, if so, is it the kind that will go away? Diagnosing this disease is a straightforward matter. The rest of this book will show you the powerful steps you can take to tackle the problem.

Diabetes develops gradually, and sometimes these warning signs can go unnoticed for years. But there are several symptoms you can look for:

- increased urination
- excess hunger or fatigue
- weight loss
- dry, itchy skin
- blurred vision
- tingling or lost feeling in the feet
- sores that heal slowly

If you experience any of these symptoms, be sure to discuss them with your doctor. These symptoms alone are not enough to tell whether you have diabetes or, if you do have it, what kind of diabetes you have. Your doctor can do several tests to determine if you have this disease, and, if so, what to do about it.

Testing for Diabetes

The doctor will use one or more of three blood glucose tests to make a diagnosis. If the test suggests diabetes, the doctor will confirm the result on another day.

The first test checks the amount of glucose in your bloodstream at any time during the day without consideration of the time of the last meal eaten. A glucose value of 200 mg/dl (11.1 mmol/l in the international units used in most countries other than the United States) or more, plus symptoms such as increased urination, increased thirst, and unexplained weight loss (the most common symptoms), are good indicators of diabetes.

The second blood test is a fasting blood glucose. The test is done after you have fasted for at least eight hours, meaning that you cannot eat or drink anything except water for eight hours prior to the blood test. Normally, fasting glucose should be in the range of 70 to 110 mg/dl. A fasting plasma glucose level of 126 mg/dl (7.0 mmol/l) or higher indicates diabetes.

The third test, an oral glucose tolerance test, measures how well your body deals with a dose of sugar. Normally, blood sugar rises

after eating and then comes back down to near or within the normal range (70 to 120 mg/dl) in one to two hours. Higher values mean your body is having trouble moving glucose out of the blood and into your cells. In the oral glucose tolerance test, you drink a syrupy solution of glucose mixed with water. During the next two to three hours, a series of blood tests is taken. A plasma glucose at two hours of more than 140 mg/dl (11.1 mmol/l) or of more than 200 mg/dl at any time during the testing period indicates diabetes. As with the other tests, the findings should be reconfirmed on a separate day.

Once your doctor determines whether you have diabetes, it is important to speak with him or her about the vital role of nutrition and to make the most of your treatment. The importance of diet is discussed throughout this book, helping you to better understand the important role it plays in the management of diabetes.

Impaired Fasting Glucose

Some people may have blood glucose levels that aren't high enough for a diagnosis of diabetes, but they are still too high to be considered healthy. Impaired fasting glucose or impaired glucose tolerance—sometimes called "prediabetes"—affects about 13.4 million Americans, and more and more people in other countries. To diagnose it, your doctor will look for a fasting blood glucose value of 110 to 125 mg/dl or a two-hour, postmeal blood sugar level of 140 to 200 mg/dl. These levels are higher than normal, but lower than the levels seen in diabetes.

Currently 25 to 30 percent of individuals with impaired fasting glucose or impaired glucose tolerance eventually end up with Type 2 diabetes. Researchers are trying to work out which people in this category will actually develop diabetes and how they can stop it from happening. If you have impaired fasting glucose, it is essential to work with your doctor, to adjust your diet as outlined in chapter 2 and discussed in more detail in chapter 3, and to begin regular exercise to head off the problem.

Understanding Your Blood Sugar Test

When looking at your blood sugar numbers, be sure to ask or notice which type of test was done. Fasting blood sugar for people without diabetes should be less than 110 mg/dl, while a two-hour, postglucose load value should be less than 140 mg/dl. Before eating, or approximately four to five hours after your last meal, a good blood sugar range for a person with diabetes is 70 to 150 mg/dl. When people with diabetes have good glucose control, their blood sugar levels return to these values within two to three hours after the glucose load.

Who Should Be Tested?

Because diabetes can sometimes go unnoticed for years, it's a good idea for anyone forty-five years of age or older to be tested for diabetes by a medical doctor. If you have no symptoms, you should be retested once every three years. Younger adults should be tested if they weigh more than 120 percent of their desirable body weight or have a close family member with diabetes, as they are at a higher risk of developing diabetes. African Americans, Hispanic Americans, Native Americans, Asian Americans, and Pacific Islanders also are at a greater risk than Caucasians. A woman delivering a baby weighing more than nine pounds and who has been diagnosed with gestational diabetes (i.e., diabetes during pregnancy) also is at risk for Type 2 diabetes. Additional risk factors include high blood pressure, a blood test showing a low level of high-density lipoprotein cholesterol (the "good cholesterol"), or a high triglyceride level. Previous testing showing impaired glucose tolerance or high fasting glucose also is a warning sign of increased risk.

You also can use the American Diabetes Association's diabetes risk test to see if you are at risk. Just answer the following questions.

Am I at Risk?

1. I am a woman who has had a baby weighing more than nine pounds at birth. Yes 1 point

2. I have a sister or a brother with diabetes. Yes 1 point

3. I have a parent with diabetes. Yes 1 point

4. My weight is equal to or above that listed in the chart below. Yes 5 points

5. I am under 65 years of age and I get little or no exercise. Yes 5 points

6. I am between 45 and 64 years of age. Yes 5 points

7. I am 65 years old or older. Yes 9 points

Scoring 10 or more points: You are at risk for developing diabetes. This doesn't mean you have it; it means that you are at risk for developing it in the not-too-distant future. Only your healthcare provider can check to see if you have diabetes. See yours soon and find out for sure.

Scoring 3 to 9 points: You are probably at low risk for having diabetes right now. But don't just forget about it. Keep your risk low by losing excess weight; by getting some exercise most days of the week; and by eating low-fat meals that are high in fruits, vegetables, and whole grain foods.

Scoring less than 3 points: You are at low risk for diabetes.

The Importance of Overcoming Diabetes

Uncontrolled high blood sugar levels can have serious consequences. For example, people with diabetes have a higher risk of heart attacks and stroke. Chronically high blood sugar levels also cause trouble for the eyes, the kidneys, and the nerves. Diabetes is the leading cause of new blindness in adults. A third of all people with Type 1 diabetes and 5 to 20 percent of people with Type 2 diabetes end up with renal disease, where their kidneys need the assistance of a dialysis machine to filter waste out of the body.

WEIGHT TABLE

If you weigh more than the amount listed for your height, you may be at risk for diabetes.

WEIGHT (IN POUNDS WITHOUT SHOES)	HEIGHT (IN FEET AND INCHES)
129	4' 10"
133	4' 11"
138	5' 0"
143	5' 1"
147	5' 2"
152	5' 3"
157	5' 4"
162	5' 5"
167	5' 6"
172	5' 7"
177	5' 8"
182	5' 9"
188	5' 10"
193	5' 11"
199	6' 0"
204	6' 1"
210	6' 2"
216	6' 3"
221	6' 4"

When nerves are damaged by excessively high blood sugar levels, a variety of symptoms can result, including a loss of sensation in the hands and feet, digestive problems, and impotence.

Can Diabetes Be Reversed?

The right food choices can make a world of difference. In fact, several clinical studies have shown that people with Type 2 diabetes can often decrease or discontinue their medication and even reverse their condition with the right eating plan. Controlling blood glucose and cholesterol levels decreases the risk of serious complications

that might otherwise occur. In study after study, the diet with the most profound and lasting effects is one made up exclusively of whole grain foods, such as hearty breads, pastas, and cereals, along with fresh fruit; a rich array of vegetables; and low-fat, protein-rich beans, peas, and lentils.

While Type 1 diabetes is not reversible, these same dietary practices, along with a carefully managed insulin regimen and moderate exercise, have a remarkable ability to keep complications at bay. Gestational diabetes, the kind that can occur during pregnancy, most often goes away after your baby is born, and healthy eating habits can keep it from leading to Type 2 diabetes.

The ever-increasing rates of diabetes can be rapidly turned around to the extent that we take advantage of the diet change whose power is proven by modern research studies. For an individual, this means regaining a new level of health and vitality you may have thought impossible. Please read this book carefully, take advantage of what it has to offer, and share this good news with anyone you know who is shouldering the same challenge.

2

The Power of Food:
A New Dietary Approach to
Overcoming Diabetes

Doctors and nutritionists have known for a long time that eating habits are an important part of the treatment of all types of diabetes. Professional medical organizations such as the American Dietetic Association and the American Diabetes Association offer nutrition guidelines and meal planning guides to help manage blood glucose levels and prevent associated complications. These recommendations have gradually evolved over the years to reflect our growing understanding of the connection between diet and diabetes. Today, preferred diets are much higher in carbohydrates and lower in fat and protein than in years past. Sweets used to be entirely excluded, and now people with diabetes can safely consume sweets in small amounts along with other foods.

Exciting research findings have emerged over the past two decades that have given us extraordinary power to change the course of diabetes even beyond the recommendations in the ADA guidelines. More than forty years ago, researchers at the University of Minnesota began to study the eating habits of more than twenty-five thousand Seventh-Day Adventists, a religious group that has long been of interest to scientists because virtually all abstain from

alcohol and smoking, but about half are vegetarian while half are not, providing an unusual opportunity to assess the effects of diet on health. They followed them for twenty-one years to see what could be learned about diet and the occurrence of various diseases. The results were clear. Participants who regularly avoided meat had a much lower chance of getting diabetes. Since then many studies in diverse groups of people have supported these findings.

A New Dietary Approach to Diabetes

A 1999 study conducted by the Physicians Committee for Responsible Medicine and Georgetown University looked at the health benefits of a low-fat, unrefined, vegan diet (excluding all animal products) in people with Type 2 diabetes. Portions of vegetables, grains, fruits, and legumes were unlimited. These ingredients were used to prepare hearty stews, vegetable fajitas, colorful platefuls of roasted vegetables and mashed sweet potatoes, spicy black bean chili, fruit smoothies, and all manner of delicious menus. No oils were used in preparing the meals, and refined white flour and pasta were replaced with whole-grain varieties. The meals were very rich in fiber, providing about 60 to 70 grams of fiber per day—three to four times what many of us usually get—and were naturally free of cholesterol. For comparison, a second group was prescribed a diet using American Diabetes Association (ADA) guidelines. It was higher in fat, with about 30 grams of fiber and 200 milligrams of cholesterol per day.

During the three-month study, participants attended group meetings twice per week for support, nutrition lectures, and cooking instructions. The results were astounding. The vegan group lowered their fasting blood sugars 59 percent more than the group following the ADA diet. Many discontinued their medications, another benefit not enjoyed by the ADA group. The vegan group lost an average of about 16 pounds, compared with only about 8 pounds in the ADA group. The vegan group also had more substantial decreases in their cholesterol levels compared to the ADA group.

Although this was a small study, it illustrates that a plant-based diet can dramatically improve the health of people with diabetes.

Getting Healthy

When Stuart was diagnosed with diabetes, he was thirty-eight years old and thoroughly wrapped up in his job as a business consultant. There was no history of diabetes in his family, and he had never given it a thought. He really didn't have time to worry about health problems anyway. His schedule kept him hopping from one business lunch to another, and at the office late several nights a week. His weight had gradually inched up over the years, his cholesterol was up, and his blood pressure was borderline high.

The diabetes diagnosis annoyed him. It meant that he now had to check his blood sugar every day and carefully watch what he ate. Meanwhile, his business friends ate seemingly with abandon. At first, diet alone controlled his blood sugar, but eventually he needed medications to keep it under control. As his doses gradually escalated, he began to feel old before his time.

One day, he read a newspaper advertisement about a research study at the Physicians Committee for Responsible Medicine that tested a low-fat vegetarian diet as a more powerful means of combating diabetes. The change in eating habits sounded like a challenge, but he was anxious to get off the downward spiral that was leading him nowhere.

When he arrived at the study, he learned about how foods affect diabetes and how to put the menu change to work. To his surprise, the diet was a snap. There were no calorie limits or portion sizes. A typical dinner might start with salad with a fat-free dressing. Soup might be lentil, split pea, minestrone, or black bean, and he learned how to make hearty stews, chili, pasta dishes, and many other delights. He followed the recommendation to avoid meats, dairy products, and added oils, and although this felt awkward at first, it soon became second nature.

The improvements in his health came almost day by day. His beltline began to loosen perceptibly by the second week. In the twelve-week study he lost nearly twenty pounds. His cholesterol level dropped, and he was eventually able to get off all his medications. He felt that for the first time in his adult life he was getting healthier and stronger. He was really in charge, not only of his business but of his health, too, and he radiated this healthy sense to his coworkers and clients.

NEAL BARNARD, M.D.

Other studies have confirmed that making simple changes—bringing in vegetables, beans, and whole grains while avoiding animal products and added oils—has a powerful effect on diabetes.

Another striking change in our thinking has occurred with regard to the role of food in *preventing* diabetes. We are finally coming to understand that diet is often a primary cause of Type 2 diabetes and that simple changes can be used to stop diabetes from occurring in the first place. And new research is revealing the possible causes of Type 1 diabetes. Certain foods appear to protect a child from developing the disease, while others speed it on its way.

The Problem with Dairy Products

While scientists have long known that genetic factors and viral infections play a role in this form of the disease, strong evidence suggests that diet does as well. The most surprising research finding in recent years comes from studies showing that consuming cow's milk—even through infant formula—increases the risk of developing Type 1 diabetes in infants or children.

Researchers believe that under certain conditions proteins found in cow's milk can pass from a child's digestive tract into the bloodstream. The immune system recognizes these proteins as foreign substances and produces antibodies to destroy the intruders. The problem is, these antibodies do not only attack the milk protein. They also attack proteins on the cells in the pancreas that produce insulin, because, by a fluke of nature, the proteins on the cells' surface are very similar to the milk protein. These antibodies eventually destroy the cell's ability to make insulin.

These milk proteins are found in milk-based infant formulas and in regular cow's milk. While research on this subject continues, there is enough evidence for the American Academy of Pediatrics to conclude in 1994 that avoiding cow's milk in infancy is likely to cut the risk of diabetes later. A study of 142 children newly diagnosed with diabetes found that every one of them had high levels of antibodies to a specific cow's milk protein. Not surprisingly,

infants who are exclusively breastfed have a lower risk of developing Type 1 diabetes.

Dairy products are sometimes touted for their supposedly beneficial ingredients, but all mothers produce nutritionally superior milk for their babies. Besides having a lower risk of developing Type 1 diabetes, breastfed babies receive a powerful dose of antibodies to protect against illness and allergies, and all the nutrition necessary for the first four to six months of life.

As an infant's nutritional needs grow to include solid foods, providing adequate amounts of whole grains, legumes, fruits, vegetables, nuts, and seeds—appropriate to the child's age—will meet these needs in the healthiest way possible. A detailed discussion of nutritional requirements of infants and toddlers can be found in the companion book *Healthy Eating for Life for Children*.

Does Sugar Cause Diabetes?

Sugar is not the cause of either Type 1 or Type 2 diabetes. People with diabetes do have to be careful with sugar because, as explained in chapter 1, their bodies do not deal with it well. But the primary culprit in diabetes is not the sugar. For Type 2 diabetes, it's the fat-rich, animal-protein-rich, fiber-poor, super-serving-sized eating pattern that too many of us have become accustomed to. This overly fatty diet causes us to gain weight, clogs our arteries, pushes our blood pressure up, and encourages our cells to become insulin-resistant. For many, Type 2 diabetes soon follows.

The solution is simple. We just need to turn this dietary pattern around by leaving the troublemakers—meat, dairy, eggs, fried foods, and oils—behind and, instead, building our diets from healthier foods. Foods from plant sources—fruits, vegetables, grains, and legumes—are high-carbohydrate, low-fat, cholesterol-free, and fiber-rich. It sounds easy, and it is. These are the foods that will prevent diabetes or turn it around if you already have it. Just think of all the delicious combinations of flavors nature has to offer. The recipe section at the back of the book will get you started. But first let's take a closer look at how the nutrients in this healthy eating style help turn around diabetes.

Carbohydrate Powerhouses

Carbohydrates are the body's primary source of energy. The two main types of carbohydrates are complex (starches) and simple (sugars).

A diet high in complex carbohydrates is the best way to achieve blood glucose control. Each time you choose meat, poultry, fish, or eggs, you're missing out on this important nutrient. Plant foods, on the other hand, are bursting with healthy complex carbohydrates, not to mention fiber. So try whole wheat spaghetti with zesty tomatoes, zucchini, and carrots tonight, or oatmeal with season-fresh berries tomorrow morning. These changes are easy and affordable, yet profoundly important for staying well. Research studies have shown that diets high in complex carbohydrates, along with physical activity, will help you to achieve good blood glucose control, lose weight, and even reduce your need for medication. When you build your diet from low-fat plant foods, there is no need to skip meals or restrict portions.

Some people are fearful of carbohydrate-rich foods, because some of these foods can increase blood sugar rapidly enough to give insulin a real challenge in trying to cope with it. While that is true for some (more on this shortly), this does not mean you should avoid whole grains and vegetables and eat meat and eggs instead. The fact is, high-protein foods can raise insulin levels in the blood and can be as harmful as an increase in glucose. For example, beef can stimulate an increase in insulin as powerfully as pure glucose. Other meats do essentially the same thing.

Glycemic Index

Not all carbohydrate-rich foods are created equal. Some help your blood sugar stay in a healthy range, while others allow it to climb too high. Here's what you need to know about carbohydrates:

The carbohydrate molecule is a chain of sugars that, one by one, are broken down during digestion into the simplest sugars. These single sugars then pass into your bloodstream, where they can be transferred to the cells of your body to be used as energy. The more the carbohydrate is left in its natural form—with all its natural fiber intact—the longer it takes to break down. For example, whole grain

pasta would take longer to break down and release its sugars compared with refined white bread, and this slow release is an advantage. It means that insulin will have a fairly easy time escorting sugar into the cells of the body.

The glycemic index (GI) is a measure of how quickly a food releases its sugars. The GI can be very helpful in planning your food choices. Foods with a high GI raise blood sugar levels quickly. This rapid rise can overwhelm your insulin's ability to remove it from the blood.

Several factors influence glycemic index. How a food is cooked and processed, whether it is eaten alone or as part of a mixed meal, and characteristics of the starch itself influence the GI. The following table lists the GI for various foods. Look, for example, at the GIs for potatoes. The numbers vary greatly, depending on how the potatoes are cooked (baked vs. boiled), or by the degree of processing involved (natural vs. instant potatoes). The GIs for pasta and bread also are very different from one another, even though both are made from wheat. Starch is tightly packed to make pasta, so its sugars are released slowly. Bread is lighter and fluffier, and its sugars are released much more quickly. Beans and less-processed grains and fruits have a lower GI than most bread. Smaller quantities of higher-GI foods are usually not a problem when eaten at the same time as lower-GI foods. For example, the higher-GI food instant white rice does not cause much trouble when mixed in with foods with lower-GIs such as beans and vegetables in a burrito. In fact, it's quite a healthy treat.

This may sound like a lot to remember, but one or two trips to the supermarket to select healthy, low-GI foods will have you in the habit in no time. Just take the list along; you'll find many favorite foods on it. Checking the GI of foods you frequently eat helps you achieve good blood glucose control. Some research also suggests that it can reduce the risk of kidney, eye, and nerve problems as well as heart and blood vessel damage.

There are no hard-and-fast rules about what is a high GI and what is a low one. The values are standardized to the glycemic index of white bread, which is a refined product and a quick-release carbohydrate. In this table the GI of white bread is 100, so foods that have a glycemic index higher than that are also quick-release;

those lower are released more slowly, and are therefore preferred. A good rule of thumb would be to mostly choose foods with a GI of 90 or less.

Glycemic Index of Selected Foods

Breads

Bagel, white	103
Bread, French baguette	97
Bread, mixed grain	64
Bread, oat bran	68
Bread, pita	82
Bread, pumpernickel	58
Bread, white	100
Doughnut, cake-type	108
Kaiser roll	104
Muffin, bran	85
Waffles, Aunt Jemima	109

Cereals

All-Bran	60
Cheerios	106
Corn Flakes	119
Grapenuts	96
Oatmeal	87
Rice Krispies	117
Shredded Wheat	99

Grains

Barley	36
Bulgur wheat	68
Couscous	93
Millet	101
Sweet corn	78

Rice, long-grain white	81
Rice, brown	79
Rice, instant	128
Rice, parboiled	68

Fruits

Apple	52
Apricots	44
Banana	76
Orange	62
Orange juice	74
Peach	40
Peaches, canned in syrup	83
Pear	51
Raisins	91

Legumes

Baked beans	69
Black-eyed beans	59
Chickpeas	47
Kidney beans	42
Lentils	41
Soybeans	25
Split peas	45

Pasta

Linguine	65
Macaroni	64
Spaghetti	59

Vegetables

Carrots	101
Peas	68

Vegetables (continued)

Potato, baked russet	121
Potatoes, instant	118
Potatoes, white, boiled	80
Potatoes, white, mashed	100
Potato, new	81
Sweet potato	69
Yam	73

Snack Foods

Corn chips	103
Jelly beans	114
Potato chips	77
Peanuts	21

As you can see, vegetarian diets boost valuable complex carbohydrates. Meat, dairy products, and eggs don't contain any complex carbohydrates at all, so meat-heavy diets are too high in protein and fat and too low in carbohydrates. Selecting a diet that contains a variety of fruits, vegetables, whole grain products, and legumes, while reducing refined and processed foods can result in much better sugar control.

Don't Forget the Fiber

Dietary fiber, or what your mom may have called "roughage," plays an important role in the management of both Type 1 and Type 2 diabetes. Found only in plant foods—never in meats, dairy products, or eggs—fiber is the part of the plant that resists digestion as it passes through the intestinal tract. Good sources of fiber include brown rice, oats, pears, black beans, celery, and carrots.

One type of fiber, called soluble fiber, is found in fruits, vegetables, barley, beans, oats, and oat bran. Researchers have found that soluble fiber slows the absorption of glucose from the digestive tract after a meal, helping keep glucose levels under con-

trol and decreasing insulin requirements. Soluble fiber also helps lower your blood cholesterol level, as we'll see in more detail in chapter 6.

Insoluble fiber, found in fruits, vegetables, cereals, whole wheat products, and wheat bran, remains basically unchanged during digestion, helps prevent constipation, and can delay glucose absorption.

Fiber is part of what makes you feel full and satisfied after a meal, which may help control your appetite so you can avoid gaining weight. The increased time it takes to eat high-fiber foods also may contribute to weight loss. It also provides bulk, helping to prevent constipation.

Try filling your shopping cart with a variety of fruits, vegetables, whole grain breads and cereals, and legumes. The recipes in the back of this book will help you get started.

WHERE TO FIND FIBER

Grains

Bagel, plain (1 small)	1.6 grams
Barley, pearled, cooked (1 cup)	6.0 grams
Bulgur, cooked (1 cup)	8.2 grams
Kellogg's All Bran (1 cup)	20.0 grams
Kellogg's Corn Flakes (1 cup)	1.1 grams
Millet, cooked (1 cup)	3.1 grams
Nabisco Shredded Wheat 'N Bran (1 cup)	6.4 grams
Oatbran, raw (1/3 cup)	4.8 grams
Oatmeal, quick, cooked (1 cup)	4.0 grams
Quinoa (1 cup)	10.0 grams

Fruits

Apple (1 medium)	3.7 grams
Banana (1 medium)	2.7 grams
Orange (1 medium)	3.1 grams
Pear (1 medium)	4.0 grams

Vegetables

Broccoli, boiled (1 cup)	4.6 grams
Brussels sprouts, boiled (1 cup)	4.0 grams
Carrots, boiled (1 cup)	5.2 grams
Collard greens, boiled, chopped (1 cup)	3.6 grams
Corn, boiled (1 cup)	4.6 grams
Peas, green, boiled (1 cup)	8.8 grams
Tomato, red, raw (1 medium)	1.4 grams

Legumes

Baked beans (1 cup)	13.9 grams
Black beans, boiled (1 cup)	15.0 grams
Chickpeas, boiled (1 cup)	12.5 grams
Kidney beans, red, boiled (1 cup)	13.1 grams
Lentils, boiled (1 cup)	15.6 grams
Navy beans, boiled (1 cup)	11.6 grams
Soybeans, green, boiled (1 cup)	7.6 grams

Source: J. A. T. Pennington, *Bowes and Church's Food Values of Portions Commonly Used,* 17th ed. (Philadelphia: J. B. Lippincott, 1998).

A New Look at Protein

People with diabetes were once encouraged to consume large amounts of protein. We now know that this may actually be harmful, accelerating kidney disease and the bone loss of osteoporosis (see chapter 9 for a detailed discussion of kidney disease). Diets centered on meat (including chicken and fish) or eggs tend to be too high in protein. Plant foods supply just enough protein to build, repair, and maintain your body tissues without the excesses that would burden your bones and kidneys.

In the 1970s, Frances Moore Lappé popularized the concept of "protein complementing" in her book *Diet for a Small Planet.* The idea was to eat plant foods in certain combinations so that you would be sure to get complete proteins. Rice would be combined

with beans, for example, and peanut butter with whole grain bread. In the 1980s she recanted this approach, stating in an updated version of her book "In combating the myth that meat is the only way to get high quality protein, I reinforced another myth. I gave the impression that in order to get enough protein without meat, considerable care was needed in choosing foods. Actually it is much easier than I thought." Leading experts certainly agree. Nevertheless, Dr. Lappé's book was important in that it recognized that you could easily get all the protein you need from plants. Beans of any variety, soy products, whole grains, vegetables such as spinach and broccoli, and many other plant foods are good sources of protein. Include any from the following list in your diet often and you'll find it easy to meet your needs.

SOME HEALTHY PROTEIN SOURCES (IN GRAMS)

Black beans, boiled (1 cup)	15.2
Broccoli (1 cup)	4.6
Bulgur, cooked (1 cup)	5.6
Chickpeas, boiled (1 cup)	14.5
Lentils, boiled (1 cup)	17.9
Peanut butter (2 tbsp)	8.0
Quinoa, cooked (1 cup)	11.0
Seitan* (4 oz)	24.0
Spinach, boiled (1 cup)	5.4
Tempeh (½ cup)	15.7
Tofu, firm (½ cup)	19.9
Whole wheat bread (1 slice)	2.7

*A vegetarian product made from wheat gluten; protein value from manufacturer's information.

Source: J. A. T. Pennington, Bowes and Church's Food Values of Portions Commonly Used, 17th ed. (Philadelphia: J. B. Lippincott, 1998).

Sources of Fat in the Diet

Saturated fat	Meat, poultry, whole dairy products, eggs, butter, lard, palm oil, and coconut oil
Monounsaturated fat	Nuts, olives, olive oil, canola oil, and avocados
Polyunsaturated fat	Safflower oil, sunflower oil, and corn oil

One of the main goals of diabetes management is to achieve and maintain good blood cholesterol levels to reduce your risk of heart disease. Eliminating foods high in saturated fat and cholesterol such as meat, dairy products, and eggs cuts your risk of heart disease.

In general you'll want to keep fat in your diet—from any source—to a minimum, and whatever fat you do have should come from plant sources. Diets that are low in fat promote weight loss, which is particularly important for people with Type 2 diabetes. Studies show that weight loss can reduce or even eliminate the need for medications.

The Facts about Fat

You may think fat is the enemy, but it's not quite that simple. Fats in the diet have important functions, such as supplying energy and serving as building blocks for many compounds used in the body. However, in large quantities they keep insulin from working properly. Here's what you need to know about fats:

Saturated fats are solid at room temperature. Butter, chicken, and beef fat, for example, are high in saturated fat, which can increase your risk of heart disease and cancer.

Polyunsaturated fats are liquids, and are mainly found in vegetable oils. They do not tend to raise your cholesterol.

Monounsaturated fats are liquid at room temperature and semisolid when refrigerated. Like polyunsaturated fats, they do not raise cholesterol levels. Some sources include olives, olive oil, and avocados.

Pulling It All Together

We no longer look at nutrition the way we once did—as a rather weak ally that can only delay the inevitable complications of diabetes. Not only do healthy foods help manage diabetes, they also can cut your need for medicines and sometimes even make the illness go away completely.

Because the change to a low-fat, vegan diet can cut the amount of insulin or other medication you need, be sure to discuss your diet change with your physician and dietitian. Don't settle for an old-fashioned diet. You deserve the very best. Delicious foods are waiting, as near as your corner grocery, to help you achieve your goals.

3

Healthy Eating Basics

Evidence has been accumulating over the past quarter century pointing to the tremendous impact our food choices have on our health. In particular, researchers have found how foods, properly chosen, can trim our waistlines, prevent or control diabetes, and rein in blood pressure and cholesterol levels. Arguably the most important of these habits is diet. More and more research points to the benefits of choosing a diet built from simple, healthy plant foods.

Health Advantages of Plant-Based Diets

In the preceding chapter we looked at the surprising power of plant-based diets to combat diabetes. But what does a plant-based or vegan diet mean? It means choosing all your foods from plant sources such as whole grains, legumes (beans, peas, lentils), fruits, and vegetables. This a sensible option for people with diabetes—and for anyone else, for that matter. Over and over again, research studies have shown that when people make sweeping changes in

their diet, their overall health greatly improves. We've focused on the vegan diet because it simply works the best in improving health. Here are the health benefits you'll enjoy if you choose to take this important step.

Hypertension

Hypertension, or high blood pressure, occurs in about one in every five Americans. And while hypertension may be a common condition, a third of people with high blood pressure don't know they have it, which is why hypertension is sometimes called the silent killer. A vegetarian diet can prevent hypertension from ever happening and even lower blood pressure in people who already have it. Researchers have served vegetarian diets to people with and without high blood pressure and have found significant reductions in both groups. By taking the high-sodium, low-fiber animal foods out of the diet and replacing them with fiber- and potassium-rich vegan foods, your blood pressure will reach lower, healthier levels, too.

Cholesterol

Not surprisingly, the same meat- and dairy-centered diet that raises blood pressure is also causing our cholesterol levels to skyrocket. By filling our plates with hamburgers, chicken, and cheese, we've seen the occurrence of high cholesterol levels soar. A recent report from the American Heart Association (AHA) found that more than 99 million American adults now have a total blood cholesterol of 200 mg/dl or higher. The AHA considers cholesterol levels to be "borderline high" between 200 and 240 mg/dl and "high" if more than 240 mg/dl. However, there is substantial benefit to keeping your cholesterol well under this limit. Fortunately, our cholesterol levels respond quickly and easily to a simple diet makeover. Researchers have examined the effect of a vegetarian diet on cholesterol levels and have found that the same diet that lowers blood pressure also lowers cholesterol levels by 26 percent after just six weeks.

The remedy is clear and simple: Take the saturated fat and cholesterol out of the diet and replace them with cholesterol-free foods.

All animal products—beef, fish, eggs, cheese, milk—have choles-terol in them. Even if we remove the skin off the leanest part of the chicken, we're still left with about 100 mg of cholesterol in a medium-size chicken breast. That's 100 mg more than we should be eating in our diet.

Cancer

Most of us know someone who has been affected by cancer. While cancer is easy to get, we are certainly not powerless to build a strong defense against it. Just as we've uncovered the value of quit-ting smoking to prevent lung cancer, so we are realizing that a healthy diet plays a tremendous role in preventing almost every form of cancer. Studies have shown that vegetarians are at half the risk of developing cancer compared to meat eaters. This is probably due to many factors. For one, vegetarians have twice the level of cancer fighter cells (natural killer cells) than meat eaters. Vegans also consume more fiber, more antioxidants, and less fat than those on an omnivorous diet. All of these factors help protect us from cancer.

People who choose a diet built from fruits, vegetables, grains, and legumes also manage to avoid the foods that cause cancer. Ani-mal products such as meat, fish, chicken, eggs, and cheese all con-tain fat. High-fat diets have been linked to higher cancer rates. All meat, including fish and poultry, forms heterocyclic amines (HCAs) when cooked. These HCAs are cancer-causing substances that cause damage to our DNA. So fill your plate with cancer-fighting foods such as vegetables, fruits, whole grains, and legumes and get rid of the foods that promote cancer: meat and fried foods.

Obesity

One of the treatment goals for people with both Type 1 and Type 2 diabetes is to achieve and maintain a healthy body weight. This doesn't mean going on a restrictive low-calorie diet or counting every calorie along the way. It means switching from high-fat, no-fiber foods to fiber-rich plant foods. By switching to these foods, your weight will naturally come down, and the added fiber will leave you feeling full and satisfied.

The New Four Food Groups

Growing up, you probably learned about the old Four Food Groups. A "balanced" diet meant having a serving of meat, dairy, starch, and a fruit or a vegetable at every meal. What nutrition experts counted on as being a healthy food model turned out to be a food pattern that wasn't very healthy at all. Enter the New Four Food Groups, proposed by the Physicians Committee for Responsible Medicine in 1991. The meat and dairy products were laid off, and better foods were hired to fill their places. Fruits and vegetables, instead of being crammed into one cubicle, get their own offices. Grains still have their own space, with an emphasis on fiber-rich whole grains. Legumes, long thought of as a food only eaten when you're low on cash, are now thought of as food fit for a king. These protein and fiber powerhouses get their own place in the New Four Food Groups, too. Here's an easy-to-follow eating guide that is designed for health promotion and disease prevention.

How do these foods translate into healthy meals? Envision your plate divided into four sections, with each section taken up by one of the New Four Food Groups. Picture seasoned black-eyed peas, a brown rice pilaf, roasted vegetables, and a fruit salad. You don't have to divide the foods up, of course. Combining them is fine, too. Imagine a bean burrito stuffed with roasted vegetables wrapped in a whole-wheat tortilla and topped with a mango salsa, and you have all the New Four Food Groups wrapped into one delicious meal. Make sure you include a vitamin B_{12} source in your diet such as a multivitamin or fortified cereals and soy milks.

Making the switch from your current diet to the New Four Food Groups takes some patience and creativity, but it's easy to do. First, think of the meatless meals you already love: pasta with marinara sauce, lentil soup, or vegetable stir-fries, for starters. Begin by incorporating more of these familiar favorites into your eating routine. Next, try changing some of the meat and dairy dishes you commonly prepare to healthier versions. Order a cheeseless pizza loaded with vegetables. Change a beef taco to a bean burrito. Make lasagna with blended tofu and your favorite vegetables instead of cheese and meat. Swap the turkey in your sandwich for a bean spread. Most restaurants offer vegetarian items now, and many will

The New Four Food Groups

Vegetables: 3 or more servings a day

Serving size: 1 cup raw vegetables; ½ cup cooked vegetables

Vegetables provide vitamin C, beta-carotene, riboflavin, iron, calcium, fiber, and other nutrients. Dark green, leafy vegetables such as broccoli, collards, kale, mustard and turnip greens, chicory, and bok choy are especially good sources. Dark yellow and orange vegetables such as carrots, winter squash, sweet potatoes, and pumpkin provide extra beta-carotene. Consume a variety of vegetables every day.

Whole grains: 5 or more servings a day

Serving size: ½ cup hot cereal; 1 ounce dry cereal; 1 slice bread

This group includes bread, rice, pasta, hot or cold cereal, corn, millet, barley, bulgur, buckwheat groats, and tortillas. Whole grains are rich in fiber and other complex carbohydrates as well as protein, B vitamins, and zinc. Make sure at least half of your grain servings each day are from whole grains.

Fruit: 3 or more servings a day

Serving size: 1 medium piece fruit; ½ cup cooked fruit; 4 ounces juice

Fruits are rich in fiber, vitamin C, and beta-carotene. Be sure to include at least one serving each day of fruits that are high in vitamin C—citrus fruits, melons, and strawberries are all good choices. Choose whole fruit over fruit juices, which do not contain very much fiber.

Legumes: 2 or more servings a day

Serving size: ½ cup cooked beans; 4 ounces tofu or tempeh; 8 ounces soy milk

Legumes—another name for beans, peas, and lentils—are good sources of fiber, protein, iron, calcium, zinc, and B vitamins. This group also includes chickpeas, baked and refried beans, soy milk, tempeh, and textured vegetable protein.

Be sure to include a good source of vitamin B_{12} such as fortified cereals or vitamin supplements.

make a dish if you request it. Veggieburgers and vegetarian pasta dishes are commonplace now at eateries. Request a steamed vegetable plate with brown rice and whole grain bread. The final step is to give the diet a chance to show its power. By following this new eating style exactly for three weeks, you'll see changes in your taste buds and improvements in your blood glucose.

This approach may seem a bit daunting at first. The idea of cutting out your favorite foods can be frightening. Unfortunately, many of our favorite foods are the same ones that can seriously damage our health. Foods such as French fries, hamburgers, milkshakes, pizza, and cheese omelets are sold everywhere, but they weren't created with your health in mind. The good news is that our taste buds have a short-term memory. Within about three weeks your taste buds will forget what potato chips and pork chops taste like, and you'll stop craving the greasy, fatty foods you once adored.

It also may seem strange that a healthy diet for people with diabetes would include so many carbohydrate-rich foods. If so, take another look at the previous chapter, in which we discussed why this new dietary approach is being recommended for people with diabetes to help lower and stabilize blood glucose levels.

Key Nutrients and Where to Find Them

Our bodies are miraculous machines. Without us even thinking about it, our bodies take the food we eat and extract the essential nutrients we need. Our bodies need something to work with, however, so having a little knowledge about where to get the nutrients we need is helpful. Here is a list of nutrients and where you'll find them in your food.

Macronutrients: Protein, Complex Carbohydrate, and Fat

Protein

Protein builds muscle and makes blood cells, among other important functions. Nutritionists recommend consuming about 10 percent of your calories from protein. On a 2,000-calorie diet, that translates to

about 200 calories from protein, or about 50 grams. This 10 percent recommendation builds in a margin of safety as well.

How does that translate into food? Try a bean burrito or spaghetti with marinara sauce for 10 grams of protein. A tofu vegetable stir-fry over brown rice has 15 grams. For every bite you'll get a nice helping of fiber, very little fat, and no cholesterol. We once believed that it was necessary to combine certain plant proteins together, but nutrition experts know now that there is plenty of protein in a varied, plant-based diet with no combining required.

Complex Carbohydrate

It is important, especially for people with diabetes, to get the majority of carbohydrate calories from fiber-rich, complex carbohydrate, found in whole, plant foods. The reason is simple: The more fiber that's in a food, the slower the sugar will be released into the bloodstream. This helps your blood glucose levels to remain steady. What about fruit? Many people with diabetes avoid fruit, because they contain simpler sugars than beans, whole grains, and vegetables do. But they are still rich in soluble fiber. This means fruit can release its sugars much more slowly than foods such as candy or soft drinks, which contain no fiber at all.

You'll find plenty of high-fiber, complex carbohydrates in the beans, vegetables, and grain groups. One cup of beans has 10 grams of fiber, one cup of cooked broccoli has 5 grams of fiber, and one cup of whole-wheat spaghetti has 6 grams of fiber. Compare that to the zero grams of fiber in meat, milk, eggs, and cheese and you'll see why plant sources of nutrients are the way to go. The minimum daily recommendation for fiber intake for adults is 25 grams. People with diabetes (and everyone else for that matter) should aim for even higher intakes, of about 30 to 40 grams a day. Vegetarians tend to meet this recommendation easily. Increase your fiber intake slowly and make sure to include plenty of water so the fiber can do its job.

Fat

Gram for gram, fat has more calories than both carbohydrates and protein. That's one of the reasons why it's so easy to consume too many calories by eating meat and cheese at meals. By eating all

your foods from the New Four Food Groups and by keeping the vegetable oils low, you'll be sure to consume a diet that is naturally low in calories but still very filling.

You've probably heard some good things about essential fatty acids (EFAs), but where do we find them? EFAs are fats we must get through the diet because we can't make them ourselves. Alpha-linolenic acid (omega-3 fatty) and linoleic acids (omega-6) are the two types of EFAs we must get through the diet. You can find alpha-linolenic in nuts, seeds, and soy products as well as beans, vegetables, and whole grains. If you are looking for an especially rich source, you'll find it in flaxseed and flaxseed oil (found at any natural food store). You may have heard that fish are good sources of this type of fat, but the high amounts of fat, cholesterol, and the lack of fiber make fish a poor choice. Fish also are often high in mercury and other environmental toxins that have no place in an optimal diet. Linoleic acid is abundant in most of the foods we eat. They're found in most plant foods and in any vegetable oil.

Micronutrients: Vitamins

Vitamin A and Beta-carotene

Beta-carotene is what makes carrots and sweet potatoes orange. It's also a powerful antioxidant and cancer protector that is converted to vitamin A in our body. Vitamin A helps maintain healthy eyesight, cell growth, and immune function. We can get beta-carotene through a variety of sources, including sweet potatoes, cantaloupes, pumpkins, carrots, and broccoli.

Vitamin D

We need vitamin D to absorb and utilize calcium. The best place to get vitamin D naturally is from the sun. As you walk to the bus stop or take a lunchtime stroll, the rays that warm your hands and face also give your body vitamin D. What can you do when it's cloudy or you're inside all day? You can get vitamin D from fortified cereals, soy and rice milks, or a multivitamin. You should take a multivitamin that contains vitamin D if you live in a cloudy area, are housebound, or wear sunscreen every day.

Vitamin E

You'll find another powerful antioxidant in vitamin E. It strengthens our immune system, keeps our skin cells healthy, and may even play a role in protecting us against heart disease. Get your vitamin E from whole grains; wheat germ; spinach, broccoli, and other green, leafy vegetables; corn; nuts; seeds; and vegetable oils. For a vitamin E powerhouse, sauté broccoli and spinach in soybean oil and top with walnuts and wheat germ.

Vitamin K

Vitamin K helps with blood clotting and bone formation. This vitamin is abundant in green, leafy vegetables such as kale, broccoli, and collard greens. You can also find it in fruit. To get your vitamin K, try making a spinach enchilada with a fruit salad made of oranges and apples. If you are taking a blood thinner, such as Coumadin or Warfarin, consult your dietitian or doctor before greatly increasing or decreasing your intake of this vitamin.

Vitamin C

Vitamin C was popularized as the shining star in your morning orange juice, but it's actually in plenty of other foods. Vitamin C helps maintain our immune system and proper cell growth and also aids in wound healing. Vitamin C is abundant in the plant world. In fact, you can only get vitamin C from plants. Citrus fruits such as oranges and grapefruit, and many vegetables such as collard greens, broccoli, spinach, tomatoes, and bell peppers are excellent sources. Top your cereal with strawberries, try a kiwi as snack, or put some extra tomatoes on your hummus sandwich and you'll be sure to get a healthy dose of vitamin C. In fact, just one cup of cooked broccoli, one cup of orange juice, or one grapefruit gives you all the vitamin C you need.

The B Vitamins

Vitamin B_1 (thiamin), B_2 (riboflavin), B_3 (niacin), and B_6 (pyridoxine) are all involved in energy metabolism. They take the foods we eat and turn them into energy we can use. Grains, seeds, nuts, and beans are all good sources of these nutrients. Vitamin B_6 also is

plentiful in corn; cabbage; bananas; green, leafy vegetables; and cantaloupes. Loading your plate with whole foods such as beans and grains should give you a healthy dose of B vitamins at every meal.

Folate or Folic Acid

Folate (found in plants) and folic acid (found in supplements) prevent certain birth defects and are required to make new cells. The word *folate* comes from the term *foliage,* so it should come as no surprise that you'll find it in leafy greens such as broccoli and spinach, as well as in oranges and orange juice, strawberries, beans, and seeds. It's hard not to meet the Reference Daily Intake (RDI) for folate by eating a completely plant-based diet. If you started your day with a cup of orange juice and topped your cereal with a cup of strawberries, and then ate a spinach and bean burrito, you'd already have met the daily requirement . . . and that's even before dinnertime!

Vitamin B_{12}

Vitamin B_{12} is used in new cell synthesis. Bacteria rather than plants or animals produce B_{12}, so it's not found in unfortified foods from plants. Animal products contain vitamin B_{12} because their intestines contain bacteria that produce it, but meat, eggs, and cheese also contain a lot more of the things you don't want. To get your vitamin B_{12}, reach for a daily multivitamin, fortified soy and rice milks, and fortified cereals. You need only 2 micrograms a day.

Micronutrients: Minerals

Calcium

As you'll find out in this book, dairy products have many downsides. So how can you get your calcium without them? You get your calcium the way many people in most of the rest of the world do: from plant sources. It surprises many people that good, absorbable calcium can be found in the plant world, but it's true. We need calcium to build strong bones and teeth, and it is also involved in maintaining blood pressure, conducting muscle contraction and nerve transmission, and it aids in blood clotting.

You'll find plenty of calcium in beans, leafy greens, and fortified juices and soy milks.

Another reason to avoid animal products has to do with the effect animal protein has on calcium in our bodies. Animal protein contains sulfur-containing amino acids that make the blood slightly acidic. To neutralize this acid, our bodies pull calcium from our bones when we eat animal protein. This means that by switching to plant sources of calcium, not only will you be getting fiber and antioxidants with your calcium dose, but you will also be holding on to the calcium you already have.

You can also retain more of your calcium by making other simple changes in your diet and lifestyle. One way you can do that is by cutting down on sodium and caffeine. Sodium and caffeine act as diuretics, pulling calcium with them on their way out of the body. Try avoiding salty foods, including highly processed, prepared foods such as canned soups, TV dinners, and salty snacks. When you learn to cook with savory spices, salt will easily lose its appeal. Also limit the amount of salt you use from the saltshaker. By avoiding foods with high sodium content, you can hold on to more calcium. Limiting your caffeine is important, too. Try to limit yourself to no more than 1 to 2 cups of a caffeinated beverage, such as coffee or soda, each day.

It's not just what you put into your body that affects calcium loss, but also how often you move your body. The more sedentary you are, the more your body will think it doesn't have any use for strong bones. By doing weight-bearing exercises a few times a week, such as weight lifting, running, or hiking, you can send the message to your bones that they better shape up and hold on to that calcium.

Iron

When most people think of iron, they envision plates piled high with steaks, burgers, and other forms of red meat. Those foods do contain iron, but in a form the body can't regulate very well. This form of iron, known as heme iron, is absorbed quickly, whether we need it or not. Plants, on the other hand, contain nonheme iron, the gentle variety that stays around when it is needed and isn't absorbed when it's not.

Iron is used in our blood cells to help carry oxygen. When we don't have enough iron in our diets, we can become anemic, resulting in sluggishness and an inability to keep warm. Some people think they must be anemic because they are often tired. However, there are many causes of fatigue, and only your doctor can diagnose anemia. A good strategy to get adequate iron in the diet is to center your meals around beans, vegetables, and whole grains. You can enhance your iron absorption by consuming vitamin C–rich foods with these vegetable iron sources. For instance, have orange juice with a whole grain cereal, top your brown rice with sautéed broccoli, or add bell peppers to your bean burritos, and you'll aid your absorption of iron in a healthy and delicious way.

Zinc

Zinc helps with growth and development and helps keep the immune system healthy. Get your zinc from the same foods that give you iron, such as whole grains, beans, and vegetables. Like iron, getting too much zinc can be harmful, so avoid taking supplements with high levels of zinc.

Chromium

Chromium works in conjunction with the hormone insulin to get glucose into the cells where we can use it for energy. A deficiency in chromium can lead to high blood glucose levels. Unfortunately, increasing chromium in the diet can't make diabetes go away, but diabetes may be worsened by a diet low in chromium.

Since chromium is easily lost in food processing, few people get all they should. The new recommendation for chromium intake has been set at 35 micrograms/day for men under fifty-one years old and 25 micrograms/day for women under fifty-one years old. For folks fifty-one and older, the recommendation is slightly decreased, to 30 micrograms/day for men and 20 micrograms/day for women. Like iron, chromium's absorption may be enhanced by vitamin C foods. It hasn't been determined yet whether chromium can improve blood glucose regulation, but it makes sense to meet the current recommendations each day by consuming chromium-rich whole grains and nuts. You can even get chromium when you

eat acidic canned foods such as canned tomatoes, since a small amount of the chromium embedded in the metal can seeps out.

What about Meat, Dairy, and Eggs?

We've already touched on some of the reasons why meat, dairy, and egg products don't belong in a healthy diet. We know that animal protein rich foods leach calcium from the bones and contain cholesterol. We know that most animal products are loaded with heart-damaging, saturated fat and that the iron found in meat is difficult for our bodies to regulate. We also know that diets containing animal products are more likely to cause cancer, heart disease, and high blood pressure. These are reasons enough to leave the meat and dairy off our plate, but here's something else to consider.

Every time we have a cheese omelet, a grilled chicken breast, or a glass of milk, we are squeezing out healthier choices. Each bite of turkey replaces a healthy bite of broccoli, beans, or bananas. Each bite of cheese means a bite less of a fiber-rich food. Many people with diabetes are told to lose weight to improve their glucose tolerance, but it is difficult to lose the weight and still include meat, cheese, and eggs in your diet. When you move over to the right foods, weight loss is much easier. To get into better control of diabetes and your overall health, it is important to start viewing food as a wonderful and powerful tool to help you meet your goals.

What about Sugary Foods?

People with diabetes used to avoid sugar like the plague. Sugar-free gum, syrups, and sodas were the only "treats" allowed in a diabetic diet. As you'll see in the next chapter, sugar actually causes a slower rise in blood glucose than some other foods, such as white bread or white baking potatoes. That doesn't mean you should load up on sodas, candy, and cookies. High sugar foods like these contain little or no fiber and few nutrients. Again, you should view every bite of food as a powerful tool to improving your health, and that means avoiding things such as sugar-sweetened soft drinks, candy, and desserts. For a sweet treat, try foods that contain natural

sugars and fiber together, such as fruit or oatmeal made with raisins. Recipes in the back of this book will provide you with some great dessert ideas.

What about Artificial Sweeteners?

The safety of artificial sweeteners has been widely debated in the nutrition world. Some people worry that sugar substitutes such as saccharin or aspartame cause cancer or brain tumors. While there is not enough evidence to prove these claims, there is another reason why you should consider avoiding these artificial sweeteners. Your cravings for sweet things will never diminish if you continue to consume items that are sweetened with saccharin, asulfame-k, sucrolose, or aspartame. While these sweeteners may not contain any calories, they still *taste* sweet to us. As a result, when we are faced with a plateful of cookies or a slice of cheesecake, we still crave these foods because we haven't stopped consuming "copy cat" foods. Try avoiding both artificially sweetened and sugar-sweetened snacks for three weeks and see if your level of craving for these foods decreases. You may be surprised.

Does the Amount of Processing Matter?

Most of us consume processed foods every day and at every meal. We consume cereal for breakfast, potato chips with lunch, and a frozen meal for dinner. People with diabetes need to pay special attention to the amount of processed foods they eat. That's because the more processing a food undergoes, the more fiber it loses, and the more sodium it gains. Your body also breaks down processed foods more rapidly (when the fiber has been removed or highly milled), which means that your blood glucose levels will rise faster.

Picture a bowl of whole grain oats. The oat flakes are large and hearty. It may take a few minutes longer to make, but you'll see that it's worth it. Now picture a bowl of instant oatmeal. The flakes are cut into tiny pieces, and when you make it, the oatmeal is more like a mushy blob than separate oats. When oats are processed into instant oatmeal, fiber is lost and salt is added, not to mention sugar

most of the time. These tiny, fine oats get digested and absorbed much faster than the hearty, old-fashioned oats and, as a result, your blood sugar level shoots up faster. You can avoid the pitfalls of processed foods by sticking to whole, unprocessed foods. Eat an apple instead of applesauce. Try steamed broccoli instead of a cream of broccoli soup. Have a side dish of corn instead of corn chips. Favor hearty pumpernickel bread to fluffy slices of white bread. Soon your body will prefer these healthy whole foods.

A Healthy Dietary Approach for People with Diabetes

The eating plan described in this chapter is a healthy diet for everyone, not just for people with diabetes. However, people with diabetes have certain nutrient concerns, making it all the more important to get on track today. Fortunately, diabetes is a disease that can be largely controlled through lifestyle changes, including the right diet and exercise. As we saw in the previous chapter, the new dietary approach to diabetes is based around delicious, whole, plant foods. The power to take control over diabetes is in your hands. As you gain the tools to manage, prevent, or reverse this disease, your overall health will improve dramatically.

PART II

Making It
Work for You

4

Preventing Diabetes

If you, or someone you care about, are at risk for diabetes, this chapter is for you. As we saw in chapter 1, simply getting older, putting on a few extra pounds, having a relative with diabetes, or neglecting to exercise can all add to our risk of diabetes. As you have probably already figured out, the easiest way to avoid the health consequences of diabetes is to keep from getting it in the first place.

And it's worth giving our best efforts to prevent it. According to the American Diabetes Association, diabetes is the fourth leading cause of death in the United States, and more people in the United States die each year from diabetes than from breast cancer or AIDS. And, because of the variety of possible complications of diabetes—vision difficulties, kidney damage, foot problems, heart disease, and even stroke—plus all of the medical attention needed to treat these problems, diabetes is a major contributor to healthcare costs.

You'll be happy to know, though, that diabetes is preventable for the majority of people. Diabetes researcher JoAnn Manson, M.D., at Harvard Medical School, has estimated that "At least 75 percent of new cases of Type 2 diabetes can be prevented by choosing a diet

high in fiber-rich foods—fruits, vegetables, grains, and legumes."
Other doctors agree that the vast majority of cases are preventable
by eating healthfully and staying physically active. Scientists also
have had some success using diet to prevent or delay Type 1 dia-
betes in high-risk individuals. And, not surprisingly, with the right
diet, you can make vast improvements in your health whether or not
you have diabetes.

While the guidelines for treating, reversing, and managing Type
1 diabetes and Type 2 diabetes are generally the same, the methods
for prevention vary slightly. First, the similarities: Type 1 and Type
2 diabetes both appear to have a genetic component. This means
that you are more likely to get diabetes if one or both of your par-
ents has it. However, families are more likely to pass on diabetes by
sharing lifestyle and eating habits than by passing down their
genes. Both types of diabetes are decidedly influenced by how we
live each day. While we do not know what all of these factors are
yet, there are precautions you can take to dramatically reduce your
chances of getting diabetes.

Preventing Type 1 Diabetes

Unlike many chronic diseases that develop after years of wear and
tear on our bodies, Type 1 diabetes shows up quite suddenly. It most
commonly appears during childhood and is caused by autoimmune
destruction of the insulin-producing cells of the pancreas. This
means it's irreversible. Once these cells are destroyed, they cannot
be regenerated. As you can see, prevention should be a priority of
all parents, yet many do not receive enough information from their
healthcare practitioners to do so.

To better understand how prevention might be possible, let's take
a little closer look at the beginning stages of the disease process.
Scientists believe that the trigger of an autoimmune response is
most likely exposure to some environmental factor in early child-
hood. Possibly the result of genetic influences, some children are
more susceptible to these potential triggers. After the autoimmune
response has started, there is a period of time (from a few months
to several years) when the number of insulin-producing cells

decreases. If doctors identify the disease at this stage, they may be able to slow its progression or prevent it completely.

With this in mind, there are two ways individuals can work to prevent Type 1 diabetes in children. First, parents can make every attempt to reduce exposure to possible triggers, as we'll see shortly. Second, if a child is thought to be at risk, parents can ask their pediatrician to test the child's blood periodically for antibodies to the insulin-producing cells, a sign of an autoimmune response. If the doctor finds these antibodies, he or she can try one of a variety of currently experimental therapies to slow or stop the destruction of the insulin-producing cells.

There are three major research trials currently under way to determine what type of therapy is most effective at preventing or delaying the onset of Type 1 diabetes in high-risk children. Over the next few years the results of these trials will improve our ability to effectively prevent Type 1 diabetes.

What You Can Do

Environmental factors implicated in Type 1 diabetes can either be triggers, also sometimes called initiators, or they can accelerate the progression of the disease (from the point of the trigger to diabetes). One of the key triggers of the autoimmune response is the proteins found in cow's milk, and infant formula made from cow's milk. In 1994 the American Academy of Pediatrics reported that avoiding cow's milk in infancy could likely reduce diabetes risk. Cow's milk proteins can even be passed from a milk-drinking mother to her breastfeeding baby. Mothers would do well to avoid dairy products, both during pregnancy and breastfeeding. Not only will this reduce her child's exposure to a known autoimmune trigger, but it also often reduces problems with colic.

Other dietary factors have been implicated as well. In studies from Iceland and Sweden it appears that a mother's exposure to nitrosamines, compounds found in high levels in charred or highly processed meats, at about the time of conception also increases the risk of Type 1 diabetes in her children. A protein called gliadin, found in wheat, has been connected with an autoimmune response in some children.

Stacking the Odds in Your Child's Favor

Here are some steps you can take to help prevent Type 1 diabetes in your child:

1. Choose a healthy diet built from grains, legumes, fruits, and vegetables during pregnancy and breastfeeding.

2. Avoid meat and dairy products from prepregnancy through weaning.

3. Wean your child with soy-based infant formulas, if necessary, and to fortified soy milks instead of cow's milk after he or she is at least a year old.

4. If you or someone in your family has Type 1 diabetes, have your child screened regularly for the antibodies involved in the destruction of insulin-producing cells.

Aside from triggers, a number of accelerators of this process have been identified. A high growth rate during prenatal development and during early childhood is the clearest of these risk factors. Diets that accelerate growth are those seen in the wealthiest countries, where overly fatty diets that contain large amounts of meat and milk are standard. A simple change to a vegetarian diet seems to moderate growth to a pace that is more conducive to the long-term good health of children, and, naturally, it does wonders for mothers as well.

Viral infections, before and after birth, as well as stressful life events also have been shown to accelerate the onset of Type 1 diabetes in susceptible children.

Doctors still have much to learn about preventing Type 1 diabetes, and we are likely to hear about additional important preventive methods in the upcoming years. Nonetheless, wise parents who take these precautions will be doing all they can to prevent child-onset diabetes for their families.

Preventing Type 2 Diabetes

Whether or not you have diabetes in your family, all you need to do to steer clear of Type 2 diabetes is to take the three steps outlined here:

1. Maintain a healthy weight.
2. Choose a low-fat vegetarian diet by planning your meals using the New Four Food Groups.
3. Do at least thirty minutes of physical activity most days of the week.

Scientists know that these three steps are essential to preventing Type 2 diabetes. The challenge often lies in getting people to begin. More on that shortly. First let's understand why these keys are so important.

In the following sections we'll take a closer look at the importance of each of these steps and how to go about taking them.

Maintaining a Healthy Weight

Doctors estimate that 50 to 75 percent of new cases of Type 2 diabetes are triggered by obesity. Being overweight by just 20 percent increases your risk tenfold.

The good news is that small changes make a big difference. University of Pittsburgh psychologist Rena Wing found that men and women at high risk of diabetes cut their risk by 30 percent by losing just ten pounds.

Where we carry excess weight matters, too. People who carry their weight at the waist are more at risk of diabetes than those who carry it mainly at the hips. This just means that if you tend to gain weight around your waist you need to pay extra attention to maintaining a healthy weight.

The Extra Body Fat—Diabetes Connection

Why do extra pounds make people more susceptible to getting diabetes? It turns out that the more fat you have stored on your body, the harder it is for you to get the glucose from your bloodstream into your cells, where it can be used for energy. To get a handle on why that is, let's take a closer look at how our bodies process the foods we consume.

When we eat food, it is broken down into carbohydrates, fat, and proteins. Proteins are used to build muscles and cells; fat is shuttled off to make cell membranes, hormones, or to get packed into storage; and carbohydrates go toward meeting your energy needs. To

use this energy source, your body must first break the complex car-
bohydrate molecules into glucose. Insulin, as you learned earlier,
shuttles glucose into your cells, where your body uses it for energy.
Your cells are anxious to receive glucose, because it is used for fuel
to power their many functions, in much the same way as gasoline
fuels your car. Think of insulin as the key to your gas tank. If it is
working right, the key opens the cap so the gas can get into the
tank.

What happens when you gain too much weight? Your cells
slowly become resistant to insulin. It is as if the lock is gummed up,
and the key no longer fits. If fuel can't get in, your car won't run. In
your body, this means that your cells don't get enough glucose
inside. Instead, it builds up in your blood. This is called insulin
resistance, and it is what leads to high blood glucose and diabetes.

Your body responds by making more and more insulin, trying to
get glucose into your cells. And insulin resistance translates into
other problems as well, making it harder to lose weight and raising
your cholesterol and blood pressure.

The high-carbohydrate, high-fiber, and low-fat eating style rec-
ommended throughout these pages will help counteract insulin
resistance, and make achieving and maintaining a healthy weight
straightforward and enjoyable. The next chapter is chock full of
helpful information on how to put it to work to lose weight and
maintain a lean, healthy body.

Choosing a Healthy Diet

In study after study, scientists have found that diets high in fiber-
rich foods—fruits, vegetables, beans, and whole grains—reduce
the risk of diabetes. Fiber, which simply means plant roughage,
slows down the absorption of natural sugars from the starchy foods
we eat and has been shown to reduce insulin resistance. These same
nutrition powerhouses are excellent sources of complex carbohy-
drates, which give you energy and help keep you slim. Vegetables
and fruits also provide a healthy dose of antioxidants, vitamins, and
minerals, which are essential for all of us, but especially for people
trying to prevent diabetes.

Avoiding foods that are high in fat and cholesterol can also
reduce your risk. Animal products—dairy products, meat, and

eggs—contain plenty of saturated fats that clog our arteries and encourage weight gain. Low-fat, vegetarian diets have no cholesterol and are extremely low in saturated fat. In fact, Type 2 diabetes is very rare in lean people following a low-fat, vegetarian diet. (For more details, revisit chapter 3.)

Scientists have been investigating specific nutrients that may play a role in the prevention of Type 2 diabetes. In some studies, vitamin C, vitamin E, and chromium have been shown to reduce insulin resistance in prediabetic individuals. Your best bet is to get these nutrients from plant food sources rather than from supplements. Vitamin C is plentiful in citrus fruits, of course, but also in many vegetables. Vitamin E is found in whole grains, beans, nuts, and seeds. Chromium occurs naturally in whole grains and nuts.

Maintaining an Active Lifestyle

Getting your heart pumping helps, too. Walking, swimming, bicycling, gardening, and other activities will help trim your waistline, and even a small amount of exercise each week helps keep your blood pressure in check and your heart healthy.

Doctors estimate that 30 to 50 percent of new diabetes diagnoses each year are caused, at least in part, by too little exercise. It's no surprise, really. Most of us spend the bulk of our days sitting. We drive to work, sit at our desks, drive home, and often lie on the couch before we go to bed. From the phone by the couch, we can call out for pizza, or drive around the corner to get the super-size "value" meal. This era of convenience foods, sedentary jobs, and long workdays has led to less physical activity, larger waistlines, and higher incidence of Type 2 diabetes.

The connection between lack of exercise and diabetes risk has been confirmed in two large studies including more than a hundred thousand doctors and nurses. Researchers from Harvard University found that those who exercised at least once a week had a 30 to 40 percent lower risk of getting diabetes than those who exercised less often.

What can you do if you find that the sum total of your exercise is lifting your fork from plate to mouth? Take stock of your weekly schedule to figure out where you could fit in a few half-hour blocks of activity. Some people find it helpful to take a class at the local

parks and recreation department, join a gym, or sign up at a dance studio. Others find it more convenient to fit in an early morning walk or jog with the dog, to set up a lunchtime walking date with a coworker or two, or to ride their bike to work a few days a week. Fun physical activities can be an excellent way to spend time with friends of family members. Plan a weekend day hike with one or more of your friends or to go skating or swimming with your kids on Sunday afternoon.

Any type of exercise that gets you moving will do the trick. The most important thing is just fitting in at least a half hour of activity most days of the week. With exercise it is important to start with activities that are appropriate to your current fitness level, and to talk with your doctor about your plans. You'll find more information on exercise in chapter 10.

One last tip on prevention: Research has shown that making comprehensive changes rather than small ones seems to work best for most people. Not only do bigger changes, such as starting a daily walking program (rather than taking the stairs occasionally) have more dramatic effects, they also soon become new habits that alter your *entire* lifestyle. Try making a sweeping change in your eating habits for at least three weeks. Choose all your foods from the New Four Food Groups and completely avoid foods from animal sources, and you'll see how easy it really is. You very well may be amazed at how good you feel—and you will be well on your way to preventing diabetes and other chronic health problems.

If you are at risk for diabetes, you very well may be able to sidestep it altogether. The simple steps outlined in this chapter will improve your fitness and energy level and help diabetes-proof your body. Get started now on the road to prevention by choosing to build a healthy diet from fruits, vegetables, grains, and legumes and getting your body moving. You and your family members will be glad you did.

5

Achieving and Maintaining a Healthy Weight

If you have been diagnosed with diabetes, your doctor has probably told you about the importance of managing your weight. As you know, excess weight makes it difficult to control your glucose levels. The more weight you carry around, the harder it is for your body to use the insulin it produces, and the more insulin-resistant it becomes. A weight loss of just ten to twenty pounds can make diabetes more manageable.

Type 2 diabetes is rare in thin people, and losing weight is one major step in reversing this disease in people above their healthy weight range. See the weight table in chapter 1 to check whether your current weight puts you at risk.

Losing weight not only improves your insulin function but also takes strain off your heart, lowers your blood pressure, and reduces your risk of stroke. You'll also enjoy a major reduction in cancer risk, especially for the hormone-dependent varieties such as those in the breast, prostate, and ovary. Breast cancer, for example, is influenced by estrogen levels. As you trim fat from your diet and your waistline, these levels come back down from the danger zone.

What Is Healthy Weight?

There are several methods doctors and other medical professionals can use to calculate what your weight should be. One way to find out if you're at a healthy weight is to look up your body mass index (BMI) in the following table.

BMI is a simple index of body size. It does not tell you whether extra weight comes from body fat or from bulging muscles. In fact, many highly trained, very muscular athletes are heavier than the healthy weight standards, but they usually have a healthy body composition—meaning their "extra" weight is lean muscle mass rather than fat. For most of us, however, maintaining a weight outside of these "norms" is often one of the early signs of a lack of fitness. A healthy weight varies for everyone. You probably know what weight you feel your best at. Check with a medical professional if you have questions about whether you are above your healthy weight.

BMI CLASSIFICATION TABLES FOR ADULTS
(19 years or older)

BMI CATEGORY	HEALTH RISK	WITH OTHER HEALTH CONDITIONS*
<25	Minimal	Low
25 to <27	Low	Moderate
27 to <30	Moderate	High
>30	High to extremely high	Very high to extremely high

* Such as hypertension, cardiovascular disease, dyslipidemia, Type 2 diabetes, sleep apnea, osteoarthritis, infertility, and other conditions.

Source: American Society of Bariatric Physicians (www.asbp.org).

FINDING YOUR BMI (KG/M^2)

WEIGHT (POUNDS)	HEIGHT (INCHES)													
	50	52	54	56	58	60	62	64	66	68	70	72	74	76
45	13	12	11	10	9	9								
50	14	13	12	11	10	10	9	9						
55	15	14	13	12	12	11	10	9	9					
60	16	16	15	13	13	12	11	10	10	9				
65	18	17	16	15	14	13	12	11	10	10				
70	20	18	17	16	15	14	13	12	11	11	10			
75	21	20	18	17	16	15	14	13	12	11	11			
80	22	21	19	18	17	16	15	14	13	12	11	11		
85	24	22	21	19	18	17	16	15	14	13	12	12		
90	25	23	22	20	19	18	17	15	14	14	13	12	12	
100	28	26	24	22	21	20	18	17	16	15	14	14	13	12
110	31	29	27	25	23	22	20	19	18	17	16	15	14	13
120	34	31	29	27	25	24	22	20	19	18	17	16	15	15
130	37	34	31	29	27	26	24	22	21	20	19	18	17	16
140	39	36	34	31	29	27	26	24	22	21	20	19	18	17
150	42	39	36	34	31	29	28	26	24	23	21	20	19	18
160	45	42	39	36	34	31	29	27	26	24	23	22	21	19
170	48	44	41	38	36	33	31	29	27	26	24	23	22	21
180	51	47	44	40	38	35	33	31	29	27	26	24	23	22
190		49	46	43	40	37	35	32	31	29	27	26	24	23
200			48	45	42	39	37	34	32	30	29	27	26	24
220			49	46	43	40	38	35	33	31	30	28	27	
240				50	47	44	41	39	36	34	33	31	29	
260					50	47	44	42	39	37	35	33	32	
280							48	45	42	40	38	36	34	

As part of this dietary approach, the focus is taken off counting calories and carbohydrate grams. The emphasis is on eating an overall healthy diet. By eating low-fat, fiber-rich plant foods, your weight will naturally come down to where it should be.

The Problem with Dieting

When we feel we need to lose a few extra pounds, many of us just stop eating as many calories. If we feel we need to lose a lot of weight fast, sometimes we will stop eating most everything, going on liquid crash diets or fasts. According to a recent study, about half of American adults are currently trying to lose weight, and most of them are counting calories, limiting their portions, and feeling guilty about wanting seconds. The problem is that calorie-restricting diets don't work in the long run and can actually be harmful.

When you restrict the number of calories your body needs, your body reacts. As you starve yourself, all you can think of is food. You dream of having a doughnut or envision eating a whole pizza by yourself. The fact is, your body is rebelling against your calorie reduction. It doesn't know you want to lose weight. All it knows is that something has gone terribly wrong and that you are not able to get enough food. Not only will the diet make you preoccupied with food, but also your body lowers your metabolism so you'll burn less calories. It's a cruel trick, but when you cut calories too low, your body struggles to hold on to the fat that's there (both from your food and on your body). This is even true for people who are chronic breakfast skippers. If you don't eat breakfast and wait until noon to eat your first meal, your metabolism lowers to conserve its energy stores.

So, as you dream of food, your metabolism lowers, and then it happens. It's late at night, you open the freezer, and you see the big tub of ice cream. Before you know it, you've eaten the whole container. And because of your lowered metabolism, you will probably gain even more weight than you would have without "dieting" at all.

This pattern is familiar to most people who diet. They begin a diet, are successful for a while, go back to their old eating habits, gain the weight back, and then diet again. Each time you lose weight with a low-calorie diet and then gain the weight back, you disturb your metabolism. And each time you gain weight back after the diet, you usually gain more than you lost. This yo-yo dieting not only hurts our bodies, it also hurts our self-esteem and confidence.

A Better Approach

How do you end this cycle and still lose weight? You do it by making a total lifestyle change to a diet that leaves you satisfied, has no calorie limits, and is actually good for your health. By eating a diet built completely on legumes, vegetables, fruits, and whole grains, and by keeping the vegetable oils low, you will be able to satisfy your hunger and meet your weight goals.

The key is to change the *type* of food you eat rather than decreasing the amount of food consumed. Choosing a diet based on fruits, vegetables, grains, and legumes is an easy way to achieve and maintain a healthy weight, because no calorie counting is necessary, and it contains the nutrients a healthy body needs. Many researchers have confirmed that when people regularly eat low-fat, fiber-rich foods they achieve lower weights than when they consume a fat-rich or protein-rich diet. In study after study, vegetarians have been shown to be leaner than their meat-eating peers.

In a study at the Physicians Committee for Responsible Medicine, researchers have found that simply by avoiding animal products and added oils, most people lose weight without counting calories. And weight loss is at a very healthy pace—about 1 to 1½ pounds per week. The guidelines they use, and that will also work for you, are simple but powerful:

1. Build your menu from vegetables, fruits, whole grains, and legumes. (See chapter 13 for menus and recipes.)
2. Avoid meats, dairy products, and eggs.
3. Keep vegetable oils to a minimum.
4. Be sure to get adequate vitamin B_{12} (See chapter 2 for more details.)

Similarly, physicians Dean Ornish of the Preventive Medicine Research Institute, Caldwell Esselstyn of the Cleveland Clinic, and others prescribing similar diets have had excellent success at promoting weight loss among their overweight patients by prescribing a plant-based diet. What's more, they report that blood pressure, heart problems, and blood sugar levels often improve and the need for medications is reduced. In a study conducted by Hawaiian physician Terry Shintani, patients not only reduced their diabetes

medications but also lost an average of seventeen pounds in three weeks while eating as much food as they wanted. Not surprisingly, the "Hawaiian" diet was composed mainly of starchy root vegetables, greens, and fruits, similar to the vegan diet discussed in this book. Whatever plant foods you choose, they will be naturally low in fat, and this is the key to lifelong weight maintenance.

When you kick the eggs, cheese, meat, fish, and poultry off your plate, you may ask, "What can I replace these foods with?" Substituting vegetable stir-fries, or lightly seasoned beans and rice, in place of the high-fat, unhealthy animal products will naturally bring down the calories and increase your sense of satiety after a meal. You'll find delicious recipes for Stuffed Portobello Mushrooms, Curried Cauliflower with Peas, and Ginger Peachy Bread Pudding in the back of this book. Expand your cooking repertoire and try one tonight. Substituting can also be as easy as trading a chicken breast sandwich for a bean burrito. You'll save about 150 calories and get fiber as an added healthy bonus.

Following is an example of how simply changing the foods you eat will make a difference at your waistline. Let's say your normal meal pattern looks like this:

Breakfast: Egg McMuffin and hash browns from McDonald's

Lunch: Roast beef sub on white bread with chips and a soda

Snack: Doughnut and coffee

Dinner: Chicken breast, white bread roll, and a salad with ranch dressing

Total calories and fat: 1,700 calories and 70 grams of fat

Now, what if you changed your foods to healthy, low-fat, vegetarian foods:

Breakfast: Old-fashioned oats with raisins, ½ grapefruit, whole-wheat toast with jam

Lunch: Veggieburger on a whole-grain bun, carrots sticks, apple

Snack: Hummus and low-fat crackers, applesauce

Dinner: Vegetable stir-fry with a black bean sauce over brown rice

Total calories and fat: 1,400 calories and 18 grams of fat

Just by making simple switches in your everyday eating routine you can dramatically drop the fat and calories without feeling hungry and deprived. That's a major reduction in fat grams without missing one delicious bite of food. And, in fact, if you're still hungry, you can freely add additional fruit, vegetables, grains, and beans.

Even with the best diet in the world, we sometimes need a little more help to achieve our healthy weight goals. You may seem to be losing weight for a few weeks, and then you start to slow down or even plateau. Dietitians at the Physicians Committee for Responsible Medicine came up with these easy tips. You can use them if you get stuck at a weight you're not comfortable with.

Tip 1: *Be sure you are eating enough servings from each of the fiber-rich New Four Food Groups.*

You should aim for a minimum of five whole grain servings, three vegetable servings, three fruit servings, and two bean servings every day. Think of a serving as ½ cup cooked or one cup raw. See the New Four Food Groups in chapter 2 for more detailed information on serving sizes. Focus on eating the minimum number of servings before you reach for sweets or processed foods. Try sticking with less processed versions of your favorite plant foods, such as old-fashioned oatmeal instead of instant oatmeal, lightly steamed green beans instead of green bean casserole with sauce, and a whole orange instead of orange juice. Switching to whole-grain cereals, rice, pastas, and breads also can be a big help. And don't forget to choose fresh fruits and vegetables to meet snack cravings. These simple changes will boost your fiber intake. You might try checking the total number of fiber grams you are eating for one or two days, using the table on page 25. You should be getting at least 25 grams per day, although 30 to 40 grams would be even better. The more you get, the fuller you'll feel and the fewer calories you'll consume.

If you feel like the amount of food you are eating is just too

much and may have stalled your weight loss, try focusing on your food choices. Simple, high fiber foods are your best bets. Many people find that incorporating simple meals such as sautéed garlic with beans and brown rice, spaghetti with marinara sauce, minestrone soup, and vegetable and bean salads into their menu plan helps to keep them on track. It takes about three weeks for your tastes to change, so give yourself a little time to adjust to the simpler, cleaner tastes of these foods.

Tip 2: *Keep oils low.*

You're already avoiding meats, dairy products, and eggs, so you've knocked out all the animal fat. But be careful about vegetable oils. Yes, they're better for your heart than animal fat, but they are every bit as eager to add to your waistline.

Take stock of your diet to make sure you are avoiding added fat. Try choosing lower-fat recipes and foods whenever possible. For example, try oven-roasted potatoes instead of French fries, or pasta with a light marinara sauce instead of an oily sauce, and sorbet instead of cake. The net effect will be a reduction in both the number of calories and grams of fat consumed in any given portion of food. And for the most part, you won't be able to detect it. Skip the fatty condiments such as creamy salad dressings, mayonnaise, butter, and margarine. You also may want to try some new lower fat recipes or try switching from the oil and other fatty ingredients to fat-free alternatives. Braise vegetables in water, vegetable stock, or wine instead of sautéing in oil. Add garlic or herbs rather than oil or margarine to flavor grain dishes.

When you know you will be on the go, pack a hearty meal with healthy favorites such as a hummus, tomato, and cucumber pita pocket or a roasted vegetable wrap or one of the hearty salads in the recipe section. You could make the colorful, zippy Aztec Salad (see page 177) and the sweeter, mild Couscous Confetti Salad (see page 176) on Sunday and pack them in single-serving containers to take with you throughout the week. Or try making a double recipe when you are cooking dinner and pack half of it for the next meal you would need to eat away from home.

When going to parties, bring a delicious fat-free dish to share; then everyone will enjoy the benefits that you are from your healthy

eating style, at least for that one meal. And when you eat out, feel free to request that your meal be prepared the way you want it. Remember your clout as a customer; restaurateurs are in the business of pleasing the palates of their customers.

Tip 3: *Eat regular meals and snacks.*

Skipping meals is a common effect of a busy schedule, but we've seen how it can sabotage your efforts to achieve a healthy weight. When you skip a meal and go without eating for more than four to six hours, your brain responds by turning up your hunger and turning down your metabolism, as we've seen. When you do finally eat later in the day, you are likely to eat too much.

To avoid this problem, look for healthy, quick breakfast and lunch ideas so you won't skip these meals. Fill your cabinet and desk drawer with healthful, low-fat, vegan snacks that you can eat in a pinch when you don't have time to make something more substantial. While you are at it, throw out (and do not replace) foods you are likely to go overboard on.

Tip 4: *Eat when you are hungry, stop when you are full.*

Do you find yourself eating when you are not at all hungry? Before you take a bite, try asking yourself "Am I actually hungry?" If not, choose an alternate activity. Take a walk, knit a few rows, call a friend, or read a book or a magazine. If you are noticeably hungry, then eat something healthy.

Sometimes we mistake thirst for hunger. Try drinking two glasses of water and waiting fifteen minutes to see if you're still hungry. Also, if you are an emotional eater, pay attention to what emotions cause you to snack uncontrollably, and prepare ahead what you will do when you experience these emotions.

Tip 5: *Eat a lower-sodium diet.*

Sodium (salt) can make you retain water. You can lose up to five pounds of water by just eliminating most of the salt from your diet. A lower-sodium diet (no more than 2,400 mg/day) also can reduce the need for blood pressure medicines in some individuals. Watch out for restaurant foods—they tend to be higher in salt as well as fat. You may find it easy to avoid adding salt to your food in the kitchen and at the table, but be extra careful with canned foods and

convenience foods, as they are often especially high in salt. One cup of spaghetti sauce from a jar has 1,200 mg of sodium. But one cup of chopped fresh tomatoes has only 12 mg of sodium. And one cup of instant oatmeal has 300 mg, but regular oatmeal has 1 mg of sodium.

Reaching Your Goal with the New Four Food Groups

Before reading this book, your idea of healthy eating or dieting was probably very different from the New Four Food Groups eating pattern. You may have felt that eating healthy meant taking the skin off your chicken, drinking skim milk, and eating egg white omelets. As you have probably figured out, just switching your higher-fat animal products to lower-fat versions doesn't do much good. You still aren't getting the fiber that is so important for people with diabetes. And you're missing out on many of the valuable disease-fighting nutrients found only in plant foods. But now you know how to leave these old habits behind. Fill your plate with legumes, whole grains, fruit, and vegetables—your tastes will change, and so will your outlook. Half of the battle to controlling diabetes, particularly Type 2 diabetes, is controlling your weight. The other half of the battle is controlling your blood sugar, and we'll take this up in the next chapter.

6

Managing Your Diabetes with Food

As was discussed in detail in chapter 3, there is a lot you can do to control your blood sugar level with diet. Foods that are rich in complex carbohydrates and fiber and low in fat will help you maintain a healthy blood glucose level. In this chapter we'll put these principles to work.

Well-meaning doctors and nutritionists provide a wide variety of dietary advice to their patients with diabetes. Unfortunately, some of it is based on older research and is now clearly outdated. For example, some doctors recommend limiting carbohydrate intake to less than 50 percent of calories; others recommend consuming more than 15 percent of calories from protein. While these doctors may be excellent at diagnosing diabetes, they would benefit from learning more about current approaches to managing it.

Diets very low in carbohydrates or very high in fat or protein can actually cause problems for people with diabetes. Diets high in fat and protein contribute to weight gain, cause problems with the heart, aggravate problems with blood pressure, and can cause kidney problems down the road. If your doctor is recommending outdated nutrition advice for managing your blood sugar level, you

could suggest that he or she read this book to learn about these safer and more effective strategies. Or you may want to look for a healthcare team that is more knowledgeable about optimal nutrition for people with diabetes.

The new and effective approach to diabetes is remarkably simple. Here are the three easy steps to managing blood sugar with diet.

1. Build your diet from fruits, vegetables, legumes, and whole grains. Use the New Four Food Groups as a menu-planning tool (see page 35).

 Choose foods that are high in complex carbohydrates, such as whole grains, vegetables, and legumes. They will help reduce your blood glucose and your need for medication. Many plant foods also contain soluble fiber, which slows the passage of sugar into your bloodstream. Because processing often removes fiber and adds sugar or oil, the closer the carbohydrate-rich food is to its natural state, the better. Also, you'll want to take another look at chapter 2, which lists the glycemic index of foods to help you choose those that are rich in complex carbohydrates and fiber, that release their sugars slowly.

2. Avoid the troublemakers—meats of all kinds, dairy products, and eggs.

 The best diets avoid meats and other animal products. These foods can encourage insulin resistance, not to mention the fat and cholesterol they carry. A better choice is to get your protein from plant foods such as beans, vegetables, tofu, whole grains, nuts, and seeds, many of which are also high in healthy complex carbohydrates.

3. Keep added fats to a bare minimum.

 Diets high in fat can impair your insulin sensitivity. In other words, insulin will have a hard time doing its job. This is especially true for saturated fat (the kind found in meat, eggs, and dairy products), as opposed to monunsaturated fat (found in olive and canola oil). Plant foods generally tend to be much lower in fat, particularly saturated fat, compared to animal products. So beans, vegetables, and whole grains are good not just

for their complex carbohydrates, but also for their lower fat content. Even nuts and seeds, which are fairly high in fat, contain more unsaturated fats and are much better choices than animal products such as butter, bacon fat, sour cream, and so on, which are high in saturated fat. Even so, don't overdo it—it's still good to limit the amount of any fatty foods.

How to Work with Exchange Lists

The Exchange Lists for Meal Planning were developed by the American Dietetic Association and the American Diabetes Association as a tool for designing meal plans. Exchange lists are no longer considered the easiest method for planning healthy meals, as a low-fat vegan diet allows more freedom of choice throughout the day. However, if you have become comfortable using this system, a few easy substitutions and additions will make it even more effective. Here's how to upgrade your current exchange lists:

The Starch List. Choose foods made from whole grains with little or no added fat. These foods will be higher in fiber than refined foods. Some good choices include brown rice, bulgur, bran cereal, whole grain bread, and oatmeal. Beans, peas, and lentils are counted as one starch exchange plus one lean meat exchange (from the meat and meat substitutes list), because they are good sources of both protein and carbohydrates, not to mention fiber. They will be discussed further in the Meat and Meat Substitutes section.

The Fruit List. Fruits are virtually fat-free and are good sources of fiber. Choose from a variety of fresh fruits, such as apples, pears, bananas, oranges, mangoes, papayas, or peaches.

The Milk List. Replace servings of dairy products with low-fat, calcium-fortified rice milk, soy milk, or soy yogurt. These foods are good sources of carbohydrates and calcium.

The Vegetable List. Choose fresh or frozen vegetables with little or no added fat. Choose more dark green and deep yellow vegetables. Good choices include broccoli, spinach, Brussels sprouts, collard greens, kale, carrots, and squash. Dark green leafy

vegetables are good sources of calcium, with the exception of spinach. Vegetables also are good sources of fiber and generally are very low in fat.

Meat and Meat Substitutes. Replace servings of meat, poultry, fish, and eggs with beans, peas, lentils, tofu, tempeh, and soy milk. As noted above, beans, peas, and lentils should be counted as one starch exchange and one lean meat exchange. Soy milk can be counted as one dairy exchange or one meat exchange. Choose lower-fat versions of tofu, soy milk, and tempeh. Peanut butter also is listed in this group and counts as one high-fat meat exchange and two fat exchanges, but you'll want to limit nut butters in your diet due to their high fat content.

The Fat List. By eliminating animal products, your fat intake will naturally come way down. Take care to limit vegetable sources of fat as well. If you do choose foods from the fat section of the exchange lists, pick from the monounsaturated and polyunsaturated fats, which include avocados, olives and olive oil, nuts, and seeds, and avoid the hydrogenated and saturated fats such as butter, margarine, mayonnaise, and shortenings.

While the exchange lists are helpful in teaching you the kinds and amounts of foods to eat, they may be too rigidly structured for you to use over the long term. There are many ways to plan meals. As it is such an important aspect of diabetes management, you may find it helpful to work with a registered dietitian to develop a meal plan that is tailored to your specific needs. Be sure to inquire about his or her familiarity with meat- and dairy-free menu planning.

How to Work with
Carbohydrate Counting

Some diabetes educators use a method called "carbohydrate counting," which allows patients to exchange starches, fruits, and dairy alternatives (soy milk, rice milk, soy yogurt) without changing the overall carbohydrate content of the meal. If you take insulin, this method can help you consume consistent amounts of carbohydrates at each meal and to take the correct amount of insulin to process the

meal. If you are using this method, here is what you need to know:

In the exchange lists, each starch, bread, or fruit serving contains 15 grams of carbohydrates, which count as one carbohydrate counting equivalent (CCE). One exchange of vegetables, on the other hand, is equal to only 5 grams of carbohydrates, so it takes three servings eaten at one time to equal one CCE. The idea of this method is that you can interchange starches, breads, fruits, or vegetables within your meal plan without altering the total carbohydrate content of the meal.

This method was designed to simplify carbohydrate counting, and that it does, but it doesn't guarantee complete and balanced nutrition. You could choose all breads or all fruits and miss out on important vitamins and minerals. You also may end up choosing refined, processed foods instead of whole grains and whole grain cereals. Fruits, vegetables, grains, and legumes each contribute a variety of nutrients to the diet. If you choose to use the carbohydrate counting method, be sure to include a variety of foods listed in each of the groups mentioned in the exchanges lists section above. Better still, work with your healthcare professional to switch to a low-fat vegan diet based on the New Four Food Groups, where balance is achieved more easily.

7

Managing Your Diabetes
with Medicine

With the discovery of insulin in the early 1920s, people living with diabetes were given a new lease on life. Many different diabetes medicines have been developed since then. This chapter will review the common types, how diet along with medication can help keep your blood sugar levels in check, and what to do if it goes too high or too low.

Only your doctor can determine your need for diabetes medication, which can change as time goes by. If you have Type 1 diabetes, you will need to take insulin, because your body can no longer make enough of it. If you have Type 2 diabetes, your eating habits, weight, and exercise can greatly influence your need for medication.

Medications for Controlling Diabetes:
Type 1 Diabetes

If you have Type 1 diabetes you will need insulin, since your pancreas is simply unable to make it for you. It is normally administered through a short needle under the skin. As people with this disease

soon find out, insulin can't be taken as a pill, because it is a protein, and your body would break it down and digest it before it could get into your bloodstream to do its job. Scientists have been trying to find other methods that work for taking insulin, with some success.

Many people use a syringe to take insulin, but there are other choices. Insulin pens contain a cartridge and inject insulin through a needle. Another choice is an insulin pump, usually worn around your waist in a fanny pack. It delivers insulin through a small disposable catheter into your abdomen, and can be programmed to deliver insulin consistently throughout the day or in larger doses after eating meals or snacks. You may prefer to use this instead of injections and should discuss this option with your doctor.

Most people with Type 1 diabetes need at least two insulin shots each day to control blood sugar. It is usually taken thirty minutes prior to eating a meal when taking regular insulin alone or in combination with longer-acting insulin. Quick-acting insulin should be taken just before you eat.

How fast or slow insulin works depends on many factors: your diet, where the insulin is injected, and the type and amount of exercise you do, among others. For example, insulin injected into the upper arm works more slowly than when injected in the stomach. It works even slower when injected into the thigh or buttock. Try to be consistent with where and when you inject insulin. If you take two shots a day, you may take your first injection in the stomach and the second in the upper arm. Consistently using the same areas at the same times during the day can steady the insulin release.

Timing also is important. Be sure to take your insulin when you know the glucose from your food will start to enter your bloodstream. That is the time when it will work best. Talk to your doctor about the best timing for your insulin type and method of injection.

To keep your insulin from being destroyed, don't store it at very hot (more than 86 degrees Fahrenheit) or very cold (below 36 degrees Fahrenheit) temperatures, or put it in the freezer or direct sunlight. Extra insulin can be stored in the refrigerator. Bring insulin to room temperature by rolling the bottle gently between your hands before use, as injecting cold insulin can be painful. Discard any bottle that has been open for more than thirty days or that has passed its expiration date.

Different Types of Insulin

Your doctor will likely prescribe for you one of five general types of insulin. Each type differs by how quickly the insulin starts working, when it works the best (peak), and for how long it continues. Together you will decide which type is best for your lifestyle and changing blood sugar levels.

1. Quick-acting insulin lispro (Humalog)
 - begins working in five to fifteen minutes
 - decreases blood sugar best within forty-five to ninety minutes
 - stops working in three to four hours
2. Short-acting regular (R) insulin
 - begins working in thirty minutes
 - decreases blood sugar best within two to five hours
 - stops working in five to eight hours
3. Intermediate-acting NPH (N) or Lente (L) insulin
 - begins working in one to three hours
 - decreases blood sugar best in six to twelve hours
 - stops working in sixteen to twenty-four hours
4. Long-acting ultralente (U) insulin
 - begins working in four to six hours
 - decreases blood sugar best in eight to twenty hours
 - stops working in twenty-four to twenty-eight hours
5. NPH and regular insulin mixture
 - two different types of insulin combined in one bottle
 - begins working in thirty minutes
 - decreases blood sugar best in seven to twelve hours
 - stops working in sixteen to twenty-four hours

Testing Your Blood Sugar

Many people feel pretty anxious at the thought of testing their blood sugar, but soon realize that it's just a small inconvenience in exchange for a big peace of mind and better health. Checking it is easy. First, be sure to wash your hands with soap and water. Then prick your finger with a lancet. It is best to prick the side of your

fingernail to avoid having sore spots on the most-used parts of your fingers. Squeeze a droplet of blood onto the test strip, and use your meter to read your blood sugar level. Nowadays, there are a variety of meters available, and your healthcare team can help you chose the one that is best for you. Log your blood glucose levels in a booklet that you can show to your physician.

Medications for Controlling Diabetes: Type 2 Diabetes

If you have Type 2 diabetes, your body is still able to make insulin but cannot properly use it. If you make the right changes early on, you will likely be able to control your diabetes with diet and exercise. Sometimes, though, people find that if this condition is allowed to linger, their bodies may stop making enough insulin. If this happens in your case, you would need to take injectable insulin, as we described above, or oral medications, which now come in a variety of forms.

With that said, there is a critical point to remember: Your medication will help regulate your blood sugar, but it is no substitute for the right diet. Healthy foods, along with exercise, may help you to reduce or even eliminate the need for medication. In fact, if your diet and exercise habits are improved enough, you may well make Type 2 diabetes go away.

Diabetes pills work in a variety of different ways. Your doctor may prescribe one or a combination, based upon your individual needs. Here are the major types:

Sulfonylureas (pronounced SUL-fah-nil-YOO-ree-ahs) stimulate your pancreas to produce more insulin, which in turn helps lower your blood sugar. These drugs also help insulin to work more efficiently, decreasing your blood sugar. For these pills to work, your pancreas has to be making some insulin. The downside is that these pills can cause your blood sugar to go too low, so it is important to make sure that you are eating enough to prevent hypoglycemia. Generic names for medicines in this group include acetohexamide, chlorpropamide, glimepiride, glipizide, glyburide, tolazamide, and tolbutamide.

Biguanides (pronounced by-GWAN-ides) lower the amount of glucose made by your liver. They can cause you to lose some weight when you first start taking them, which can be beneficial in controlling your blood sugar. They are not as powerful in this respect as the sulfonylureas. Biguanides such as metformin also can improve cholesterol levels, although you can accomplish the same effect with the low-fat, vegan diet that is the optimal menu for diabetic control. Medicines in this class usually are taken two or three times a day with a meal. Your doctor will tell you what meals to take them with, which is important, because metformin can cause nausea, other stomach irritations, and diarrhea initially. Biguanides shouldn't be taken if you have kidney problems or drink more than two alcoholic beverages a week. If you become weak, dizzy, tired, or have difficulty breathing while on this medication, call your doctor right away.

Alpha-glucosidase inhibitors (pronounced AL-fa gloo-KOS-ih-dayz in-HIB-it-ers) slow down the enzymes that digest the starch in the food you eat. As a result, starch releases its natural sugars more slowly, causing your blood sugars to stay lower and rise more gently during the day. This medicine will not cause you to become hypoglycemic when taken as the only diabetes medicine. Usually it is taken three times a day with the first bite of your meal. Sometimes it can cause gas, bloating, or diarrhea initially, but these symptoms usually go away once you have taken this medicine for a while. Common generic names for this medicine are acarbose and miglitol.

Thiazolidinediones (pronounced THIGH-ah-ZO-li-deen-DYE-owns), sold under the generic name troglitazone, make your muscles more sensitive to insulin, helping them to use it better. When used as your only diabetes medicine, troglitazone won't cause you to become hypoglycemic. Normally you'll take it once a day with your largest meal, but pay close attention to your doctor's specific instructions. If you are taking birth control pills, be sure to let your doctor know, as this medicine will cause them to be less effective.

Meglitinides (pronounced meh-GLIT-in-ides), sold under the generic name repaglinide, encourage your pancreas to produce more insulin after eating, decreasing your blood glucose. One

advantage is that they work very quickly, so you can change your mealtimes and the number of meals you have more easily than with other diabetes medicines. They should be taken within thirty minutes of your meal, and not at all if you skip meals. Unlike most of the other diabetes medicines, this one can cause hypoglycemia and weight gain.

Staying on Track

With any type of medicine, you should not change your dose or schedule without first talking it over with your doctor. Keeping track of your blood sugar levels and the amount of diabetes medicine you take will help your doctor assess how well it is working for you. It may be helpful to also keep a list of all the medicines you take to be sure you are taking them as prescribed. Here is a sample form that may be useful to you. Copy it as many times as you need to, and ask your healthcare team to help you fill it out.

Medicine Log

Name of Medicine	Dosage	When to Take It (Time)	When to Take It (Meal)	Comments

When Medicines Are Too Strong: Hypoglycemia

Insulin moves sugar out of your blood and into the cells of the body. If you have too little blood sugar or too much insulin, you can become hypoglycemic (also called insulin reaction or insulin shock). This simply means that your blood sugar has fallen too low. If your blood sugar is below 70 mg/dl, you are hypoglycemic.

Hypoglycemia can occur if you have:

- eaten too little or not on time
- skipped meals
- taken too much insulin
- engaged in more physical activity than usual
- had alcohol

Here are the symptoms:

- hunger
- excessive sweating
- headache
- nervousness, shaking
- pounding of heart
- irritability
- impaired vision

If you experience only mild symptoms, eat something small, such as two crackers with peanut butter, or drink half a cup of soy milk. If your reaction is more serious, such as feeling dizzy or shaky, it is best to consume some sort of sugar. Try a half cup of fruit juice or regular soda, one to two teaspoons of sugar, or several hard candies. Another option is taking two to three glucose tablets or a tube of sugared gel. The tablets can be eaten and the tube of gel squeezed into your mouth. Both are easy to carry with you. It will take approximately ten to fifteen minutes for the sugar to help. If you still aren't feeling better after this amount of time, repeat the sugar treatment. You'll also want to have a small snack and check your blood glucose to be sure it has improved.

In some situations, hypoglycemia can be so severe that you pass

out. It's good to be prepared for this possible situation ahead of time, and you may want to talk to your doctor to see if you may need a glucagon kit. Glucagon is a hormone that stimulates the release of sugar from the liver. You should explain to at least one family member and a coworker how to administer the glucagon. It's easy to do, just like injecting insulin. After administering the glucagon, they should call for medical attention. If you should happen to pass out and glucagon isn't available, you should be taken to the nearest hospital emergency room or someone should call 911 for assistance.

Please rest assured, emergencies like this are not very common. But medicines are powerful, and sometimes they overshoot their mark, dropping your blood sugar too low.

When Blood Sugar Goes Too High: Hyperglycemia

Sometimes your blood sugar may go too high, called hyperglycemia. This can occur in anyone with diabetes and is one of the biggest causes of complications. But the good news is that it is preventable.

Hyperglycemia occurs when your body does not have enough insulin or is unable to use the insulin it has properly. It can happen if you miss a medication dose or change your eating or exercise habits. For example, if you eat more or exercise less than normal, your blood sugar can go too high. Stress, such as a cold or flu or family tensions, also can cause your blood sugar to rise. Here are the common signs and symptoms of hyperglycemia:

- increased thirst
- increased urination
- high blood glucose
- high sugar levels in the urine

Some medicines can cause your blood sugar levels to rise, too. Common ones include:

- glucocorticoids
- thiazides

- estrogen-containing products
- beta-blockers
- nicotinic acid

How Food and Medicines Interact

Sometimes it may feel like diabetes medicines take your body on a bit of a roller-coaster ride. If you miss your dose, your sugar goes up too high. If you overdo it, sugar falls too low. It can be a challenge to keep things level, but you can help control those highs and lows by committing to the right diet. You'll see that what you eat can have a profound effect on the types and amounts of medication you need. In some cases a simple diet change can eliminate your need for medications. Good nutrition is *that* powerful. In a study of Type 2 diabetes, most participants were able to reduce or eliminate use of medications within twelve weeks by following a low-fat, unrefined, vegan diet. On the other hand, none of the participants following a conventional diet was able to reduce their use of medication.

You will soon develop an intimate knowledge of how certain foods affect your blood sugar. You'll naturally gravitate toward vegetables, beans, rice, and other healthy foods. In turn, they'll help you trim down and feel healthy, whether you use medications or not.

8

Healthy Blood Vessels, Healthy Heart

From the moment it begins beating, your heart delivers oxygen-rich blood throughout your body, providing the power needed for life. Needless to say, if your heart doesn't stay healthy, neither will the rest of you. Yet millions of people have hearts that aren't functioning well at all. Simply put, blood that should be flowing freely through the heart's major arteries is being slowed down, clogged up, and put under unnecessary stress. Similarly, when blood vessels to the brain are restricted, a stroke can result. Heart disease takes more lives each year in the United States than any other disease.

As troubling as these statistics are, they become even more tragic in light of the fact that the keys to heart disease prevention no longer elude us. In fact, they are very straightforward. Heart disease is certainly not an inevitable consequence of aging. And it's not unstoppable, either. Your heart is extremely sensitive to what you eat and to your other daily habits.

People who have diabetes are at higher risk of heart attack and stroke, and the risk factors for all three conditions overlap. Obesity, a sedentary lifestyle, and fatty diets—some of the same

contributors to Type 2 diabetes—can spell trouble for our delicate blood vessels as well.

Let's focus for a moment on how heart disease develops and then on easy changes we can make in our lives to modify major risk factors.

What Is Heart Disease?

Heart disease begins slowly, many years before symptoms begin to show. The first stage involves subtle damage to the arteries, not just in the heart, but also in major vessels throughout the body. This damage is called a fatty streak, and it is the beginning of the condition called atherosclerosis, or the slow, progressive narrowing of blood vessels due to deposits of fat and cholesterol called plaque. Just like clogged pipes in your home, the more plaque that builds up inside these vessels, the smaller the passage for blood becomes. Pipes that are clogged won't allow water to flow through freely, and the same is true of the passage of blood through clogged arteries. To make matters worse, arterial plaque is harder than the blood vessel wall, so this plaque causes a loss of elasticity and impairs the blood vessels' ability to adjust to changes in pressure and volume. By the time we are adults, most of us have at least minor deposits in our artery walls, and many of us have advanced deposits.

The most serious stage of this blood vessel blockage occurs when an artery in the heart or the brain becomes completely blocked off, allowing no blood or oxygen through. In the coronary arteries that nourish the heart muscles, a loss of blood supply will spell the death of a portion of this muscle, weakening the heart's ability to pump blood. This is called a heart attack, or a myocardial infarction. In the arteries to the brain, the loss of blood supply means the death of brain tissue (a stroke). When a stroke or a heart attack occurs, immediate medical attention is often essential. These conditions can be fatal.

If you're worried about heart disease, put your fears aside for just a moment. There are few serious conditions that respond so well to lifestyle changes as this one. You have tremendous power to remove yourself from this high-risk group in no time at all. In 1990 a young,

Harvard-trained physician named Dean Ornish, M.D., made medical history by showing that heart disease could actually be *reversed*—not with medications, but with diet and lifestyle changes alone. In a one-year program using four simple features—no smoking, a low-fat vegetarian diet, regular simple exercise, and stress reduction—coronary artery blockages began to *open up on their own* in 82 percent of participants. In 1998 the *Journal of the American Medical Association* reported the long-term follow-up results. The patients continued to get healthier and healthier, while other heart patients declined. Let's look at the keys to a healthy heart.

Benefits That Await You as a Nonsmoker

In just 20 minutes	Blood pressure, pulse rate, and body temperature return to normal
In 8 hours	Oxygen level in the blood returns to normal
In 24 hours	Chance of heart attack decreases
In 2 weeks to 3 months	Lung function increases up to 30 percent
In 1 to 9 months	Cilia regrow and can again clean lungs and fight off infection
In 1 year	Risk of heart disease is half that of a smoker
In 5 years	Chance of fatal lung cancer is reduced by 50 percent
	Risk of mouth and throat cancer is reduced by 50 percent
In 10 years	Chance of fatal lung cancer is as low as that of a nonsmoker
	Precancerous cells are replaced by healthy ones
In 15 years	Risk of heart disease is the same as for a nonsmoker

Toss Out the Cigarettes

Cigarettes speed up atherosclerosis and are a major contributor to heart disease. The solution to smoking is certainly straightforward, if not always easy: Quit, and quit for good. If you smoke, don't wait for a milestone birthday or the New Year to quit. Days (even hours) count in the smoking game.

Researchers from the National Academy of Sciences estimate that smoking is responsible for 21 percent of heart disease deaths overall, and more than 40 percent of heart disease deaths in people under age sixty-five. Smokers are also prime candidates for lung cancer. Beyond the grave consequences, quitting the habit will spare you from accelerated skin aging, discolored teeth, and will even pad your pockets with some well-earned dollars. If quitting on your own seems daunting, ask your doctor, pharmacist, or even your friends for assistance. Most importantly, make the commitment to yourself.

New "nonsmokers" are often surprised by their increased energy level and their improved sense of taste and smell. Within about two weeks, many find that physical activities are more enjoyable and less tiring, after the bulk of tar and nicotine have cleared out of their lungs. For a little inspiration, tack the list of benefits on page 85 to your computer monitor or refrigerator.

Managing Your Blood Pressure

High blood pressure damages blood vessels and speeds up the formation of plaque. In turn, this artery damage makes the vessels less able to stretch and adjust to changes in flow, thus making blood pressure go up. It's a dangerous cycle, but the remedy to both is the same.

You might think of a blood vessel like a garden hose. A new hose is stretchy and pliable, effectively handling all levels of water pressure. But this changes if the hose has been left outside for a few winters, dragged all over the yard, stepped on, run over with the mower, and so forth. It may be patched with tape in several places and hardened from exposure to the hot sun and freezing snow. If you turn on the water, even halfway, one of the patches is likely to let some water out. A blood vessel full of plaque isn't so different.

With sufficient wear and tear, it's likely to spring a leak. If it is a blood vessel passing through your brain, the results can be deadly.

People with high blood pressure are three to four times as likely to suffer a heart attack and seven times as likely to have a stroke as people with normal blood pressure. High blood pressure is common in people with diabetes, and it may be something that you are trying to get control of now.

When you have your blood pressure measured, the first number (called systolic) shows the pressure in your arteries every time your heart beats. The second number (called diastolic) shows the pressure between beats. Your doctor will want you to have a blood pressure of less than 130 mmHg systolic and less than 85 mmHg diastolic, as higher numbers in either instance indicate problems.

Although medication sometimes is used to control blood pressure, you can also take a measure of control by watching what you eat, exercising, and, if you are overweight, bringing your weight down to a healthy level.

For many doctors, the first step is to limit salt. Some people are sensitive to salt, and that can affect their blood pressure. Here are some tips on how to cut the salt in your diet:

- Use less and less salt when preparing foods.
- Avoid adding salt to foods at the table.
- Learn to prepare food with *different* spices and seasonings, such as fresh garlic, onion, or cilantro.
- Stay away from salty snack foods.
- Choose low-sodium varieties of canned and frozen foods.
- Read food labels. The amount of salt in a food is listed on the Nutrition Facts label. Some manufacturers also may include the following labels on their products:

 Low sodium—contains 140 mg or less of sodium per serving.

 Very low sodium—contains 35 mg or less sodium per serving.

 Sodium-free—contains less than 5 mg of sodium per serving.

While sodium clearly plays a role in blood pressure, reducing sodium intake doesn't generally cause enough of a drop in your

pressure to get you off medications, so you'll want to do more. Here are important steps that will bring you much farther:

- Greatly increase fruits and vegetables in your diet. They are rich in potassium, which lowers blood pressure.
- Avoid all animal products (meats, dairy products, and eggs). A research team in Australia has proved the value of a vegetarian diet beyond a shadow of a doubt. Within six weeks the diet led to dramatic reductions in blood pressure without medication. Over time, the same diet promotes effective weight loss, which reduces blood pressure even farther. Vegetarian foods are a perfect blood-pressure-lowering combination. They are low in fat and high in potassium. The result is lowered blood viscosity and easier blood flow. In long-term studies, many people following this sort of diet are able to come off all their blood pressure medications, yet maintain lower pressures than when they were taking medications.

Potassium Sources (in milligrams)

FRUITS

Apple (1 medium)	159
Banana (1 medium)	451
Grapefruit (1 medium)	316
Orange (1 medium)	250

VEGETABLES

Broccoli, cooked (1 cup)	332
Cauliflower, cooked (1 cup)	400
Potato, cooked (1 medium)	844

LEGUMES

Black beans, cooked (½ cup)	401
Navy beans, cooked (½ cup)	335

Source: J. A. T. Pennington, *Bowes and Church's Food Values of Portions Commonly Used,* 17th ed. (Philadelphia: J. B. Lippincott, 1998).

- Keep fried foods and added vegetable oils to a bare minimum.
- Restrict or eliminate alcohol consumption.
- Get as much regular exercise as your doctor will permit.

Lowering Your Cholesterol Level

Everyone has heard of cholesterol. It's the fatty, waxy stuff that comes from foods from animal sources that invades your blood vessel walls when there is too much of it in your bloodstream. It is very important to keep your blood cholesterol levels in a healthy range. Researchers in Framingham, Massachusetts, found that for every 1 percent reduction in cholesterol levels there is a 2 percent reduction in risk of heart disease. This means that even small changes in your blood cholesterol levels make a difference. While blood cholesterol levels below 200 mg/dl are considered safe and normal by the U.S. government, these doctors found that a total blood cholesterol level of less than 150 mg/dl was far more protective. None of the thousands of people whom these doctors studied over a thirty-five-year period had a heart attack when their cholesterol level was this low.

There is a little more to the story of cholesterol. Because cholesterol is a fatty, viscous substance it needs help from a transporter to move around the body. Once cholesterol gets into your bloodstream it is considered either "bad" or "good," depending on what type of transporter it is on and where it is headed. The "bad cholesterol" or LDL cholesterol is headed to the blood vessels and cells. When there is too much LDL cholesterol in the bloodstream it often gets dropped off at the plaque instead of in the cells and contributes to heart disease. The "good" cholesterol, or HDL cholesterol, is being transported on the recycling trucks of the bloodstream. These HDL carriers are picking up cholesterol and taking it back to the liver for recycling.

When doctors check your cholesterol level, they will check your LDL and HDL levels as well as your total cholesterol level. A good rule of thumb is that if your total cholesterol is 150 mg/dl or less, your risk of a heart attack is minimal. But if it is above that level, you'll want to calculate a ratio in which you simply check to be

sure that your HDL is a third or more of your total cholesterol. If it is less, the diet steps in this chapter are likely to hold the keys you're looking for.

Putting Foods to Work

Let's look at how foods can help. There is cholesterol in certain foods, of course. But even worse is the tendency of some foods to stimulate your liver to make extra cholesterol. When your diet is high in fat, especially the saturated kind found mostly in butter, meat, and dairy products, your body makes more cholesterol than it needs. Although television ads for cholesterol-lowering drugs would have you believe that high cholesterol is a mysterious and stubborn condition, it really just depends on two things: how much cholesterol you eat and how much cholesterol your body makes.

When you surrender to the wonderful recipes in this book, you'll be eating exclusively from the New Four Food Groups. Vegetables, grains, fruits, and beans all have zero cholesterol. This is true of all foods from plant sources, even the more oil-dense ones such as avocados, olives, and corn oil. And most plant foods are very low in saturated fat, too, so your liver has less stimulus for making cholesterol. The major exceptions to be cautious of are tropical oils (coconut, palm, and palm kernel) and hydrogenated oils used in many snack foods, as we'll see shortly.

So one sure-fire way to reduce your blood cholesterol level is to avoid eating foods from animal sources. By building your diet from fruits, vegetables, grains, and legumes, you will effortlessly eat a diet that is cholesterol-free and low in fat. In virtually every study to date where low-fat vegetarian diets are prescribed and blood cholesterol is measured, these diets have positive effects. In Dean Ornish's research program, heart patients lowered their cholesterol levels by 23 percent in a year. Similarly, a study conducted by the Physicians Committee for Responsible Medicine including thirty-five healthy women showed that a low-fat, vegan diet reduced mean serum total and LDL cholesterol concentrations by 13 percent and 17 percent, respectively, in just five weeks. Studies have shown that unrefined, plant-based diets typically improve cholesterol levels in persons with Type 2 diabetes, too.

Dropping Dairy Makes the Difference

Although I was an athlete and at a normal weight, in my early twenties I learned that I had very high cholesterol levels, and I began to cut down on the fat I ate. I bought fat-free versions of everything, and I ate less meat and cheese. It helped a little. But over the years that followed, I learned that to really make a difference, I needed to choose a diet that set aside all animal products. Leaving behind the eggs and the meat was no problem at all. Cheese took a little more effort, but as I started to feel healthier, I was encouraged to really give it up. But there was still one daily problem—my morning latte made with low-fat milk. I had picked up the habit as a café owner and was determined to never let it go. Several people suggested soy milk, but I was certain it wouldn't taste as good. Finally, when I started to have problems with the cholesterol-lowering medicines the doctor had put me on, I decided to try a soy milk latte.

Low and behold, a soy milk latte made by a skilled barista turned out to be every bit as good as the ones I had been drinking. Two months later I had my cholesterol level checked, and it had dropped by 50 points. That one change, a cup of low-fat milk a day in an already fat-reduced vegetarian diet, put my cholesterol level out of the danger zone for the first time ever.

AMY JOY LANOU, PH.D.

You can stack the odds even more in your favor by limiting all types of fat, even from plant sources. Pay particular attention to saturated and hydrogenated fats. These types of fats tend to be solid at room temperature. In addition to animal fats, saturated fats are found naturally in large quantity in coconuts, palm, and other tropical oils. Hydrogenated fats are created by food manufacturers when they take plant oils and make them more spreadable, as in margarine and shortening. Many processed foods are made with hydrogenated fats, including snack foods, baked goods, frozen desserts, spreads, and dressings. When monounsaturated fats such as those in olive and canola oils are substituted for saturated fats in the diet, blood cholesterol levels are usually lower.

A variety of factors affect your levels of the "good cholesterol," including hormone levels, body weight, and physical activity level. To maximize your levels of HDL cholesterol:

- Lose weight, if necessary, and maintain a healthy weight for your height and frame size.
- Avoid smoking completely.
- Exercise thirty minutes or more at least four days per week.

Taking Care of Your Blood Vessels

Your blood vessels are vital for your health, of course, not only for heart disease and stroke, but also for your eyes, kidneys, prostate (if you have one), and feet. Damaged or blocked vessels are a common cause of impotence. Even varicose veins and hemorrhoids can be avoided through the same blood vessel protective diet recommended for lowering blood pressure and high blood cholesterol levels.

Stack your diet with fiber-rich foods to lower blood cholesterol, improve glucose tolerance, and avoid varicose veins and hemorrhoids. Be sure to include delicious fiber-rich fruits and vegetables such as artichokes, apples, pears, celery, broccoli, blueberries, spinach, and potatoes. Black beans, garbanzos, whole wheat, barley, and oats are good examples of fiber-rich grains and legumes.

The antioxidants found in plant foods also have been shown to be protective against heart disease, diabetes, and the damage associated with aging. Start your day off with an antioxidant-rich smoothie made from orange juice, frozen berries, and a splash of soy milk. Try a Rainbow Wrap (see page 170) for lunch and the Carrot and Jicama Salad (see page 174) paired with Spinach Turnovers (see page 171) for dinner to supercharge your body with healthy antioxidant-rich vegetables.

Taken together, all these recommendations for reducing heart disease risk are remarkably similar to those for reducing problems associated with diabetes. What this means is that whatever reason you use to decide to eat well and be physically active, you will get more benefits than you had imagined. Do an experiment with yourself. Try following these guidelines for at least a month. For most people, the results are dramatic enough to keep them on track for the rest of their lives.

9

Preventing Complications

Overcoming the problems posed by diabetes is not as challenging as you may have imagined. True, hearing about the possibility that diabetes can affect your eyesight, kidneys, and even heart can seem alarming at first, but take heart. All the tools you've acquired with this book will protect not just your heart and blood vessels, as discussed in chapter 8, but all of your delicate organs as well. By building each meal from healthy plant foods, you'll get better control of your blood sugars. With some exercise and perhaps medication, you'll avoid many of the serious complications that many people with diabetes might otherwise succumb to. Complications from diabetes occur over time. If you stay on the right road, you can look forward to a long, healthy life free of these difficulties.

Keeping Healthy Eyes

Whether you have Type 1 or Type 2 diabetes you'll have to take special care to protect your eyesight. Diabetes is the leading cause of blindness in adults aged twenty to seventy-four in the United

States. Especially in people with Type 1 diabetes, diabetic retinopathy, or damage to the retina in the back of the eye, can lead to a gradual loss of vision. In the mildest form of retinopathy, tiny amounts of blood and fluid leak into the eye from the blood vessels. A less common but more damaging form is when new blood vessels develop, causing bleeding and scarring.

The longer people have diabetes, the more likely they are to develop eye problems. After twenty years with diabetes, most people will have at least some problems with their eyes, especially if they have high blood pressure or persistent high blood sugar. But there is a lot you can do about it. First of all, retinopathy generally doesn't occur until after about ten years from the onset of diabetes. From the very beginning, the key to slowing or preventing it is to have tight control over your blood sugar levels. You have learned from this book that vegetarian foods—along with regular exercise—can help enormously with blood sugar control. But these foods are also packed with nutrients that can help protect your eyes. Let's take a closer look at how retinopathy begins.

When blood sugar levels are high, excess sugars can attach to proteins. This sugar-protein combination, called glycosylated protein, is thought to create free radicals—unstable molecules that can attack the lens of the eye. Glycosylated proteins also can join with fats we eat and deposit in blood vessels in the retina. Together these sugar-protein complexes, and the free radicals they create, are big contributors to retinopathy and other complications.

As you saw in chapter 2, antioxidant vitamins and minerals found in plant foods go to work in all of your cells, strengthening them and protecting them from free radical damage. Certain antioxidants work specifically inside your eyes, healing delicate tissues, enhancing their function.

Selenium is an important one. This mineral protects the cells of the heart and blood vessels from damage. Some researchers suspect that a decrease in the amount of selenium in the blood can alter its viscosity or "thickness." This heightened blood viscosity, as well as a change in the fluidity of red blood cells, can cause blockages of blood vessels so that less oxygen reaches the retina, causing damage to the eye. Consuming adequate selenium may help to change the thickness of the blood, reducing the risk of these problems.

Many plant foods such as nuts, seeds, and grains contain selenium, and you'll also find it in common multivitamins. The recommended daily allowance of selenium is 55 micrograms—the amount found in a bowl of spaghetti, a handful of sunflower seeds, and a pita pocket with vegetables, or just one Brazil nut.

Vitamin C is another potent eye protector. As a water-soluble vitamin, it fights free radicals in body fluids. People with diabetes should take special care to include vitamin C in their diet, as researchers have found that patients with retinopathy have lower levels in their blood. Vitamin C may help prevent the sugar-protein combining mentioned above. As you know, this vitamin is not hard to find. It is in many fruits and vegetables such as oranges and grapefruits; tomatoes; green, leafy vegetables; guavas; papayas; and bell peppers. Vegetarian diets easily supply adequate amounts of vitamin C. If you are a woman, the U.S. government recommends that you aim for at least 75 milligrams a day. Have a cup of strawberries, a glass of orange juice, or a serving of broccoli. Men should strive for 90 milligrams or more daily, which can be had from just one grapefruit. Some researchers believe that higher intakes are even more helpful. But be sure to include at least one vitamin C-rich food in your diet daily.

Vitamin E has antioxidant properties, too. Since it is fat-soluble, it works inside the cell membrane and fat tissues in your body to protect them from free radicals. And like vitamin C, vitamin E plays a role in preventing sugar-protein combining, and it improves circulation in the eyes. You'll find vitamin E in whole grains; wheat germ; green, leafy vegetables; vegetable oils; nuts; and seeds. See the following table for food sources of this nutrient, and aim for 15 milligrams of vitamin E per day.

The mineral magnesium may play a role in preventing retinopathy as well. A study of seventy-one people who had Type 1 diabetes for at least ten years found that most had low levels of magnesium. Those with the lowest levels had the most advanced retinopathy. Magnesium has many diverse functions in the body, including maintenance of nerve cells. Women should aim for 320 milligrams a day and men for 420 milligrams daily.

Vitamin B_6—also called pyridoxine—may help prevent diabetic retinopathy. Researchers gathered data on participants with

VITAMIN E (IN MILLIGRAMS)

FRUITS

Avocados (1 medium)	2.32
Blueberries (1 cup)	1.45
Elderberries (1 cup)	1.45
Mangoes (1 medium)	2.32
Nectarine (1 medium)	1.21

GRAINS

Rice bran (1 ounce)	1.72
Rye flour, dark (½ cup)	1.65
Whole wheat flour (½ cup)	0.74
Wheat germ, toasted (¼ cup)	5.26
Whole wheat pita bread (1)	0.60
Whole wheat English muffin (1)	0.48

NUTS AND SEEDS

Almond butter (1 tbsp)	3.25
Almonds (1 oz)	6.72
Peanut butter (1 tbsp)	3.20
Sunflower seeds (1 oz)	14.25

LEGUMES

Navy beans (½ cup, boiled)	0.50
Pinto beans (½ cup, boiled)	0.81

VEGETABLES

Broccoli (½ cup, boiled)	1.32
Kohlrabi (½ cup slices, boiled)	1.37

VEGETABLES *(continued)*

Mustard greens ($\frac{1}{2}$ cup, boiled)	1.30
Turnip greens ($\frac{1}{2}$ cup, boiled)	2.39
Swiss chard ($\frac{1}{2}$ cup, boiled)	1.66

MISCELLANEOUS

Hummus ($\frac{1}{2}$ cup)	1.23
Meat analogue, sausage (1 patty)	0.80

Source: J. A. T. Pennington, *Bowes and Church's Food Values of Portions Commonly Used.* 17th ed. (Philadelphia: J. B. Lippincott, 1998).

diabetes over a period of eight months to twenty-eight years and found that those who had been taking B_6 supplements did not have retinopathy. This B vitamin is found in a variety of plant foods such as whole grains, beans, vegetables, and fruits. See the following table for a list of food sources of both magnesium and vitamin B_6.

The earliest stages of retinopathy are often symptom-free, so, it is very important that you have a thorough eye exam approximately three years after being diagnosed with Type 1 diabetes. Be sure that you visit an ophthalmologist, a medical doctor who has received extensive specialized training in the care of the eye, as opposed to an optometrist, whose job focuses primarily on testing the eyes for visual acuity and prescribing corrective glasses or contact lenses.

People with Type 2 diabetes often go undiagnosed for years, so a professional eye exam should be done right away once it is discovered. Follow-up examinations should be done at least yearly whether you have Type 1 or Type 2 diabetes, and more frequently depending upon any progression of damage to your eyes. Women with diabetes who are planning to have a baby should have their eyes checked prior to becoming pregnant.

If you are experiencing any of the symptoms listed on page 99, be sure to have your eyes examined by an ophthalmologist.

Vitamin B$_6$ and Magnesium (in milligrams)

Grains and Cereals	B$_6$	Mg
Bulgur, cooked (1/2 cup)	0.08	29
Cream of Wheat (1 pkt)	0.57	7
Millet, cooked (1/2 cup)	0.13	53
Oatmeal, instant (1 pkt)	0.74	42
Kellogg's All Bran (1/2 cup)	0.50	140
General Mills Cheerios (1 cup)	0.50	32
Post Grape Nut Flakes (3/4 cup)	0.50	32
General Mills Total (3/4 cup)	2.00	24
Wheat germ (1/4 cup)	0.38	69

Legumes		
Beans, vegetarian, canned (1/2 cup)	0.17	41
Black beans, boiled (1/2 cup)	0.06	60
Chickpeas, boiled (1/2 cup)	0.12	40
Great Northern beans, canned (1/2 cup)	0.14	67
Kidney beans, boiled (1/2 cup)	0.11	40
Lentils, boiled (1/2 cup)	0.18	36
Navy beans, boiled (1/2 cup)	0.15	54
Pinto beans, boiled (1/2 cup)	0.14	47
Soybeans, mature, boiled (1/2 cup)	0.20	74
Tempeh (1/2 cup)	0.25	58
Tofu, raw, firm (1/2 cup)	0.16	57

Fruits and Vegetables		
Banana (1 medium)	0.66	33
Carrot juice (4 fluid oz)	0.27	17
Potato with skin, baked (1)	0.70	55

FRUITS AND VEGETABLES *(continued)*	B$_6$	M$_G$
Spinach, boiled ($\frac{1}{2}$ cup)	0.22	78
Tomato juice (4 fluid oz)	0.13	13
Watermelon (1 cup)	0.23	18
NUTS AND SEEDS		
Cashews, dry roasted (1 oz)	0.07	74
Peanut butter (2 tbsp)	0.14	57
Sesame seeds (1 tbsp)	0.01	28
Sunflower seeds (1 oz)	0.22	100
Walnuts (1 oz)	0.16	57

Source: J. A. T. Pennington, *Bowes and Church's Food Values of Portions Commonly Used,* 17th ed. (Philadelphia: J. B. Lippincott, 1998).

Symptoms of retinopathy are:

- pain in one or both eyes
- double vision
- blurred vision
- excess eye pressure
- poor peripheral vision
- difficulty reading
- floaters or spots

If you already have damage to your eyes, you may benefit from laser eye surgery. Discuss this option with your doctor.

Healthy Nerves

Your nerves carry messages—actually, electrical impulses—throughout your body. High blood sugar levels can damage your nerves over time, disrupting their ability to transmit impulses, a condition called neuropathy. Tight control over your blood sugar is

essential, since the damage can occur slowly, and you may not realize it is happening.

Symptoms of neuropathy include:

- numbness, particularly in lower legs and feet
- prickling, tingling, or jabbing sensations
- burning sensations
- weak muscles
- bladder infections
- fainting
- vomiting
- sexual difficulties

There are two main types of nerve damage. Peripheral neuropathy is the more common and refers to nerve damage in the hands and the feet. It can cause pain, numbness, and a decreased ability to sense temperature and pressure. Autonomic neuropathy affects nerves that control your digestion, ability to urinate, blood pressure, heartbeat, and sexual functioning. Strong control of your blood sugar levels can help slow or prevent this damage from occurring, and diet, of course is key.

Exercise is another vital key to blood sugar control, as we saw in chapter 4, but be sure to talk to your doctor before starting any new exercise program, particularly if you currently have some form of neuropathy. As peripheral neuropathy causes loss of sensation to the feet, exercises such as using a treadmill, prolonged walking, jogging, step exercise, and other weight-bearing activities may not be right for you. Better choices include swimming, bicycling, rowing, chair exercises, and arm exercises. If you have autonomic neuropathy, is it also very important to have a thorough physical examination prior to starting an exercise program because of the possibility of heart and blood pressure problems. With a little guidance, your diabetes care team will have you on the road to better fitness in no time.

If you smoke, don't waste another day pledging to quit. Let your doctor offer programs that help you do it *today*. Smoking contributes to poor circulation, narrowing of blood vessels, and decreased circulation in your feet.

Your doctor should check your nerve function annually. Let him

or her know if you are experiencing any problems with your arms, legs, feet, or hands.

Always pay careful attention to your feet, as poor circulation in the legs can cause sore spots on the feet to become infected. With decreased sensitivity, you may be unaware if cuts fail to heal properly. Many people with diabetes needlessly face serious infections and even amputations. A little care and prevention will ensure that your arms and legs stay healthy for life.

GUIDELINES FOR TAKING GOOD CARE OF YOUR FEET

- Check bare feet daily for cuts, sores, bumps, or red spots.
- Wash your feet in warm water daily, using mild soap. Avoid soaking your feet. Dry them with a soft towel. Be sure to dry between your toes.
- Cover your feet with lotion after drying, being careful not to use lotion between your toes.
- Cut your toenails straight across, making sure there are no sharp edges.
- Rub off dead skin with a dry towel.
- See a qualified podiatrist to remove calluses, warts, or corns.
- Wear thick, soft socks instead of stockings with holes or seams that can rub into your feet.
- Wear shoes that fit well and allow your toes to move. Avoid flip-flops, plastic shoes, or shoes with pointed toes. Do not walk in bare feet.
- Have your feet checked by your physician at each visit.

Researchers have found that people with diabetes, especially those with uncontrolled blood sugar levels, are much more sensitive to pain than people without diabetes. Nerve pain can be physically and emotionally debilitating. Antidepressants may be prescribed for diabetic pain, as they seem to reduce transmissions among pain nerves. They do not improve nerve function, however.

Vitamin B_6, in doses of 50 to 150 milligrams per day, also has been found to be helpful in relieving pain. Doses greater than 200 milligrams per day are not recommended, as they can worsen

neuropathy. Some people with diabetes have found pain relief through acupuncture or massage, which can improve circulation in the arms and the legs.

Reversing Nerve Problems

A healthy diet can work wonders for nerve problems. The Weimar Institute in Weimar, California, has developed a cutting-edge method that is improving neuropathy in many people with diabetes. Their nineteen-day program uses a combination of diet, exercise, and stress management to bring diabetes under better control. Not surprisingly, one of the keys to its success is a vegetarian meal plan.

Milton Crane, M.D., of the Weimar Institute, studied patients who had developed painful neuropathies in their legs and feet after having diabetes for many years. Using a diet that did not include any animal products and very little vegetable oil, along with regular exercise, caused leg pains to disappear in seventeen of the twenty-one patients within *two weeks*. Others experienced partial relief as well. In all, five patients discontinued all their diabetes medicines, and the remaining patients cut their doses by about half. Plant foods have a tremendous effect on controlling diabetes and preventing nerve damage before it turns into a serious and painful problem.

But that's not all. The complex carbohydrates found so abundantly in vegetarian food stimulate the production of two neurotransmitters that are involved in mood and pain control: noradrenaline and serotonin. These are the same chemicals that antidepressants are designed to increase. So don't be afraid to eat plenty of wholesome bread, pasta, and cereal foods as long as they are the low-fat, whole grain variety. You'll find endless ideas in this and other vegan recipe books, Web sites, and magazines.

Healthy Kidneys

The kidneys filter waste products from the blood and keep sodium and fluid in balance. When blood sugar is high over a number of years, it can cause serious damage to the kidneys, diminishing their

ability to properly filter the blood. As a result, protein is lost in the urine and waste products build up in the blood.

Diabetes is the most common cause of serious kidney disease, called end-stage renal disease, a troubling but accurate name. When the kidneys no longer function, dialysis is necessary to filter toxins from the blood. Approximately 20 to 30 percent of people with diabetes develop this condition.

Several research studies have shown that proper control of blood sugar can reduce the risk of developing kidney disease. Because your food choices influence blood sugar levels, they also significantly affect how well your kidneys can do their work.

Certain foods cause the kidneys to wear out faster. Animal protein in particular—fish, chicken, red meat, eggs, and dairy products—overwork the kidneys' filter units, called nephrons. People who get their protein from plant sources preserve their kidney functions longer.

Symptoms of kidney disease take time to show and usually are not seen until the kidneys are seriously damaged. One of the first signs is a trace of protein, called albumin, in the urine, detectable with a simple urine test. This test is usually done beginning at puberty or within five years of diagnosis of Type 1 diabetes. It is done immediately with Type 2 diabetes. Your doctor will perform annual follow-up screenings to check for protein and to help you keep your kidneys working well.

It's Time to Take Control

By now you know how the power of food and exercise can drastically improve your control over blood sugar. Following a plant-based diet in combination with exercise and, in some cases, medication, can cut your risk of complications and keep you feeling your best. The sooner you adopt these changes, the better. Use the recipes in part III to help you make this important change in your eating habits. Your body will thank you.

Lifelong Health

10

Exercise Matters

Walking, biking, swimming, and even housework or gardening are good forms of exercise for anyone. But for people with diabetes, exercise plays a very special role. It helps reduce blood glucose levels and reduces insulin resistance, which means you may not need to take as much medication. It also boosts your metabolism, helping you burn more calories. This is particularly helpful if you are concerned about your weight. Exercise can help strengthen your muscles, increase flexibility, and improve your overall sense of well-being. Used in combination with nutritious, healthy foods, it can help you to have better control over your diabetes.

If you have slumped into a couch potato existence, you might be hoping that health experts will come up with reasons why you shouldn't exercise. Well, its not likely to happen. Exercise is good for people of all ages. Children with well-controlled diabetes can safely participate in many activities. If you're middle-aged or older, you may need more guidance on how to become more active, but you'll be glad you did. Sedentary living can exacerbate the deterioration of bones, joints, muscles, and ligaments, while regular activity helps keep your body strong.

In addition to reducing blood sugar and your need for medication, exercise also can help your heart and blood vessels. It improves your cholesterol level, increasing high-density lipoproteins (HDL, or "good cholesterol") and reducing low-density lipoproteins (LDL, or "bad cholesterol"). Doctors in Finland found that in young men with Type 1 diabetes, running for thirty minutes to an hour three to five times per week brought a significant drop in their cholesterol levels and an increase in their HDL.

Physical activity is good not only for your body but also for your mind. It may be the only time during the day that you have to unwind. Think of the hour you spend at the gym as a luxury—free of daily stresses from work and home. It's a healthy mental break that reduces stress, increases self-esteem, alleviates depression, and has an overall positive effect on your quality of life.

Aerobic and Resistance Exercise

What kind of exercise calls to you? Instead of committing to a program that sounds "healthy," it's better to get into activities that are *fun*. You will be more likely to stay with them.

You can't go wrong with walking. It doesn't require joining a fitness center, just an appropriate pair of shoes (see "Taking Care of Your Feet" in this chapter) and comfortable clothes. If you like, you can try to park your car a little farther away from the shopping center or work to add some extra activity into your schedule. Some people enjoy walking in the park or the mall. Whatever the venue, it is an excellent form of exercise, either alone or with a friend.

DIFFERENT TYPES OF EXERCISE

LOW INTENSITY	MODERATE INTENSITY	HIGH INTENSITY
Leisurely walking	Brisk walking	Running
Stationary bicycle	Taking the stairs	Swimming
Dancing	Mall walking	Bicycling

If you have peripheral neuropathy, degenerative arthritis, or any other condition that makes it difficult to do weight-bearing exercises such as walking, try non-weight-bearing exercises such as swimming or other water activities, or consider using a stationary bicycle (see the following table).

NON-WEIGHT-BEARING EXERCISES	WEIGHT-BEARING EXERCISES
Swimming	Running
Other water activities (e.g., water aerobics)	Aerobics
	Lifting weights
Stationary cycling	Walking
	Skiing
	Tennis

Resistance training (i.e., strength or weight training) strengthens muscles and bones, improves flexibility, improves your shape, and reduces your risk for heart disease. If you have access to a gym or a trainer, you'll easily find a program that's right for you. For best results you'll want to incorporate this type of activity into your exercise routine a minimum of twice per week. Include at least eight to ten exercises, using all of the major muscle groups, and do at least one set of each exercise. The following table lists some upper- and lower-body exercises you can try. If you are not familiar with some of these exercises, you may want to invest in a video or a book that discusses them in more detail or work with a personal trainer.

If you have eye or heart problems, be sure to talk with your doctor before starting a resistance training program.

For People with Type 1 Diabetes

Olympic athlete Gary Hall was diagnosed with Type 1 diabetes in 1996. It didn't stop him from winning four medals—two gold, a silver, and a bronze—at the 2000 Olympics. And diabetes needn't stop you either. But do be aware that many factors can influence how your blood sugar responds to exercise, including the intensity,

Types of Resistance Exercises

UPPER BODY AREA	EXERCISES
Arms	Bicep curl, tricep extension
Chest	Bench press, push-ups
Upper and middle back	Rowing machine
Shoulders	Shoulder press, side raise, front raise

LOWER BODY AREA	EXERCISES
Hip, thigh, and backside	Squat, lunge
Legs	Leg extension, leg curl
Stomach	Crunches, oblique twist
Lower back	Back extension

duration, and time of day you exercise, as well as your glycogen stores, nutritional status, blood insulin levels, and fitness level.

You may need to adjust your diet and medication to exercise safely. Check your blood glucose levels pre- and postexercise, and let your doctor know how exercise affects your blood sugar, so your medication can be adjusted accordingly.

Hypoglycemia (low blood sugar) can occur during or even long after exercise. The symptoms can come on suddenly and can be caused by eating too little, taking too much medication, or extra exercise. But you can avoid it if you are careful. How do you know if you're hypoglycemic? Watch for:

- shaking
- headache
- weakness, fatigue
- impaired vision
- fast heartbeat
- sweating
- dizziness
- hunger

Here are some important tips on managing your blood sugar response to exercise:

1. Do not exercise if your fasting blood sugar level is >250mg/dl and ketosis is present.
2. Be cautious if your blood sugar level is >300mg/dl without the presence of ketosis.
3. Check your blood sugar before and after exercise.
 a. Try to pinpoint when food patterns or insulin should be adjusted.
 b. Learn your body's glycemic response to physical activity.
4. Consume additional carbohydrate-rich foods as necessary to avoid hypoglycemia.

For People with Type 2 Diabetes

The astounding rise in the prevalence of Type 2 diabetes in the United States and many other countries reflects an increased occurrence of obesity and decreased levels of physical activity. But this is not a one-way street. You can turn this dangerous trend around, as so many others have done, and exercise is a crucial place to begin. If you have Type 2 diabetes, exercise helps control your blood sugar and improves insulin sensitivity. However, these effects last just seventy-two hours after your exercise session. So it is essential to include exercise on most days to maintain these benefits.

If you do not have significant complications or limitations, you'll want to include a combination of aerobic and resistance exercises. The payoff comes in cardiorespiratory fitness, weight loss, and improved muscle strength and endurance, in addition to improved blood sugar and cholesterol.

Hypoglycemia is rare with Type 2 diabetes. But it can occur if you are taking sulfonylurea medication or insulin (see chapter 7) and exercising for a long period. Monitor your blood sugar level before and after exercise to be sure you are in good blood control.

Before You Begin

Before starting an exercise program, talk to your doctor. Let him or her know what type of exercise you are interested in and at what intensity. Your doctor will screen for possible health complications

that signal a need for caution. These could include heart or artery disease, or problems with the eyes, nerves, and kidneys. Your doctor will also recommend keeping a diabetes identification bracelet or shoe tag visible during exercise in case of an emergency. Don't be daunted, though, by the need to be careful. Exercise is good for you, and there is a way to enjoy it no matter what shape you are in at the moment.

Let's Get Started

The best way to start a workout is to warm up, then stretch, and then gradually increase your intensity. Begin with a five- to ten-minute warm-up, usually walking, cycling, or some other aerobic activity at a low intensity level. The idea is to ready your muscles, heart, and lungs for the increase in activity. Next, do five to ten minutes of stretching, focusing especially on the muscles to be used during the activity. Now you should be ready to jump in.

Begin slowly, and gradually increase your intensity to reduce the risk of injury to your feet or other parts of the body. You might start with just ten to fifteen minutes per session and work up to thirty minutes. If weight loss is your primary goal, start at a low intensity for ten to fifteen minutes and gradually work up to sixty minutes. After you're done, spend five to ten minutes in a cooldown at a low intensity, doing activities similar to the warm-up. This will help bring your heart rate down to its pre-exercise level.

Stay Hydrated

Water makes the world go 'round, and it'll do the same wonders for your active body. A general recommendation for daily fluid intake for inactive adults is about two liters, or eight cups. If you are physically active, you will likely need more, so be sure to stock up on water, juice, tea, soup, fruit, fruit juices, or sports drinks. It is very important to drink adequate fluids before, during, and after exercise, because dehydration can affect your blood glucose level and even your heart function. Here are three practical tips for fluid replacement:

Prior to exercise. Drink two cups of water or other drink about two hours before exercising. This will allow your body time to become adequately hydrated and to eliminate any excess fluid. But you should try to develop the habit of keeping a water bottle at your desk, in your car, even in the refrigerator at home. It'll remind you to be sure to drink water throughout the day so you won't be chugging it down in one shot two hours before your activity.

During exercise. Consume fluids early and consistently throughout exercise to replace water lost through sweating.

After exercise. If you stand on a scale, you'll be able to see exactly how much water you have lost, which will be a guide for your next workout. Have two cups of fluid for every pound of weight loss during exercise.

If you are exercising for up to an hour, plain water is all you will likely need. If you exercise for more than an hour, sports drinks such as Gatorade or Powerade also will give you adequate carbohydrates to keep you going. They contain 6 to 8 percent carbohydrate (about 14 to 19 g). If you're using exchange lists, a sports drink can be counted as one starch exchange or one carbohydrate exchange. Fruit juice also can be used, but it has a much higher sugar content (13 to 14%) and may cause stomach discomfort.

Taking Care of Your Feet

Prior to increasing your physical activity, you will need to ask your doctor whether you have a type of nerve damage called peripheral neuropathy. It can reduce sensation in your feet, making it easier to injure yourself. If this is a problem for you, try using silica gel or air midsoles with polyester or cotton-polyester socks to prevent blisters and to keep your feet dry, which will reduce your risk of harming your feet. Be sure to check your feet before and after exercise for any sign of injury.

Fueling Your Active Body

Exercise puts demands on your muscles, heart, and lungs, so it is important to have an adequate diet. If you are low on fuel—meaning

healthy, carbohydrate-rich foods that give you energy, plus a variety of fruits and vegetables for vitamins and minerals—you'll be easily fatigued.

If you plan to exercise for more than 1 to 1½ hours, you may need to have a small carbohydrate-rich snack during exercise to replenish glycogen, which is your body's stored glucose. Glycogen in your muscles and liver is your basic energy source for exercise.

Healthy foods from the plant kingdom—vegetables, whole grains, legumes, and fruits—provide all the nutrients you need to fuel your active lifestyle. In fact, they encourage it by keeping your body slim and energized. Chapter 3 provides a more detailed review of foods for a healthy body.

Carbohydrate-rich foods should comprise the largest portion of your diet. They are needed to replenish your body's stores of glucose, among other things. Be sure to include whole grains such as brown rice, quinoa, barley, and millet. Beans, peas, and lentils also are good sources of complex carbohydrates and fiber. Fruits and vegetables, such as bananas, oranges, mangoes, peaches, broccoli, collard greens, and carrots are energizing and nutritious. A 2000 study by researchers at the University of Texas Southwestern Medical Center in Dallas had thirteen people with diabetes follow the American Dietetic Association's recommended diet, plus twice the amount of recommended fiber for six weeks. By adding more fiber in the form of fresh fruits, oatmeal, and whole grain breads, among other high-fiber foods, the participants were able to have better control over their blood glucose levels.

A common misconception about exercise, particularly weight lifting, is that you need large amounts of protein to build muscle. That is not necessarily the case, particularly for recreational athletes. Although protein requirements vary based on the type of exercise and the level of training, the protein in a healthy plant-based diet is more than adequate. Good protein sources include legumes, grains, and vegetables.

As always, you'll want to avoid fatty foods. In addition to skipping animal products, vegetable sources of fat should be limited, such as olives, olive oil, other vegetable oils, avocados, nuts, seeds, and tahini.

The nutrient needs of professional athletes are higher than those

of someone who exercises at a low to moderate intensity. If you are working toward a high-intensity exercise regimen, be sure to discuss this with your healthcare team. You also may need to work with a registered dietitian to develop a meal plan tailored to your specific needs.

Sticking with It

You know all the reasons why you should exercise. But how do you work it into your busy schedule? The following suggestions will help.

Don't push overly hard. Instead, set goals for yourself and gradually increase your regimen. For example, if your long-term goal is to exercise for a half hour daily, a short-term goal could be to exercise for a half hour two times a week. When this becomes routine, add another day. Setting and reaching short-term goals is much less daunting than trying to hit your ideal workout routine right away.

Schedule in exercise. Pencil in your calendar days and times to exercise. Schedule it like you would an appointment with the doctor or the dentist. Whether it is a walk around the neighborhood or a trip to the gym, a regular schedule will become routine the longer you do it. An added benefit is that it will be easier for you to make adjustments in your eating habits and medications.

Exercise with a partner. Whether it is a spouse, friend, neighbor, or coworker, find someone who will exercise with you. Plan days to go to the gym, for a bicycle ride, or a walk around the park. A partner can motivate you to continue with your exercise plan.

Reward yourself. Each time you reach a goal, give yourself a nonfood reward. Get a manicure or a massage, buy a new book, or do whatever else will help you to stay on track.

No guilt. You may find that you are having a busy week and haven't had any time to exercise. Or maybe you set goals for yourself that are not realistic at this time. Don't feel guilty about it or give up. Try to schedule some exercise the following week, or reassess your goals and make new ones that are more achievable.

Try a variety of exercises. One day you may enjoy walking, the next day taking a bicycle ride. For some people, repeating the same

exercise can become dull and boring. Find several activities you enjoy, such as gardening, walking, playing tennis, or lifting weights. Vary the exercises you do each week to keep them interesting.

Start a walking club. The workplace is the perfect setting for group activities. Post signs in your break room or meeting room about dates and times when you will meet. Just like exercising with one partner, having many people to walk with is a great incentive to continue.

Take a break. Use part of your lunch break to take a short walk around your office or building. It'll give you a little time to yourself to clear your head as well as to get you moving.

Sneak in some extra steps. When you go to the mall, food shopping, or other places, do you drive around and around looking for the closest spot? Instead, take that less-than-ideal spot that no one else is looking for—the farther away the better. At work, take the stairs when you can. Use these opportunities to add just a bit more physical activity into your day.

Instead of a dish, bring sneakers. When inviting guests over for brunch or dinner, ask them to bring their sneakers for a postmeal walk. In this way, if you've had a busy day preparing the meal, you can still work in a little exercise while spending some quality time with your guests. Maybe they'll pick up the idea as well, starting a healthy tradition.

Bad weather? No problem. If you belong to a gym, unless four feet of snow are piled at your doorstep, you should be able to get there. Or go to the mall. Mall walking is a wonderful way to exercise, if you can pass by all the temptations!

Exercise is great for everyone, and especially so when you're aiming to control diabetes as well as possible. If you have Type 2 diabetes, exercise, a healthy diet, and weight loss sometimes can make the illness go away. And for anyone with diabetes, exercise will help you both physically and mentally.

11

Diabetes during Pregnancy

Pregnancy is a time of great wonder and delight—from hearing your baby's heartbeat and feeling that first precious kick, to giving birth. Before you know it, you will be nurturing this new little person with hardly a break in the day. You'll get plenty of "oohs" and "aahs" and compliments, and even more unsolicited advice about raising your baby.

The needs of your newborn and the changes your body goes through will affect the way you manage your diabetes. But even before becoming pregnant, you will have important decisions to make. If you have diabetes, or develop it during your pregnancy, you'll want to plan for the very best for yourself and your baby. This chapter will guide you from preconception to delivery, smoothing out the challenges along the way.

Before Your Baby Is Conceived

You can give your baby a major advantage even before you become pregnant. Most pregnancies are not planned. So whether you have

diabetes or not, if you're a woman of childbearing age, it's wise to stay on top of health and fitness.

You'll want to include plenty of vegetables, fruits, and beans in your diet. They are rich in folic acid, which is essential for your baby's early nervous system development. It's no good waiting until you're pregnant to build these foods into your diet. By the time your pregnancy test comes back, your baby has already grown past the stage where folic acid plays its most critical role.

A word about fish. Many varieties, especially freshwater fish, are contaminated with industrial and agricultural chemicals. A study at Wayne State University found that women who had consumed a fair amount of fish in the years before their pregnancy tended to give birth to children who were sluggish at birth, had small head circumference, or showed other signs that all had not been well during pregnancy. If these women could turn back the clock, many would have gladly changed their diets to vegetarian choices.

If you have diabetes, the most important key to a successful and healthy pregnancy and a healthy baby is strong control of your blood sugar levels, just as you've done for yourself. Poor control, with high blood sugar levels during the first six weeks of pregnancy, can affect your baby's developing organs, possibly leading to birth defects. Part of the problem is that your developing baby is also getting some of this "extra sugar." It can cause the baby to grow too quickly, making delivery more difficult for both of you. This extra sugar can be a challenge for the little one's body to handle. Your baby's pancreas needs to make extra insulin to handle the influx of sugar, and in fact, your baby must be watched carefully after birth because it can be difficult for him or her to stop making the extra insulin.

Don't let this information scare you. Most mothers with diabetes give birth to beautiful, healthy babies. But don't leave it to chance. Your healthcare team will help you plan to use diet, exercise, and medication to control your blood sugar levels. Here are some of the areas you will want to discuss with them:

- planning appropriate meals
- learning to time your meals and snacks
- bringing exercise into your routine
- choosing the time and the location of insulin injections, if needed

- handling hypoglycemia
- reducing stress
- testing your blood sugar
- adjusting your insulin dose if necessary

Who Is on Your Healthcare Team?

- a medical doctor experienced in the care of pregnant women with diabetes
- an obstetrician who cares for pregnant women with diabetes
- a registered dietitian who understands the value of a vegetarian diet and who can answer questions and help you along the way
- a diabetes educator who will help to teach and educate you on how to handle your diabetes during your pregnancy

What to Expect at the Doctor's

At your first prepregnancy visit, your doctor will do a complete history and physical examination. Some of the questions your doctor may ask are:

- How long you have had diabetes?
- Have you any short-term or long-term complications, such as eye or nerve problems?
- How well do you manage your medication, diet, and exercise?
- What is your menstrual/pregnancy history?
- Are you currently using contraceptives?
- What kind of support system do you have at home?

Other members of the healthcare team, such as a registered dietitian and nurse, will want to review how well you monitor your blood sugar, any history of problems with hypoglycemia or hyperglycemia, your eating habits, and your calorie needs. These professionals will develop a plan to help you through your pregnancy.

The physical examination will check for eye, nerve, or heart problems and will include a pelvic examination with a Pap smear. A Pap smear can show if you have changes on your cervix that could lead to cancer and if you have a cervical or a vaginal infection.

Your doctor may want to run some laboratory tests to see how well your diabetes is controlled and to check for any complications or other disease. Some of these tests may include:

- Glycated hemoglobin. This shows how well controlled your blood sugars have been over the past two to three months. One of the goals of preconception care is to keep this value within normal limits, which can improve your chances of becoming pregnant and give your baby the best opportunity to develop healthfully.
- An assessment of kidney function. When your diabetes is under control, you'll keep your kidneys working right.
- Thyroid-stimulating hormone (TSH). About 5 to 10 percent of women with Type 1 diabetes have hyper- or hypothyroidism.
- Other tests as ordered by your physician.

Your doctor may recommend taking vitamins, iron, and folic acid prior to pregnancy to ensure that you are well nourished. More on this later in this chapter.

If you have Type 2 diabetes and are using an oral medication to control it, your doctor may want to change you to insulin prior to conception and throughout your pregnancy. This is because the safety of oral diabetes medicines during pregnancy has not been well established.

Prepregnancy Follow-up Visits

After your initial visit, your doctor may want to see you at monthly intervals to assess how you are doing. The main focus is on your blood sugar, and your doctor will be especially interested in your glycated hemoglobin values. Again, this test shows how well controlled your blood sugars have been over the preceding two to three months. Once this value gets to within the normal range, your doctor will recheck it about every six to eight weeks until you become pregnant.

Other members of the healthcare team will want to see you again, too. You will most likely meet with a registered dietitian and a diabetes educator who will help motivate and teach you about managing your diabetes now and throughout your pregnancy. Be sure to let them know of any problems you are having, whether it is with controlling your blood sugar levels, exercising, or other issues. You and your healthcare team can always revise your diet, exercise routine, or medicines to work with your individual needs.

You can help your healthcare team by logging your blood sugars and eating habits. You may wish to copy the tables on pages 122 and 123. This information will help your doctor look at:

- How well you are monitoring your blood glucose levels. Include how often you test your blood glucose, what the levels are, and your medication dose. You also can include other information in the comment section, such as whether you were not feeling well, were late checking blood sugar, etc.
- Any hyper- or hypoglycemic episodes. Record when and how often they occur in the Comments section to help your healthcare team determine the possible cause.
- Food choices. Use the sample food diary to keep track of your meals. You'll notice how certain foods affect your blood sugar levels.
- Exercise. Use the Comments section to record the types of exercise, the duration, and the frequency. For example, you may have walked at a slow pace for a half hour. That's all the detail you really need. This will help guide your doctor in planning your medication needs and help you to see if you are meeting your exercise goals.

Now That You Are Pregnant

Once you think you may be pregnant, be sure to have a laboratory test done as soon as possible to confirm the results. The health issues you'll need to think about now are not really so different from those that were already important to you.

Diet. Are you eating your vegetables? A plant-based diet can certainly help you to meet your needs for calcium, folate, and other

DAILY BLOOD SUGAR

Record for the week of _____

	MON.	TUES.	WED.	THUR.	FRI.	SAT.	SUN.	COMMENTS
Breakfast								
Time								
Blood Sugar								
Dose								
Snack								
Time								
Blood sugar								
Dose								
Lunch								
Time								
Blood sugar								
Dose								
Snack								
Time								
Blood sugar								
Dose								
Dinner								
Time								
Blood sugar								
Dose								
Snack								
Time								
Blood sugar								
Dose								

Food Diary

Date _____

Time	Food Item	Amount (TBSP, CUP, ETC.)	Cooked or Raw	Comments

important nutrients. Are you taking any vitamins? How well you follow your diet can have an impact on how well your blood sugars are controlled.

Illness. Are you having any nausea or vomiting? If so, your meal plan can be modified to help you deal with this better.

Weight gain. As we'll see shortly, you'll gain roughly twenty-five to thirty-five pounds during your pregnancy—more if you're starting your pregnancy at less than your ideal weight, less if you're overweight.

Hypoglycemia. Now is a good time to review with your doctor how to prevent low blood sugar.

Insulin. Your body's need for insulin will increase if you have Type 1 diabetes because certain hormones made by the placenta can interfere with insulin's action. If you have Type 2 diabetes and are taking medication for it, your doctor will change you to insulin.

Blood glucose levels. You'll want to check frequently, because the better the control, the better the outlook for you and your baby.

If Diabetes Starts during Pregnancy

About 4 percent of pregnancies are complicated by gestational diabetes, a type of diabetes that develops only during pregnancy. The exact cause is not known, but it is thought to be due to hormones produced from the placenta that make it difficult for insulin to do its job.

If you did not have diabetes prior to your pregnancy, your doctor should have assessed your risk of developing it at your first prenatal visit.

Here are some indications that you are at low risk for gestational diabetes (you must have all of these to be considered low risk):

- age less than twenty-five years
- normal weight prior to conception
- no close relatives with diabetes
- no history of an abnormal glucose tolerance test
- no history of poor pregnancy outcome

You are at higher-than-average risk for developing gestational diabetes if you:

- are seriously overweight
- have had gestational diabetes during a previous pregnancy
- have had sugar in your urine when tested by your doctor
- have a family history of diabetes

If you do not meet any of these criteria, your doctor will check for diabetes about six months into your pregnancy. Otherwise your doctor will want you to take a glucose test as soon as possible. Your doctor will diagnose diabetes if you have a fasting blood glucose level of 126 milligrams/deciliter or more, or a blood glucose level above 200 at any time of day. Your doctor will test you on two different days to confirm the diagnosis.

Gestational diabetes occurs late in pregnancy, but some women have had diabetes before conceiving and not been aware of it. So it is important for your doctor to see if you would be at risk of having diabetes before you get pregnant. Your doctor will want to take every precaution to ensure that you have the healthiest pregnancy possible.

What Are the Complications of Gestational Diabetes?

First of all, don't worry. With good control of your blood sugar, you and your baby are likely to do just fine.

The most common problem is macrosomia, an obstetrician's word that simply means having a very large baby. As we saw earlier, this can occur because extra sugar passes to your baby. It can make labor more difficult for you. For your baby, it sometimes leads to shoulder damage during birth, difficulty breathing, and low blood sugar levels.

Sometimes jaundice shows up as yellowish discoloration of the skin due to the buildup of old red blood cells. Jaundice disappears quickly with treatment.

After your first pregnancy with gestational diabetes, you are likely to get it again with your next pregnancy. You are also somewhat more likely to develop Type 2 diabetes later in life. But you can work to prevent this by keeping your weight in a healthy range, exercising, and making good food choices. Low-fat vegan foods will help you to stay healthy.

Good Nutrition during Pregnancy

No matter what type of diabetes you have, healthy food choices can help keep your blood sugar under control. It is still important to consume the largest percentage of your calories as carbohydrates. Plant foods—beans, vegetables, and whole grains—are excellent sources of complex carbohydrates and fiber. But you'll need to increase your portions. Your calorie needs during pregnancy increase by about 15 percent, and your need for some nutrients increases by as much as 50 percent. It is important to limit or avoid the use of sugary candy and sweets, which provide a lot of calories but few nutrients. So it bears repeating: A well-balanced diet of legumes, whole grains, vegetables, fruits, with occasional nuts and seeds is the healthiest way to meet your nutrient needs.

A registered dietitian can help you plan your meals, based on your recommended weight gain, blood sugar levels, and appetite to develop a meal plan that is best suited to meet your needs.

Getting plenty of protein without overdoing it during pregnancy is easy if you are following a vegetarian diet. Recommendations for protein intake during pregnancy are 60 grams per day, met easily by consuming a healthy variety of legumes, whole grains, and vegetables. A sampling of vegan women found that they consumed an average of 65 grams of protein daily—just right whether you are pregnant or not.

How Much Weight Should I Gain?

Weight gain is important during pregnancy. Not only is the developing fetus adding to your weight, especially after six months, but changes in your body contribute as well.

Weight gain recommendations vary based on how slim you were prior to becoming pregnant. If you were underweight (less than 85% of your ideal body weight), aim for a twenty-eight- to forty-pound weight gain. If you were at a good weight, aim for twenty-five to thirty-five pounds. Overweight women (greater than 120% of ideal body weight) will need to gain less weight, about fifteen to twenty-five pounds, and obese women (greater than 135% percent of ideal body weight) will need to gain only about fifteen pounds.

Where You Can Gain Weight during Pregnancy

Baby	6 to 8 pounds
Placenta	1½ pounds
Amniotic fluid	1¾ pounds
Enlargement of uterus	2 pounds
Mother's breast tissue	1 pound
Mother's blood volume	2¾ pounds
Fluids in mother's tissues	3 pounds
Mother's fat	7 pounds

If you are underweight, try adding more foods to your diet that are concentrated sources of calories. Some good choices include soy products, nut butters, dried fruits, and bean dips and spreads. Consuming smaller meals more frequently may help you to take in enough calories to meet your needs.

Do I Need to Take Any Vitamins?

If your food intake during pregnancy is adequate, a prenatal vitamin may not be necessary. But your doctor should prescribe a prenatal vitamin if you are not meeting all your nutrient needs. As you know by now, a plant-based diet can easily meet your daily requirements. However, there are a few nutrients that should be given special attention.

Iron. Your need for iron doubles during pregnancy, from 15 to 30 milligrams per day, because both you and your baby are busily making red blood cells. Iron deficiency is no more likely in vegetarians than in nonvegetarians during pregnancy. Still, it is important to choose iron-rich foods. And consuming vitamin C and iron-rich foods together allows iron to be easily absorbed.

Folic acid. All women of childbearing age are encouraged to take a supplement of 400 micrograms (or 0.4 mg) of folic acid daily whether they are pregnant or not. It helps your baby's nervous system to develop properly, decreasing the risk of spina bifida or other neural tube defects. Since nervous system defects can occur in an embryo before a woman even knows she is pregnant, and because

HEALTHY, IRON-RICH FOODS (IN MILLIGRAMS)

Vegetables, cooked

Broccoli (1 cup)	1.3
Collards (1 cup)	1.9
Kale (1 cup)	1.2
Mushrooms (1 cup)	2.7

Legumes, cooked

Black beans (½ cup)	1.8
Chickpeas (½ cup)	2.4
Lentils (½ cup)	3.3
Pinto beans (½ cup)	2.2
Soybeans, mature (½ cup)	4.4

Grains, cooked

Barley, pearled (½ cup)	0.9
Brown rice (½ cup)	0.5
Millet (½ cup)	0.8
Quinoa (½ cup)	7.9

Cereals

Cream of Wheat (¾ cup, cooked)	7.7
Kellogg's Product 19 (1 cup)	18.0
Post Grape-Nuts (½ cup)	8.1
Wheat germ (¼ cup, toasted)	2.6

Dried fruit

Dates (10)	1.0
Figs (10)	4.2
Raisins (⅓ cup)	1.0

Nuts and seeds

Almonds (1 oz)	1.1
Cashews (1 oz)	1.7
Sesame seeds (1 oz, toasted)	2.2

Source: J. A. T. Pennington, *Bowes and Church's Food Values of Portions Commonly Used.* 17th ed. (Philadelphia: J. B. Lippincott, 1998).

most pregnancies are unplanned, it is important to consume adequate amounts of this vitamin as part of your routine. Folate is found in many plant-based foods such as dark green, leafy vegetables; beans; peas; and enriched cereals.

Calcium. Developing babies need calcium, not just for strong bones and teeth but also for muscle, heart, and nerve development,

VITAMIN C–RICH FOODS (IN MILLIGRAMS)

Fruit

Cantaloupe (1 cup)	68
Grapefruit (½ medium)	42
Orange (1)	75
Orange juice (½ cup)	62
Papaya (1 medium)	188
Strawberries (1 cup)	84

Vegetables

Broccoli (1 cup, cooked)	74
Pepper, sweet (1 cup, cooked)	102
Spinach (1 cup, cooked)	18
Tomato (1, raw)	23

Source: J. A. T. Pennington, *Bowes and Church's Food Values of Portions Commonly Used.* 17th ed. (Philadelphia: J. B. Lippincott, 1998).

FOODS RICH IN FOLIC ACID (IN MICROGRAMS)

Fruit

Orange juice (½ cup)	37
Orange (1 medium)	47

Vegetables, cooked

Asparagus (½ cup)	132
Broccoli (1 cup)	104
Collards (1 cup)	130
Mustard greens (1 cup)	104
Spinach (1 cup)	262

Legumes, cooked

Black beans (½ cup)	128
Kidney beans (½ cup)	115
Lentils (½ cup)	179
Pinto beans (½ cup)	147

Breakfast cereals (½ to 1½ cups) 100–400

Source: J. A. T. Pennington, *Bowes and Church's Food Values of Portions Commonly Used.* 17th ed. (Philadelphia: J. B. Lippincott, 1998).

blood clotting, and enzyme activity. If you are not getting enough calcium from your diet, your body will take it from your bones to meet your baby's needs. However, one nutritional benefit of pregnancy is that your body tends to absorb and hold on to calcium better. According to current U.S. recommendations, pregnant women should take in 1,000 milligrams of calcium daily. While this guideline may be overly generous, plant-based foods can easily give you plenty of calcium. Have green, leafy vegetables; beans; or, for especially rich sources, calcium-fortified soy milk and juices, and tofu processed with calcium sulfate.

Healthy, Calcium-Rich Foods (in milligrams)

Grains

Corn bread (1 2-oz piece)	133
Corn tortilla (1)	42
Whole wheat flour (1 cup)	40

Fruits

Orange juice, calcium-fortified (1 cup)	300
Dried figs (10)	269
Navel orange (1)	56
Raisins (1/3 cup)	27

Vegetables

Broccoli (1 cup, cooked)	94
Brussels sprouts (1 cup, cooked)	56
Butternut squash (1 cup, cooked)	84
Carrots (2 medium, raw)	38
Celery (1 cup, cooked)	64
Collards (1 cup, cooked)	348
Kale (1 cup, cooked)	94

Legumes, cooked

Black turtle beans (1/2 cup)	52
Chickpeas (1/2 cup)	39
Great Northern beans (1/2 cup)	61
Kidney beans (1/2 cup)	25
Navy beans (1/2 cup)	64
Soybeans (1/2 cup)	88
Tofu, raw, firm (1/2 cup)	258
Vegetarian baked beans (1/2 cup)	64

Source: J. A. T. Pennington, *Bowes and Church's Food Values of Portions Commonly Used.* 17th ed. (Philadelphia: J. B. Lippincott, 1998).

Vitamin B$_{12}$. Although vitamin B$_{12}$ is found in animal products, the healthiest sources are fortified cereals or soy milk, multivitamins, and prenatal supplements. Pregnant women need 2.6 micrograms.

HEALTHFUL SOURCES OF VITAMIN B$_{12}$ (IN MICROGRAMS)

All regular and prenatal vitamins include vitamin B$_{12}$. But you'll also find it in these healthful foods:

Total cereal (1 cup)	8.0
Product 19 cereal (1 cup)	6.0
Kellogg's Corn Flakes (1 cup)	2.0
Grape-Nuts cereal (1 cup)	3.0
Edensoy Extra soy milk (1 cup)	3.0
Meat analogues (variable servings)	2–7
Nutritional yeast (1 tbsp) (Red Star Vegetarian Support Formula)	4.0

Source: J. A. T. Pennington, *Bowes and Church's Food Values of Portions Commonly Used.* 17th ed. (Philadelphia: J. B. Lippincott, 1998).

Eating well-planned plant-based meals during your pregnancy can help you to keep your blood sugar level under control. And if you have gestational diabetes, following good eating habits along with other lifestyle modifications after you deliver will keep you slim, reducing your chances of developing Type 2 diabetes later in life.

12

Putting It All Together

We have now turned an important corner in diabetes. Although, for many people, diabetes has been very troubling indeed, leading to all manner of complications—not to mention the annoyances of having to keep track of your blood sugar and watch your diet—a new approach makes everything much easier.

We've started with a very different look at the disease itself. For Type 2 diabetes, our goal is not simply to try to hold our blood sugar steady. We're actually aiming to rejuvenate our insulin. We'll make it work more efficiently so we can reduce our reliance on drugs—perhaps eliminating them completely. For Type 1 diabetes our goal is to prevent it or, when it has occurred, minimize our need for insulin. Over time this will help us stay in excellent health. For gestational diabetes our goal is to keep it from recurring to turning into Type 2 diabetes.

We can accomplish these goals with a new and very different take on diet. Instead of rigidly adhering to old-fashioned exchange lists and counting every last carbohydrate gram, we will choose foods that jump-start our insulin sensitivity, that help us slim down (or stay that way), and that keep our heart and blood vessels healthy.

In the process we gain the freedom to enjoy foods that are tasty, familiar, and filling. With a few simple but important changes in our diet, we can control our blood sugar much better—to the point where, if we have Type 2 diabetes, it can even go away.

If a major diet change seems like a challenge, try this: First, make major diet changes rather than minor ones. Really give it a chance to work, so you can see results. A minor adjustment in the diet here or there will not give you any reward. But to make it doable, focus on the short term. Try it for just three weeks. If you like it—if you feel better and your energy improves—you'll want to stick with it. But in the beginning, focus on making major changes with a short-term focus.

In the process we'll not only trim our waistlines, cut our cholesterol level, and lower our blood pressure, we'll also have a healthy effect on those around us. The fact is, your good eating habits will rub off on people around you. When they try the same foods that are helping you tackle diabetes, they'll get healthier, too.

Good luck as you embark on your new, healthy life!

13

Cooking Tips
and Techniques

Getting Started

In this chapter you will find menus and tips to help you prepare delicious and healthy meals. You'll find practical suggestions for menu planning and shopping, and sample menus based on the recipes in this book. "Stocking Your Pantry" provides suggestions for staple ingredients as well as convenient instant meals to keep on hand, and the Glossary lists foods that may be new to you. The recipes are quick and easy to prepare, with ingredients that are available in most grocery stores. Many of the recipes are for healthy versions of familiar foods, and each of the recipes includes a nutrient analysis. The foods featured in this chapter are designed to help keep blood sugar levels on an even keel.

Planning a Menu

Planning ahead is the key to easy meal preparation. You will be amazed at the amount of time and money you save when you plan weekly menus and shop for a week at a time. You'll spend less time

looking for parking and standing in line, and by planning ahead you'll spend less money on impulse items and instant meals. When you begin cooking, you'll be delighted to find that all the ingredients you need will be on hand.

Set aside a bit of time and find a quiet spot to plan a one-week menu. Your menu plan does not have to specify every item for every meal. Breakfasts, especially during the week, will probably be much the same from day to day: fruits, whole grain cereals and breads. For lunches, leftovers make perfect instant meals. Soup (either homemade or commercially prepared) is another quick and nutritious option. Add whole grain bread and salad mix sprinkled with seasoned rice vinegar for a meal in minutes! Bean or grain salads are also excellent fiber-boosting lunch foods that can be prepared in quantity and kept on hand for a quick meal. Thus your lunch menu plan might include a couple of soups and two or three salads. For dinners, plan four main dishes prepared in large enough quantities to provide at least two meals. Add whole grains such as brown rice or bulgur wheat, and vegetables for complete, satisfying meals.

A Sample Menu Plan

This flexible menu plan does not specify exact meals for each day of the week. The indicated meals can be prepared according to your time and taste. At the same time, it provides you with the assurance that the ingredients for any of the meals will be available when you need them. This menu plan also assures that you will get plenty of the high-fiber foods that will help you manage your diabetes more effectively. Use this menu plan to make a shopping list.

SAMPLE MENU PLAN

Breakfasts
 fresh fruit: bananas, cantaloupe, grapefruit
 toast: whole wheat raisin, multigrain
 hot cereal: oatmeal, ten-grain cereal, cracked wheat
 cold cereal: shredded wheat, Grape-Nuts

Lunches

> soups: Golden Mushroom Soup, Curried Lentil Soup, Summer Stew
>
> salads: Couscous Confetti Salad, Aztec Salad, Hoppin' John Salad

Dinners

> Chili Beans
> Polenta
> Carrot and Jicama Salad
>
> Stuffed Portobello Mushrooms
> Broccoli with Sesame Seasoning
>
> Spinach and Mushroom Fritatta
> Mashed Potatoes and Brown Gravy
> Braised Collards or Kale
>
> Lasagna Roll-ups
> Crostini with Roasted Red Peppers
> Cucumbers with Creamy Dill Dressing

Making a Shopping List

Use your menu plan to prepare a shopping list. Look up the recipes you have chosen and note the ingredients you'll need to purchase. Add a variety of fresh vegetables and fruits, whole grains, and breads to round out your meals. Check the refrigerator, freezer and pantry to see what staples need to be restocked (see "Stocking Your Pantry," page 142). These might include condiments, spices, baking supplies, canned foods, frozen foods, or beverages.

To streamline your shopping trip, arrange the foods on your list in categories that reflect the departments in your grocery store, such as fresh produce, grains, dried beans, canned fruits and vegetables, and frozen foods.

SAMPLE SHOPPING LIST

Fresh Produce

oranges	celery	broccoli
bananas	mushrooms	collard greens
cantaloupes	cucumbers	zucchini
grapes	green onions	avocados
grapefruit	Japanese eggplant	yellow onions
other seasonal fruits	red bell peppers	red onions
	green bell peppers	garlic
prewashed salad mix	tomatoes	jicamas
	fresh basil	other seasonal vegetables
prewashed spinach	potatoes	
carrots		

Breakfast Cereals

oatmeal	multigrain cereals	Grape-Nuts
shredded wheat		

Grains and Pasta

rolled oats	polenta	lasagna noodles
couscous	whole wheat pastry flour	pasta shells
brown basmati rice		

Dried Beans and Peas

lentils	pinto beans	split peas

Canned Vegetables and Fruits

15-ounce can diced beets	15-ounce can black beans	roasted red peppers
28-ounce can crushed tomatoes	15-ounce can black-eyed peas	

Packaged Foods

ramen soups	fortified soy milk or rice milk

Refrigerated Foods

tofu	flour tortillas	corn tortillas

Bread

whole wheat bread rye bread

Condiments

peanut butter balsamic vinegar

Herbs and Spices

chili powder oregano

Frozen Foods

orange juice Italian green beans
concentrate

Seasonal Eating

Seasonal eating refers to choosing fruits and vegetables when they are fresh and in season. By doing so, you will enjoy better-tasting, more nutritious produce and cut your food costs at the same time. Seasonal produce tastes better because it is usually picked at its prime. It hasn't spent weeks in transit from the other side of the equator, or months in cold storage where it loses moisture, flavor, and nutrients. Ironically, transportation and cold storage, which detract from the flavor and nutritional value of produce, add significantly to its cost.

There are a number of ways to know what foods are in season. Seasonal foods are usually featured in advertisements and in the produce department at your market. Check your store's advertising flyer and look for large end-aisle displays in the produce department. In general you will find that seasonal foods are more reasonably priced than out-of-season produce because of lower storage, shipping, and handling costs. You will also find that when foods are in season, there are often several varieties to choose from. For example, when apples get ripe in autumn, most stores feature several varieties. By spring and summer, however, only the few varieties that can be held in cold storage are available.

Farmers' markets offer an enjoyable way to find out what is in season. The produce at farmers' markets is not only seasonal, but is often organically grown as well. An easy way to obtain seasonal produce is to join a CSA (community-supported agriculture), in which you pay a fee to a local grower who then supplies you with a variety of fresh produce throughout the season. At http://www. umass.edu/umext/csa/us/StateList.html you can get more information about CSAs, including local listings.

The most basic way of knowing what is in season is to consider what part of the plant a food comes from. During the colder months, foods that are in season generally come from the roots, stems, and leaves of plants. As the weather warms, pods, flowers, and eventually fruits come into season. Fruit, by the way, refers to the seed-bearing portion of a plant and includes such foods as tomatoes, peppers, avocados, squashes, corn, and eggplant.

Stocking Up

With your shopping list in hand, you will be ready to stock up quickly and conveniently for the whole week. Make sure you have eaten *before* you head for the store. Shopping on an empty stomach can override the best of intentions and lead to impulsive purchases of less-than-nutritious foods.

Most processed foods have nutrition labels and ingredient lists that provide you with useful information for making healthful food choices. The nutrition label indicates the size of a single serving and the number of calories as well as the amount of fat, protein, sugar, fiber, and salt in that serving. You can also gather a lot of useful information by reading through the ingredients list. The ingredients are listed in order of prominence in the food: the ingredient present in the greatest amount is first on the list, and so forth. Thus, if fat or sugar appears near the top of the list, you know that these are major ingredients. The ingredients list also indicates the presence of artificial flavors, artificial colors, preservatives, and other additives you may wish to avoid.

As you read through the ingredients list, be aware of the many different forms of sugar that may be in food. Sucrose, fructose,

dextrose, corn syrup, honey, and malt are just a few, and in general, any ingredients that end with "ose" are sugars. If a product contains several different types of sugar it is likely that sugar is a major ingredient, even if it isn't the first item on the list.

You should also avoid foods that contain hydrogenated oils. These oils have been processed to make them solid, or saturated, and like other saturated fats, they can raise blood cholesterol levels and increase the risk of heart disease.

In addition to nutrition labels and ingredients lists, foods may contain other nutrition claims, such as "fat-free," "low cholesterol," or "lite." The definition of these terms, as outlined by the U.S. Food and Drug Administration, are given in the following list.

Light (lite). May refer to calories, fat, or sodium. Contains a third fewer calories, or no more than half the fat of the higher-calorie, higher-fat version; or no more than half the sodium of the higher-sodium version.

Calorie-free. Contains fewer than 5 calories per serving.

Fat-free. Contains fewer than 0.5 gram of fat per serving.

Low-fat. Contains 3 grams of fat (or less) per serving.

Reduced or less fat. At least 25 percent less fat per serving than the higher-fat version.

Cholesterol-free. Contains fewer than 2 milligrams of cholesterol and 2 grams (or less) of saturated fat per serving.

Low cholesterol. Contains 20 milligrams (or less) of cholesterol and 2 grams (or less) of saturated fat per serving.

Reduced cholesterol. At least 25 percent less cholesterol than the higher-cholesterol version and 2 grams (or less) of saturated fat per serving.

Sodium-free. Contains fewer than 5 milligrams of sodium per serving and no sodium chloride in ingredients.

Very low sodium. Contains 35 milligrams (or less) of sodium per serving.

Low sodium. Contains 140 milligrams (or less) of sodium per serving.

Stocking Your Pantry

BASIC INGREDIENTS AND QUICK FOODS

Produce

yellow onions
red onions
garlic
red potatoes
russet potatoes
green cabbage

carrots, baby carrots
celery
prewashed salad mix
prewashed spinach
broccoli

kale or collard greens
apples
oranges
bananas

Grains and Grain Products

short-grain brown rice
long-grain brown rice
bulgur
whole wheat flour
whole wheat pastry flour

unbleached flour
potato flour
rice flour
barley flour
whole wheat couscous
rolled oats
polenta

cornmeal
eggless pasta
cold breakfast cereals without added fat or sugars
hot breakfast cereals

Dried Beans, Lentils, and Peas

pinto beans
black beans
lentils

split peas
black bean flakes: Fantastic Foods, Taste Adventure

pinto bean flakes: Fantastic Foods, Taste Adventure

Canned Foods

basic beans (pinto, garbanzo, kidney, black)
prepared beans (vegetarian chili, baked beans, refried beans)

tomato products (crushed tomatoes, tomato sauce, tomato paste)
vegetables (corn, beets, water-

packed roasted red peppers)
vegetarian soups
vegetarian pasta sauce (preferably fat-free)
salsa

Frozen Foods

unsweetened juice
concentrates
(apple, orange,
white grape)
frozen bananas

frozen berries
frozen vegetables
(corn, peas, Ital-
ian green beans,
broccoli)

chopped onions
frozen diced bell
peppers

Nuts, Seeds, and Dried Fruit

peanut butter

tahini (sesame
seed butter)

raisins

Breads, Crackers, and Snack Foods

whole grain bread
(may be frozen)
whole wheat pita
bread

corn tortillas (may
be frozen)
whole wheat
tortillas (may be
frozen)

fat-free snack
foods (crackers,
rice cakes,
popcorn cakes,
baked tortilla
chips, pretzels)

Convenience Foods

vegetarian soup
cups
vegetarian ramen
soups

silken tofu
vegetarian burgers,
cold cuts, hot
dogs

baked tofu
textured vegetable
protein

Condiments and Seasonings

herbs and spices
reduced-sodium
soy sauce
cider vinegar
balsamic vinegar
seasoned rice
vinegar
vegetable broth
vegetable oil spray

molasses
maple syrup
raw or turbinado
sugar
baking soda
low-sodium baking
powder (Feather-
weight)
spreadable fruit

fat-free salad
dressing
eggless mayon-
naise (Vegenaise,
Nayonaise)
stoneground
mustard
catsup

Beverages

fortified soy milk hot beverages
 or rice milk (herbal teas,
 Cafix, Postum,
 Pero)

Meal Preparation

With your menu and ingredients on hand, you will be able to prepare satisfying meals quickly and conveniently. You may wish to prepare several different menu items in a single cooking session as a further time-saver.

You will notice that most of the recipes in this book provide six to eight servings. As a result, you will probably have food left over that can be used to provide one or more extra meals. In this way the menu you create may actually provide meals for more than a week, with no additional shopping, planning, or cooking!

Another time-saver is to make slight modifications to the food you've already prepared so it has a different appearance the second or third time you serve it. In this way you can have maximum variety with minimum preparation. The Hummus recipe (see page 173) is a good example. Start out by preparing a double batch and serve it as a dip or as a sandwich filling as indicated in the recipe. For a second meal, add a bit more water, and serve it as a sauce for steamed red potatoes or broccoli. Or add even more water, or vegetable broth and a few chopped green onions, to turn it into a delicious soup.

Foods that take a bit of time to cook can be prepared in large enough quantities to provide for several meals. Brown rice is a good example. Once cooked, it can easily be reheated in a microwave or on the stovetop and served as a side dish with a variety of recipes. It also can be added to soups and stews, or used as a filling in a burrito or a wrap.

Diabetes can be a tiresome and complicated disease, but cooking doesn't have to be this way. Keeping things simple and planning ahead a bit will lessen your time in the kitchen and grocery store and maximize your time to exercise, spend time with family and friends, and take care of your health.

Cooking Techniques

Vegetables

The secret to preparing vegetables is to cook them only as much as is needed to tenderize them and bring out their best flavor. The following methods are quick and easy and enhance the flavor and texture of vegetables.

Steaming. A collapsible steamer rack can turn any pot into a vegetable steamer. Heat about 1 inch of water in a pot. Arrange the prepared vegetables in a single layer on a steamer rack and place them in the pot over the boiling water. Cover the pot with a lid and cook until just tender.

Braising. This technique is identical to sautéing, except that a fat-free liquid is used in place of oil. It is particularly useful for mellowing the flavor of vegetables such as onions and garlic. Heat approximately ½ cup of water, vegetable broth, or wine (the liquid you use will depend on the recipe) in a large pan or skillet. Add the vegetables and cook over high heat, stirring occasionally, adding small amounts of additional liquid if needed, until the vegetables are tender. This will take about five minutes for onions.

Grilling. High heat seals in the flavors of vegetables and adds its own distinctive flavor as well. Vegetables can be grilled on a barbecue or electric grill, or on the stove using a nonstick grill pan. Cut all the foods that will be grilled together into a uniform size. Preheat the grill, then add the vegetables. Cook over medium-high heat, turning occasionally with a spatula until uniformly browned and tender.

Roasting. A simple and delicious way to prepare vegetables is to roast them in a very hot oven (450°F). Toss the vegetables with seasonings and a small amount of olive oil if desired. Spread them in a single layer on a baking sheet and place them in the preheated oven until tender.

Microwave. A microwave oven provides an easy method for cooking vegetables, particularly those that take a long time to cook with other methods. Another benefit of microwave cooking for vegetables is that they cook quickly with little or no water, minimizing loss of nutrients. Try the recipes for potatoes, sweet potatoes, yams, and winter squash on page 197.

Grains

Whole grains are a mainstay of a healthy diet. The term "whole grain" refers to grains that have been minimally processed, leaving the bran and germ intact. As a result, whole grains provide significantly more nutrients, including protein, vitamins, and minerals, than refined grains. In addition, whole grains are an excellent source of fiber. Some fairly common whole grains include whole wheat berries, cracked wheat and bulgur, whole wheat flour, brown rice, rolled oats, whole barley, and barley flour. Some of the less common grains that are slowly making their way into the mainstream are quinoa ("keen-wah"), amaranth, kamut ("kam-oo"), and teff.

Grains should be stored in a cool, dry location. If the outer bran layer has been disturbed by crushing or grinding, as in making flour or rolled oats, the grain should be used within two to three months. Grains with the outer bran layer intact remain viable and nutritious for several years if properly stored.

When cooking grains, the following tips are useful.

- The easiest way to cook most grains is to simmer them, loosely covered, on the stovetop.
- Lightly roasting grains in a dry skillet before cooking enhances their nutty flavor and gives them a lighter texture. The flavor of millet is particularly enhanced by roasting.
- Grains should not be stirred during cooking, unless the recipe indicates otherwise. They will be lighter and fluffier if left alone.
- When cooking grains, make enough for several meals. Cooked grains can be reheated in a microwave or on the stovetop.
- An easy way to reheat grains on the stove is to place them in a vegetable steamer over boiling water.
- Fine-textured grains such as couscous and bulgur are actually fluffier when they are not cooked. Simply pour boiling water over the grain, then cover and let stand for fifteen to twenty minutes. Fluff the grain with a fork before serving.

Legumes

The term "legume" refers to dried beans and peas such as soybeans, black beans, pinto beans, garbanzos or chickpeas, lentils, and split peas. Legumes may be purchased dried, canned, and in some cases, frozen or dehydrated. Dried beans are inexpensive and easy to cook. If you don't have the time to cook dried beans, canned beans are a good alternative. Kidney beans, garbanzo beans, pinto beans, black beans, and many others are available, including some in low-sodium varieties. For an even quicker meal, vegetarian baked beans, chili beans, and refried beans are available in the canned-foods section of most supermarkets.

Recently a few companies have introduced precooked, dehydrated beans. These cook in about five minutes. Pinto beans, black beans, split peas, and lentils are some of the varieties available. Check your local natural food store for these.

Note the following tips for cooking dried beans.

- Sort through the beans, discard any debris, then rinse thoroughly.
- Soaking beans before cooking reduces their cooking time and increases their digestibility. Soak at least four hours, then pour off soak water and add fresh water for cooking.
- Cook in a large pot with plenty of water. Cover the pot loosely. Use medium-low heat to maintain a low simmer. Check occasionally, adding more water if needed.
- A Crock-Pot is an ideal place to cook beans. The slow, even heat ensures thorough cooking. Start with boiling water and use the highest setting for quickest cooking. For slower cooking, start with cold water and use the highest setting.
- Beans can be cooked very quickly in a pressure cooker. Follow the instructions that came with the cooker.
- Beans should be thoroughly cooked. They should smash easily when pressed between thumb and forefinger.
- Salt toughens the skins of beans and increases the cooking time. It should not be added until the beans are tender.
- Cooked beans may be frozen in airtight containers for later use.

COOKING DRIED BEANS AND PEAS

BEANS (1 CUP DRY)	AMOUNT OF WATER	COOKING TIME	YIELD
Adzuki beans	3 cups	1½ hours	2¼ cups
Black beans	3 cups	1½ hours	2¼ cups
Black-eyed peas	3 cups	1 hour	2 cups
Chickpeas (garbanzos)	4 cups	2–3 hours	2½ cups
Great Northern beans	3½ cups	2 hours	2 cups
Kidney beans	3 cups	2 hours	2 cups
Lentils	3 cups	1 hour	2¼ cups
Lima beans	2 cups	1½ hours	1½ cups
Navy beans	3 cups	2 hours	2 cups
Pinto beans	3 cups	2½ hours	2¼ cups
Red beans	3 cups	3 hours	2 cups
Soybeans	4 cups	3 hours	2½ cups
Split peas	3 cups	1 hour	2½ cups

Cutting Fat

Foods that are high in fat are also high in calories. In addition to causing unwanted weight gain, a high-fat diet increases your risk for heart disease, adult-onset diabetes, and several forms of cancer. By switching to a plant-based diet you will reduce your intake of fat considerably, as well as keep your blood sugar levels at a steady level. The following tips will help you reduce your fat intake even further.

- Choose cooking techniques that do not employ added fat. Baking, grilling, and oven roasting are great alternatives to frying.
- Another fat-cutting cooking trick is to sauté in a liquid such as water or vegetable broth whenever possible. Heat about ½ cup of water in a skillet (preferably nonstick) and add the

vegetables to be sautéed. Cook over high heat, stirring frequently, until the vegetables are tender. This will take about five minutes. Add a bit more water if necessary to prevent sticking.

- Add onions and garlic to soups and stews at the beginning of the cooking time so their flavors will mellow without sautéing.
- When oil is absolutely necessary to prevent sticking, lightly apply a vegetable oil spray. Another alternative is to start with a very small amount of oil (1 to 2 teaspoons), then add water or vegetable broth as needed to keep the food from sticking.
- Nonstick pots and pans allow foods to be prepared with little or no fat.
- Choose fat-free dressings for salads. In addition to commercially prepared dressings, seasoned rice vinegar makes a tasty fat-free dressing straight out of the bottle.
- Avoid deep-fried foods and fat-laden pastries. Check your market for low-fat and no-fat alternatives.
- Replace the oil in salad dressing recipes with seasoned rice vinegar, vegetable broth, bean cooking liquid, or water. For a thicker dressing, whisk in a small amount of potato flour.
- Sesame Seasoning (see page 181) is low in fat and delicious on grains, potatoes, and steamed vegetables. Fat-free salad dressing also may be used as a topping for cooked vegetables.
- Applesauce, mashed banana, prune puree, or canned pumpkin may be substituted for all or part of the fat in many baked goods.

Quick Meal and Snack Ideas

- Fresh soybeans (edamame) make a delicious snack or meal addition (find them in the freezer section of the grocery store and prepare according to package directions).
- For an instant green salad use prewashed salad mix and commercially prepared fat-free dressing. Add some canned kidney beans or garbanzo beans for a more substantial meal.
- Baby carrots make a convenient, healthy snack. Try them plain or with Hummus (see page 173).

- Ramen soup is quick and satisfying. Add some chopped, fresh vegetables for a heartier soup.
- Keep a selection of vegetarian soup cups on hand. These are great for quick meals, especially when you're traveling.
- Burritos are quick to make and very portable. They can be eaten hot or cold. For a simple burrito, spread fat-free refried beans on a flour tortilla, add prewashed salad mix and salsa, and roll it up.
- Mix fat-free refried beans with an equal amount of salsa for a delicious bean dip. Serve with baked tortilla chips or fresh vegetables.
- Simple Bean Tacos (see page 167) are quick and easy to make. Serve them with Carrot and Jicama Salad (see page 174).
- A wide variety of fat-free vegetarian cold cuts is available in many supermarkets and natural food stores. These make quick and easy sandwiches.
- Rice cakes and popcorn cakes make great snack foods. Spread them with Hummus (see page 173), apple butter, or spreadable fruit.
- Drain garbanzo beans and spoon onto a piece of pita bread. Top with prewashed salad mix and fat-free salad dressing for a quick pocket sandwich.
- Heat a fat-free vegetarian burger patty in the toaster oven. Serve it on a whole grain bun with mustard, ketchup or barbecue sauce, and lettuce. Add sliced red onion and tomato if desired.
- Keep baked or steamed potatoes in the refrigerator. For a quick meal, heat a potato in the microwave and top it with fat-free vegetarian chili or with Roasted Broccoli (see page 192) and salsa.
- Arrange chunks of fresh fruit on skewers for quick fruit kabobs.
- Frozen grapes make a refreshing summer snack. To prepare, remove them from the stems and freeze, loosely packed, in an airtight container.
- Frozen bananas make cool snacks or creamy desserts. Peel the bananas, break into chunks, and freeze in airtight containers.

14

Menus for a Week

DAY 1

Breakfast

 French Toast (page 156)

 Corn Butter (page 183)

 maple syrup or spreadable fruit

 fresh fruit

 herb tea

Lunch

 Spinach Turnovers (page 171)

 White Bean Salad (page 175)

Dinner

 Mexican Corn Pone (page 212)

 green salad

 melon or other fresh fruit

Day 2

Breakfast

 Polenta Scramble (page 157)

 whole grain toast with Pineapple Apricot Sauce (page 182)

 fresh fruit

 herb tea

Lunch

 Summer Stew (page 190)

 whole grain bread or roll

 green salad with fat-free dressing

Dinner

 Middle Eastern Lentils and Rice with Salad (page 203)

 Baked Bananas (page 220)

 cinnamon spice iced tea

Day 3

Breakfast

 Cornmeal Flapjacks (page 155)

 fresh fruit or spreadable fruit

 herb tea

Lunch

 Garbanzo Salad Sandwich (page 166)

 green salad with fat-free dressing

 fresh fruit

Dinner

 Veggieburger Patties (page 166)

 Mashed Potatoes (page 199)

 Roasted Broccoli (page 192)

 Summer Fruit Cobbler (page 217)

DAY 4

Breakfast

Double Bran Muffin (page 216)

fresh fruit

herb tea

Lunch

Garbanzo Cabbage Soup (page 187)

Garlic Bread (page 215)

green salad

Dinner

Yams with Cranberries and Apples (page 196)

Curried Cauliflower with Peas (page 200)

Cucumbers with Creamy Dill Dressing (page 173)

Fruit Gel (page 218)

DAY 5

Breakfast

Breakfast Teff (page 159), Multigrain Cereal (page 158), or
 other hot cereal

fortified soy milk or rice milk

fresh fruit

herb tea

Lunch

Zucchini Corn Fritters (page 201)

Aztec Salad (page 177)

watermelon

Dinner

Lasagna Roll-ups (page 205)

Ratatouille (page 199)

green salad with Balsamic Vinaigrette (page 179)

fresh fruit

Day 6

Breakfast

cold cereal

fortified soy milk or rice milk

fresh fruit

herb tea

Lunch

Ensalada de Frijoles (page 174)

warm corn tortillas

Tropical Freeze (page 222)

Dinner

Stuffed Portobello Mushrooms (page 210)

Couscous Confetti Salad (page 176)

Ginger Peachy Bread Pudding (page 220)

Day 7

Breakfast

Oatmeal Waffles (page 156)

fresh fruit

herb tea

Lunch

Rainbow Wrap (page 170)

Grilled Summer Vegetables (page 194)

Dinner

Spicy Thai Soup (page 188)

Chinese Bulgur (page 164)

Broccoli with Sesame Seasoning (page 201)

Gingerbread (page 217) with Pineapple Apricot Sauce
(page 182)

15

The Recipes

BREAKFASTS

Cornmeal Flapjacks
MAKES 16 3-INCH FLAPJACKS

Enjoy these sunny golden pancakes with fruit preserves, fresh fruit, or maple syrup.

1 cup fortified soy milk or rice milk	½ teaspoon sodium-free baking powder
2 tablespoons maple syrup	¼ teaspoon baking soda
1 tablespoon cider vinegar	¼ teaspoon salt
½ cup cornmeal	vegetable oil cooking spray
½ cup whole wheat pastry flour	

In a large bowl, mix milk, maple syrup, and vinegar. Set aside.

In a separate bowl stir together cornmeal, flour, baking powder, baking soda, and salt. Add to milk mixture, stirring just enough to remove any lumps and make a pourable batter. Add a bit more milk if batter seems too thick.

Preheat a nonstick skillet or griddle, then spray lightly with vegetable oil. Pour small amounts of batter onto the heated surface and cook until

tops bubble. Turn carefully with a spatula and cook the second sides until browned, about 1 minute. Serve immediately.

Per flapjack: 40 calories; 1 g protein; 8 g carbohydrate; 0.4 g fat;
1 g fiber; 55 mg sodium; calories from protein: 12%;
calories from carbohydrates: 78%; calories from fats: 10%

• • •

French Toast
MAKES 6 SLICES

This cholesterol-free French toast tastes great as it adds beneficial soy and whole wheat to your diet.

1 cup fortified soy milk (plain or vanilla)	1 teaspoon vanilla
	½ teaspoon cinnamon
¼ cup whole wheat pastry flour	6 slices whole grain bread
1 tablespoon maple syrup	vegetable oil cooking spray

Combine milk, flour, maple syrup, vanilla, and cinnamon in a blender. Blend until smooth, then pour into a flat dish.

Soak bread slices in batter until soft but not soggy. The amount of time this takes will vary depending on the bread used.

Cook in an oil-sprayed nonstick skillet over medium heat until first side is golden brown, about 3 minutes. Turn carefully with a spatula and cook second side until brown, about 3 minutes.

Per slice: 129 calories; 6 g protein; 23 g carbohydrate; 2 g fat; 4 g fiber;
191 mg sodium; calories from protein: 17%;
calories from carbohydrates: 68%; calories from fats: 15%

• • •

Oatmeal Waffles
MAKES 6 WAFFLES

These easily prepared waffles are a delicious way to add healthy oats to your diet.

2 cups rolled oats	1 teaspoon vanilla
2 cups water	vegetable oil cooking spray
1 banana	fresh fruit, spreadable fruit, or
¼ teaspoon salt	maple syrup for serving
1 tablespoon maple syrup	

Preheat waffle iron to medium-high.

Combine oats, water, banana, salt, maple syrup, and vanilla in a blender. Blend on high speed until completely smooth.

Lightly spray waffle iron with cooking spray. Pour in enough batter to just barely reach edges and cook until golden brown, 5 to 10 minutes. without lifting lid.

Note: The batter should be pourable. If it becomes too thick as it stands, add a bit more water to achieve desired consistency.

Serve with fresh fruit, spreadable fruit, or syrup.

Per waffle: 130 calories; 5 g protein; 25 g carbohydrate; 2 g fat;
3 g fiber; 90 mg sodium; calories from protein: 14%;
calories from carbohydrates: 74%; calories from fats: 12%

● ● ●

Polenta Scramble

MAKES ABOUT 6 1-CUP SERVINGS

This delicious golden scramble is also a good light dinner dish.

2 teaspoons olive oil
½ onion, chopped
10 mushrooms, sliced
½ red or green bell pepper, diced
1 teaspoon dried basil
½ teaspoon dried oregano

½ teaspoon dried thyme
½ teaspoon salt
¼ teaspoon black pepper
2 to 4 cups cooked, chilled Polenta
 (page 162)

Heat oil in a large nonstick skillet. Add onion, mushrooms, and bell pepper and cook over medium heat, stirring occasionally for 3 minutes.

Stir in basil, oregano, thyme, salt, and black pepper. Continue cooking until onion is soft, 3 to 5 minutes. Add a tablespoon or two of water if needed to prevent sticking.

Cut polenta into ½-inch cubes. Add to skillet and fold in gently with a spatula. Continue cooking until polenta is heated through, about 5 minutes.

Per 1-cup serving: 91 calories; 2 g protein; 16 g carbohydrate;
2 g fat; 2 g fiber; 180 mg sodium; calories from protein: 9%;
calories from carbohydrates: 72%; calories from fats: 19%

● ● ●

Multigrain Cereal

MAKES 2½ 1-CUP SERVINGS

Multigrain hot cereals provide great flavor as well as the nutritional benefits of several whole grains. A variety of multigrain cereal mixes are available in natural food stores and many supermarkets. One of the most delicious and most widely distributed is Bob's Red Mill 10 Grain Cereal (see Glossary). Use this method for cooking any of these hearty, satisfying breakfast cereals.

1 cup multigrain cereal mix 3 cups boiling water
½ teaspoon salt (optional)

Stir cereal and salt into boiling water in a saucepan. Cover loosely and simmer, stirring occasionally, for 7 minutes.

Remove from heat and let stand, covered, for 10 minutes before serving.

Health hint: By gradually reducing the amount of salt you add, you can re-educate your taste buds so that the cereal will taste fine with no salt at all.

Per 1-cup serving: 200 calories; 6 g protein; 40 g carbohydrate;
2 g fat; 4 g fiber; 10 to 580 mg sodium (depending on amount
of salt used in recipe); calories from protein: 13%;
calories from carbohydrates: 77%; calories from fats: 10%

● ● ●

Creamy Oatmeal

MAKES 3 1-CUP SERVINGS

You'll love this delicious, creamy oatmeal. The vanilla rice milk adds a bit of sweetness as well as creaminess.

1 cup quick-cooking rolled oats 2½ cups vanilla rice milk

Combine rolled oats and milk in an uncovered saucepan. Bring to a simmer and cook 1 minute. Cover pan, remove from heat, and let stand 3 minutes before serving.

Per 1-cup serving: 128 calories; 4 g protein; 24 g carbohydrate; 2 g fat;
2 g fiber; 112 mg sodium; calories from protein: 13%;
calories from carbohydrates: 75%; calories from fats: 12%

● ● ●

Whole Wheat Cereal

MAKES 2 TO 3 1-CUP SERVINGS

Whole wheat berries make a crunchy, flavorful breakfast cereal. They cook most quickly if they are presoaked, and of the many different varieties of wheat, spring wheat, (also called soft wheat or white wheat), is one of the quickest cooking. Look for it in natural food stores or your supermarket's bulk section.

1 cup spring wheat berries

Rinse wheat berries and soak overnight in 3 cups water.

In the morning, drain off soaking water and put wheat berries into a pan with 1 cup fresh water. Cover and simmer until tender, about 20 minutes.

Variation: For a different flavor, substitute whole oats or whole rye berries for the wheat.

Per 1-cup serving: 210 calories; 8 g protein; 46 g carbohydrate;
1 g fat; 8 g fiber; 0 mg sodium; calories from protein: 14%;
calories from carbohydrates: 82%; calories from fats: 4%

• • •

Breakfast Teff

MAKES 2 1-CUP SERVINGS

Teff, a staple grain in northern Africa for centuries, has recently become available in the United States. Perhaps the tiniest grain in the world, teff is extremely nutritious and makes a delicious breakfast cereal. Ask for teff at your favorite natural food store.

½ cup teff ¼ teaspoon salt (optional)
1½ cups water

Combine teff and water in a saucepan. Add salt if desired, and stir to mix. Cook over low heat, stirring occasionally, until thick, about 15 minutes. Serve with fortified soy milk or rice milk.

Per 1-cup serving: 200 calories; 8 g protein; 36 g carbohydrate;
2 g fat; 4 g fiber; 226 mg sodium; calories from protein: 13%;
calories from carbohydrates: 77%; calories from fats: 10%

• • •

Stewed Prunes

MAKES ABOUT 6 ½-CUP SERVINGS

Stewed prunes are simple to prepare and a delicious source of vitamins, minerals, and fiber. Enjoy them plain or with soy milk or rice milk.

2 cups dried prunes 2½ cups water

Combine prunes and water in a saucepan. Cover and simmer gently until prunes are soft, about 20 minutes. Serve hot or cold.

Per ½-cup serving: 85 calories; 1 g protein; 22 g carbohydrate;
0.1 g fat; 5 g fiber; 2 mg sodium; calories from protein: 4%;
calories from carbohydrates: 94%; calories from fats: 2%

GRAINS

Brown Rice

MAKES 3 1-CUP SERVINGS

Flavorful and satisfying, brown rice is an excellent source of protective soluble fiber. In the cooking method described below, the rice is toasted, then simmered in plenty of water (like pasta) to enhance its flavor and reduce cooking time.

1 cup short- or long-grain brown 4 cups boiling water
 rice ½ teaspoon salt

Rinse rice in cool water. Drain off as much water as possible.

Place rice in a saucepan over medium heat, stirring constantly until completely dry, 3 to 5 minutes.

Add boiling water and salt, then cover and simmer until rice is just tender, about 35 minutes. Pour off excess liquid (this can be saved and used as a broth for soups and stews if desired).

Per 1-cup serving: 228 calories; 5 g protein; 48 g carbohydrate;
2 g fat; 2 g fiber; 360 mg sodium; calories from protein: 9%;
calories from carbohydrates: 84%; calories from fats: 7%

● ● ●

Brown Rice and Barley

MAKES ABOUT 6 1-CUP SERVINGS

The addition of whole barley adds great texture to brown rice. Hulled barley, which is a bit less refined and slightly more nutritious than pearled barley, is sold in many natural food stores.

4 cups water	1 cup hulled or pearled barley
1 cup short-grain brown rice	1 teaspoon salt

Bring the water to a boil; add rice, barley, and salt. Reduce heat to a simmer, then cover and cook until grains are tender and all the water is absorbed, about 45 minutes.

Per 1-cup serving: 222 calories; 6 g protein; 46 g carbohydrate;
2 g fat; 6 g fiber; 362 mg sodium; calories from protein: 11%;
calories from carbohydrates: 81%; calories from fats: 8%

● ● ●

Bulgur

MAKES 2 1-CUP SERVINGS

Bulgur is made from whole wheat kernels that have been cracked and toasted, giving it a delicious, nutty flavor. It cooks quickly and may be served plain, or in a pilaf or salad. It is sold in natural food stores, and in some supermarkets, usually in the bulk food section.

1 cup uncooked bulgur	2 cups boiling water
½ teaspoon salt	

Mix bulgur and salt in a large bowl. Stir in boiling water. Cover and let stand until tender, about 25 minutes.

Alternate cooking method: Stir bulgur and salt into boiling water in a saucepan. Reduce heat to a simmer, then cover and cook without stirring until bulgur is tender, about 15 minutes.

Per 1-cup serving: 192 calories; 6 g protein; 42 g carbohydrate;
0.8 g fat; 10 g fiber; 436 mg sodium; calories from protein: 13%;
calories from carbohydrates: 84%; calories from fats: 3%

● ● ●

Whole Wheat Couscous
MAKES 3 1-CUP SERVINGS

Couscous is actually pasta that takes only minutes to prepare. It makes a delicious side dish or salad base. Whole wheat couscous, which contains fiber and more vitamins and minerals than refined couscous, is sold in natural food stores and some supermarkets.

1 cup whole wheat couscous	1½ cups boiling water
½ teaspoon salt	

Stir couscous and salt into boiling water in a saucepan. Remove from heat and cover. Let stand 10 to 15 minutes, then fluff with a fork and serve.

Per 1-cup serving: 200 calories; 6 g protein; 42 g carbohydrate;
0.2 g fat; 4 g fiber; 364 mg sodium; calories from protein: 14%;
calories from carbohydrates: 85%; calories from fats: 1%

● ● ●

Polenta
MAKES 4 1-CUP SERVINGS

Polenta, or coarsely ground cornmeal, is easy to prepare and tremendously versatile. When it is first cooked it is soft, like Cream of Wheat, and perfect for breakfast topped with fruit and fortified soy milk, or for dinner topped with vegetables and a savory sauce. When chilled, it becomes firm and sliceable, perfect for grilling or sautéing.

5 cups water	1 teaspoon thyme (optional)
1 cup polenta	1 teaspoon oregano (optional)
1 teaspoon salt	vegetable oil cooking spray

Measure water into a large pot, then whisk in polenta, salt, and herbs, if using.

Simmer over medium heat, stirring often, until very thick, about 25 minutes.

Serve hot or transfer to a 9-by-13-inch baking dish and chill until firm.

For grilled polenta, turn cold polenta out of the pan onto a cutting board and cut it with a sharp knife into ½-inch-thick slices. Lightly spray a large nonstick skillet with vegetable oil cooking spray and place it over medium-high heat. Arrange polenta slices in a single layer about 1 inch

apart and cook 5 minutes. Turn and cook second side 5 minutes. Repeat with remaining polenta.

Per 1-cup serving: 110 calories; 2 g protein; 23 g carbohydrate;
2 g fiber; 1 g fat; 592 mg sodium; calories from protein: 9%;
calories from carbohydrates: 82%; calories from fats: 9%

● ● ●

Quinoa

MAKES 3 1-CUP SERVINGS

Quinoa ("keen-wah") comes from the high plains of the Andes Mountains, where it is nicknamed "the mother grain" for its life-giving properties. The National Academy of Sciences has called quinoa "one of the best sources of protein in the vegetable kingdom," because of its excellent amino acid pattern. Quinoa cooks quickly, and as it cooks the germ unfolds like a little tail. It has a light, fluffy texture, and may be eaten plain, used as a pilaf, or as an addition to soups and stews. The dry grain is coated with a bitter-tasting substance called saponin, which repels insects and birds and protects it from ultraviolet radiation. Quinoa must be washed thoroughly before cooking to remove this bitter coating. The easiest way to wash it is to place it in a strainer and rinse it with cool water until the water runs clear.

1 cup quinoa 2 cups boiling water

Rinse quinoa thoroughly in a fine sieve, then add it to boiling water in a saucepan. Reduce to a simmer, then cover loosely and cook until quinoa is tender and fluffy, about 15 minutes.

Per 1-cup serving: 212 calories; 8 g protein; 40 g carbohydrate;
4 g fat; 4 g fiber; 12 mg sodium; calories from protein: 14%;
calories from carbohydrates: 72%; calories from fats: 14%

● ● ●

Risotto

MAKES ABOUT 3 1-CUP SERVINGS

Risotto is made with arborio rice, which is available in natural food stores and many supermarkets. The secret to making a wonderful, creamy risotto is adding the liquid in small amounts and stirring constantly.

4 to 5 cups heated Vegetable Broth 1 onion, finely chopped
 (page 184) 1 cup arborio rice

Place $\frac{1}{2}$ cup vegetable broth in a large pot. Add onion and cook over high heat, stirring often, until soft, about 5 minutes.

Add rice and $\frac{1}{2}$ cup vegetable broth, stirring constantly until the broth is completely absorbed. Continue adding broth, $\frac{1}{2}$ cup at a time, and stirring constantly, until rice is tender and all liquid is absorbed.

Per 1-cup serving: 306 calories; 4 g protein; 62 g carbohydrate;
2 g fat; 1 g fiber; 690 mg sodium; calories from protein: 7%;
calories from carbohydrates: 88%; calories from fats: 5%

• • •

Chinese Bulgur
MAKES ABOUT 3 1-CUP SERVINGS

This quick side dish is perfect with any vegetable stir-fry.

1 cup uncooked bulgur $\frac{1}{2}$ cup finely sliced green onions,
$\frac{1}{2}$ teaspoon salt including tops
$1\frac{3}{4}$ cups boiling water $\frac{1}{2}$ cup sliced water chestnuts
2 teaspoons toasted sesame oil $1\frac{1}{2}$ tablespoons reduced-sodium
1 tablespoon minced fresh ginger soy sauce
2 garlic cloves, minced $\frac{1}{8}$ teaspoon black pepper

Mix bulgur and salt in a bowl, then stir in boiling water. Cover and let stand until all water is absorbed, about 25 minutes.

Heat oil in a large nonstick skillet, then add ginger, garlic, and green onions. Cook 1 minute, stirring often.

Stir in water chestnuts, soaked bulgur, soy sauce, and black pepper. Cook, turning gently with a spatula, until hot, about 3 minutes.

Per 1-cup serving: 214 calories; 8 g protein; 40 g carbohydrate;
4 g fat; 10 g fiber; 620 mg sodium; calories from protein: 12%;
calories from carbohydrates: 73%; calories from fats: 15%

• • •

Basmati and Wild Rice Pilaf

MAKES ABOUT 6 1-CUP SERVINGS

Basmati and wild rice give great flavor and texture to this low-fat pilaf. The nuts can be left out to reduce the fat even further, if desired.

½ cup wild rice, rinsed
2½ cups Vegetable Broth
 (page 184)
½ cup brown basmati rice, rinsed
⅓ cup chopped pecans (optional)
¾ cup water
1 onion, finely chopped
2 garlic cloves, minced

2 cups thinly sliced mushrooms
 (about ½ pound)
2 stalks celery, thinly sliced
⅓ cup finely chopped parsley
½ teaspoon thyme
½ teaspoon marjoram
¼ teaspoon black pepper
¼ teaspoon salt

Combine wild rice and vegetable broth in a saucepan. Cover and simmer 20 minutes.

Add basmati rice, then cover and continue cooking over very low heat until tender, about 50 minutes.

Preheat oven to 375°F. Place pecans, if using, in a small ovenproof dish and bake until fragrant, about 8 minutes. Set aside, but leave oven on.

Heat ½ cup water in a large nonstick skillet and cook onion and garlic until all the water has evaporated. Add ¼ cup water, stirring to remove any browned bits of onion, and cook until the water has evaporated. Repeat until onions are browned, about 20 minutes.

Lower heat slightly and add mushrooms, celery, parsley, thyme, marjoram, black pepper, and salt. Cook, stirring frequently, for 5 minutes.

Add cooked rice and toasted pecans. Stir to mix, then transfer to a baking dish and bake 20 minutes.

Per 1-cup serving (with nuts): 190 calories; 6 g protein;
32 g carbohydrate; 6 g fat; 4 g fiber; 408 mg sodium;
calories from protein: 11%; calories from carbohydrates:
65%; calories from fats: 25%

Per 1-cup serving (without nuts): 150 calories; 4 g protein;
32 g carbohydrate; 2 g fat; 2 g fiber; 408 mg sodium;
calories from protein: 12%; calories from carbohydrates:
79%; calories from fats: 9%

SANDWICHES AND WRAPS

Garbanzo Salad Sandwich
MAKES 4 SANDWICHES

Garbanzo beans make a delicious and very nutritious sandwich filling.

1 15-ounce can garbanzo beans, drained
1 stalk celery, thinly sliced
1 green onion, finely chopped
2 tablespoons Tofu Mayo (page 180) or other vegan mayonnaise
1 tablespoon sweet pickle relish
8 slices whole wheat bread
4 lettuce leaves
4 tomato slices

Mash garbanzo beans with a fork or potato masher, leaving some chunks. Add sliced celery, chopped onion, Tofu Mayo, and pickle relish.

Spread on whole wheat bread and top with lettuce and sliced tomatoes.

Per sandwich: 268 calories; 12 g protein; 48 g carbohydrate;
4 g fat; 7 g fiber; 348 mg sodium; calories from protein: 17%;
calories from carbohydrates: 69%; calories from fats: 14%

• • •

Veggieburger Patties
MAKES 12 3-INCH PATTIES

Serve these patties with Mashed Potatoes (page 199) or on whole wheat buns with all the trimmings for a delicious and satisfying burger. For best results, all of the vegetables should be finely chopped. This is easily done with a food processor. The patties may be baked or cooked on the stovetop. Directions are given for both. Extra patties may be frozen, either before or after cooking, for later use.

⅓ cup uncooked bulgur wheat
⅔ cup boiling water
2 cups whole wheat bread crumbs
¼ cup finely chopped walnuts
1 small onion, finely chopped
1 celery stalk, finely chopped
1 small carrot, finely chopped
½ pound firm tofu
2 tablespoons barbecue sauce or ketchup
2 tablespoons reduced-sodium soy sauce
1 teaspoon stone-ground or Dijon mustard
⅛ teaspoon black pepper
⅛ teaspoon liquid smoke (optional)
vegetable oil cooking spray

Combine bulgur with boiling water in a small bowl. Cover and let stand until bulgur is soft and all the water is absorbed, about 20 minutes.

While bulgur softens, mix bread crumbs, walnuts, onion, celery, and carrot in a large bowl.

Preheat oven to 350°F.

Puree tofu in a food processor, or mash by hand until very smooth. Add to vegetable mixture along with barbecue sauce, soy sauce, mustard, black pepper, and liquid smoke, if using. Add softened bulgur, then stir or knead until mixture binds together, about 1 minute.

Form the mixture into patties, using about ⅓ cup of the mixture for each patty. Arrange on an oil-sprayed or nonstick baking sheet and bake 20 minutes. Flip and bake 15 minutes on second side.

Variation: To prepare on the stovetop, cook in an oil-sprayed nonstick skillet over medium heat until lightly browned, about 3 minutes on each side.

Per patty: 75 calories; 4 g protein; 10 g carbohydrate; 3 g fat;
2 g fiber; 169 mg sodium; calories from protein: 19%;
calories from carbohydrates: 48%; calories from fats: 33%

● ● ●

Simple Bean Tacos
MAKES 8 TACOS

These soft-shell tacos are a quick-and-easy snack or meal. Several companies make vegetarian refried beans. Look for them in natural food stores and many supermarkets.

1 15-ounce can vegetarian refried
 beans
8 corn tortillas
½ to 1 cup Salsa Fresca (page 180)
 or commercial salsa

2 cups prewashed salad mix
3 green onions, chopped
2 tomatoes, diced

Heat beans on the stove or in a microwave.

Spread a tortilla with about ¼ cup of beans, and lay it flat in an ungreased skillet over medium heat. When tortilla is warm and pliable, fold it in half and cook each side 1 minute. Garnish with salsa, salad mix, green onions, and tomatoes.

Per taco: 139 calories; 6 g protein; 27 g carbohydrate; 2 g fat;
5 g fiber; 368 mg sodium; calories from protein: 16%;
calories from carbohydrates: 75%; calories from fats: 9%

Meatlike Sandwiches, Burgers, and Hot Dogs

A wide variety of meatless cold cuts, burgers, and hot dogs are sold in natural food stores and most supermarkets. A sampling of these products is shown below. Check the deli case as well as the freezer section for these products and others. Be sure to read the ingredient list to determine that there are no animal ingredients, such as eggs, egg whites, cheese, whey, or casein. Check the nutritional information as well to determine the amounts of fat and sodium.

MEATLESS COLD CUTS AND DELI SLICES

Smart Bacon (Lightlife Foods)
Foney Baloney (Lightlife Foods)
Smart Deli Turkey (Lightlife Foods)
Smart Deli Bologna (Lightlife Foods)
Smart Deli Ham (Lightlife Foods)
Soylami (Lightlife Foods)
Pepperoni (Lightlife Foods)
Lean Links Sausage (Lightlife Foods)
Veggie Bologna Slices (Yves Fine Foods)
Veggie Pizza Pepperoni Slices (Yves Fine Foods)
Veggie Ham Slices (Yves Fine Foods)
Veggie Turkey Slices (Yves Fine Foods)
Veggie Salami Slices (Yves Fine Foods)

MEATLESS BURGERS

Veggie Cuisine Burger (Yves Fine Foods)
Veggie Burger Burgers (Yves Fine Foods)
Garden Vegetable Patties (Yves Fine Foods)
Black Bean and Mushroom Burgers (Yves Fine Foods)
Veggie Chick'n Burger (Yves Fine Foods)
LightBurgers (Lightlife Foods)
Prime Burger (White Wave Inc.)
Green Giant Harvest Burger (Pillsbury Company)
Vegan Original Boca Burger (Boca Burger Company)
Superburgers (Turtle Island Foods)
Natural Touch Vegan Burger (Worthington Foods)
Garden Vegan Burger (Wholesome and Hearty Foods)

Gardenburger Hamburger Style (Wholesome and Hearty Foods)
Amy's California Veggie Burger (Amy's Kitchen)
Amy's All American Burger (Amy's Kitchen)
Soy Deli All Natural Tofu Burger (Qwong Hop & Company)

Meatless Hot Dogs

Veggie Dogs (Yves Fine Foods)
Jumbo Veggie Dogs (Yves Fine Foods)
Hot & Spicy Jumbo Veggie Dogs (Yves Fine Foods)
Good Dogs (Yves Fine Foods)
Tofu Dogs (Yves Fine Foods)
Smart Dogs (Lightlife Foods)
Wild Dogs (Wildwood Natural Foods)

Other Meatless Products

Smart Ground (Lightlife Foods)
Veggie Ground Round Original (Yves Fine Foods)
Veggie Ground Round Italian (Yves Fine Foods)
Veggie Breakfast Links (Yves Fine Foods)
Canadian Veggie Bacon (Yves Fine Foods)
Veggie Breakfast Patties (Yves Fine Foods)
Chiken Chunks (Harvest Direct)
Chiken Breasts (Harvest Direct)
Tofurky Deli Slices (Turtle Island Foods)
Tofurky Jerky (Turtle Island Foods)
Not Chicken Deli Slices (United Specialty Foods)
White Wave Sandwich Slices (White Wave Foods)

• • •

Black Bean Burritos
Makes 4 burritos

Black bean burritos are a quick meal when time is short. Or they can be made ahead, wrapped in plastic wrap, and refrigerated for lunches and easy instant snacks. Instant black bean flakes are sold in natural food stores and some supermarkets (see Glossary).

1 cup instant black bean flakes or
 1 15-ounce can fat-free refried
 black beans
1 cup boiling water
4 flour tortillas
2 cups shredded romaine lettuce

2 tomatoes, sliced
2 green onions, sliced
½ avocado, sliced (optional)
½ cup Salsa Fresca (page 180) or
 commercial salsa

Mix bean flakes with boiling water in a small pan or bowl. Let stand until completely softened, 3 to 5 minutes. If using canned beans, drain liquid and heat on the stove or in a microwave.

Warm tortillas, one at a time, in a large dry skillet, flipping to warm both sides until soft and pliable.

Spread warm tortilla with approximately ½ cup of beans.

Top with lettuce, tomatoes, onions, avocado (if using), and salsa. Roll tortilla around filling.

Per burrito: 233 calories; 10 g protein; 36 g carbohydrate;
7 g fat; 8 g fiber; 510 mg sodium; calories from protein: 16%;
calories from carbohydrates: 58%; calories from fats: 26%

• • •

Rainbow Wrap

MAKES 2 LARGE WRAPS (4 SERVINGS)

These colorful wraps may be made in advance for a convenient snack or take-along meal.

4 cups shredded romaine lettuce
2 cups finely shredded red
 cabbage
1 celery stalk, thinly sliced
1 large carrot, grated or julienned
1 to 2 cups alfalfa sprouts or mixed
 sprouts, rinsed
1 15-ounce can garbanzo beans,
 drained

2 tablespoons tahini (sesame
 butter)
2 tablespoons seasoned rice
 vinegar
1 tablespoon white miso
1 teaspoon toasted sesame oil
1 garlic clove, peeled
2 large flour tortillas

Prepare all vegetables as directed. Set aside.

Place drained garbanzo beans in a food processor with tahini, vinegar, miso, oil, and garlic. Process until completely smooth, 1 to 2 minutes.

Warm tortillas in a dry skillet or microwave. Spread each evenly with half the garbanzo mixture. Divide lettuce between the two tortillas, then arrange parallel rows of cabbage, celery, carrot, and sprouts on each. Fold in 1 inch on the top and bottom of each tortilla, then roll sides snugly around the filling. Cut in half to serve.

Per $\frac{1}{2}$ wrap: 330 calories; 15 g protein; 49 g carbohydrate;
9 g fat; 9 g fiber; 552 mg sodium; calories from protein: 17%;
calories from carbohydrates: 57%; calories from fats: 26%

• • •

Spinach Turnovers

MAKES 16 TURNOVERS

These turnovers are surprisingly quick and easy to prepare using frozen spinach and whole wheat tortillas.

3 10-ounce packages frozen chopped spinach, thawed	$\frac{3}{4}$ teaspoon salt
$\frac{1}{4}$ cup water	$\frac{1}{2}$ teaspoon black pepper
1 onion, finely chopped	$\frac{1}{4}$ cup lemon juice
$\frac{1}{4}$ cup chopped fresh parsley	8 large flour tortillas
$1\frac{1}{2}$ teaspoons dill	1 tablespoon olive oil for brushing

Squeeze as much water as possible from thawed spinach and set aside.

Heat $\frac{1}{4}$ cup water in a large skillet, then add onion and cook until soft, about 5 minutes.

Stir in parsley, dill, salt, pepper, and spinach. Cook over medium heat, stirring often, until very dry. Stir in lemon juice.

Preheat oven to 375 °F.

To assemble, cut a tortilla in half and moisten edges with water, using your fingers or a pastry brush. Place about 2 tablespoons of filling in the center of each half, then fold it in thirds, matching curves to make a triangular shape. Press edges firmly to seal. Brush or spray lightly with olive oil. Place on a baking sheet and bake until lightly browned, about 25 minutes.

Per turnover: 72 calories; 3 g protein; 12 g carbohydrate; 2 g fat;
2 g fiber; 198 mg sodium; calories from protein: 16%;
calories from carbohydrates: 61%; calories from fats: 23%

• • •

Falafel Sandwiches

MAKES 12 SANDWICHES

These pita pocket sandwiches get their flavor from Middle Eastern cuisine. They are surprisingly flavorful and hearty—perfect for a summer lunch or dinner.

1 russet potato, peeled and diced
1 15-ounce can garbanzo beans, drained
1 small onion, finely chopped
½ cup finely chopped fresh parsley
2 garlic cloves, minced
1 tablespoon tahini (sesame butter)
2 teaspoons lemon juice
½ teaspoon turmeric
½ teaspoon coriander

1 teaspoon cumin
⅛ teaspoon cayenne
6 pieces whole wheat pita bread
vegetable oil cooking spray

Garnishes:
shredded romaine lettuce
cucumber slices
tomato wedges
sliced green onions
Cucumber Sauce (page 182)

Steam potato until soft.

Transfer to a bowl and add drained garbanzo beans. Mash thoroughly.

Add onion, parsley, garlic, tahini, lemon juice, turmeric, coriander, cumin, and cayenne. Mix well.

Preheat oven to 350°F. Wrap pita breads in a sheet of foil and place in oven to warm.

Roll garbanzo mixture into balls about the size of walnuts, then flatten each ball into a patty (you should have about 24 patties). Place on an oil-sprayed baking sheet and bake 15 minutes. Turn and bake second side 15 minutes.

Cut each piece of pita bread in half and stuff with two falafel patties. Garnish with lettuce, cucumber, tomato, and green onions. Top with Cucumber Sauce.

Per sandwich: 137 calories; 5 g protein; 26 g carbohydrate;
2 g fat; 4 g fiber; 171 mg sodium; calories from protein: 15%;
calories from carbohydrates: 72%; calories from fats: 13%

● ● ●

Hummus

MAKES 2 CUPS

This creamy garbanzo spread can be used as a sandwich filling or served as a dip with fresh vegetables or wedges of pita bread.

2 garlic cloves	2 tablespoons lemon juice
1 tablespoon fresh parsley	¼ teaspoon cumin
1 15-ounce can garbanzo beans	¼ teaspoon salt
3 tablespoons tahini (sesame butter)	¼ teaspoon paprika

Place garlic and parsley in a food processor and chop finely.

Drain beans, reserving liquid. Add beans to the food processor along with tahini, lemon juice, cumin, salt, and paprika. Process until very smooth, about 2 minutes. The mixture should be moist and spreadable. If it is too dry, add some of the reserved bean liquid to achieve desired consistency.

Per ¼ cup: 95 calories; 4 g protein; 11 g carbohydrate;
4 g fat; 2 g fiber; 136 mg sodium; calories from protein: 17%;
calories from carbohydrates: 46%; calories from fats: 37%

SALADS

Cucumbers with Creamy Dill Dressing

MAKES 4 1-CUP SERVINGS

Silken tofu makes a delicious, creamy dressing for this cool salad.

1 12.3-ounce package Mori-Nu Lite Silken Tofu (firm or extra firm)	2 tablespoons lemon juice
1 teaspoon garlic granules or powder	3 tablespoons seasoned rice vinegar
½ teaspoon dill weed	1 tablespoon cider vinegar
¼ teaspoon salt	2 cucumbers, peeled and thinly sliced
	¼ cup thinly sliced red onion

Place tofu, garlic granules, dill weed, salt, lemon juice, and vinegars in a food processor and puree until completely smooth, 2 to 3 minutes.

Place cucumbers and onion in a salad bowl. Add dressing and toss to mix. Chill 1 hour or more before serving.

Per 1-cup serving: 76 calories; 6 g protein; 12 g carbohydrate;
2 g fat; 2 g fiber; 586 mg sodium; calories from protein: 30%;
calories from carbohydrates: 57%; calories from fats: 13%

• • •

Carrot and Jicama Salad
MAKES ABOUT 10 ½-CUP SERVINGS

This colorful, crunchy salad is perfect with Mexican food or any other spicy cuisine. It may be made in advance, as it keeps well.

1 large carrot, peeled and cut into ¼-inch rounds	2 tablespoons finely chopped cilantro (optional)
1 medium jicama, peeled and diced (about 2 cups)	3 tablespoons seasoned rice vinegar
1 red bell pepper, seeded and diced	3 tablespoons lemon juice
½ small red onion, thinly sliced (about ½ cup)	2 tablespoons Sesame Seasoning (page 181)

Combine carrot, jicama, bell pepper, onion, and cilantro (if using) in a salad bowl.

Combine vinegar, lemon juice, and Sesame Seasoning. Add to salad and toss to mix.

Per ½-cup serving: 51 calories; 3 g protein; 8 g carbohydrate;
1 g fat; 2 g fiber; 209 mg sodium; calories from protein: 21%;
calories from carbohydrates: 56%; calories from fats: 23%

• • •

Ensalada de Frijoles
SERVES 4 AS A COMPLETE MEAL

This salad includes grains, beans, and vegetables and makes an easy meal, especially if you use prewashed salad mix. Jicama ("hick-ama") is a crispy root vegetable that is available in most markets.

3 cups cooked Brown Rice
 (page 160)
8 cups prewashed salad mix
2 carrots, grated or cut into
 julienne strips
1 15-ounce can black beans,
 drained and rinsed
1 small jicama (about 1 cup grated
 or julienned)
2 tomatoes, diced or cut into
 wedges

1 15-ounce can corn, drained
 (or 2 cups frozen)
½ cup coarsely chopped cilantro
 leaves (optional)
½ avocado, sliced (optional)
¼ cup your favorite salsa
¼ cup seasoned rice vinegar
1 garlic clove, pressed or minced
additional salsa for topping

Divide rice among four dinner plates and spread evenly. Top each plate with layers of salad mix, carrots, black beans, jicama, tomatoes, corn, cilantro, and avocado, if using.

Mix salsa, seasoned rice vinegar, and garlic. Sprinkle over each of the salads, then top with generous spoonfuls of salsa.

Variation: Substitute warmed corn tortillas (about 2 per plate) for the brown rice.

Variation: Good Seasons Fat-Free Italian Dressing is a nice alternative dressing on this salad. I like to mix it with a bit of salsa before adding it to the salad.

> Per serving with avocado (¼ of recipe): 415 calories;
> 16 g protein; 79 g carbohydrate; 7 g fat; 17 g fiber;
> 555 mg sodium; calories from protein: 14%;
> calories from carbohydrates: 72%; calories from fats: 14%

> Per serving without avocado (¼ of recipe): 374 calories;
> 15 g protein; 77 g carbohydrate; 3 g fat; 16 g fiber;
> 553 mg sodium; calories from protein: 15%;
> calories from carbohydrates: 78%; calories from fats: 7%

● ● ●

White Bean Salad
MAKES 5 ½-CUP SERVINGS

You'll love the tangy flavor of this super-easy salad.

1 15-ounce can white beans,
 drained and rinsed
1 small red bell pepper, diced
½ cup finely chopped fresh parsley
juice of 1 lemon

2 teaspoons balsamic vinegar
¼ teaspoon garlic granules or
 powder
¼ teaspoon black pepper

Combine all ingredients in a large bowl and toss to mix. Let stand 10 to 15 minutes before serving.

Per ½-cup serving: 96 calories; 7 g protein; 18 g carbohydrate; 0.3 g fat; 4.5 g fiber; 180 mg sodium; calories from protein: 26%; calories from carbohydrates: 71%; calories from fats: 3%

● ● ●

Hoppin' John Salad

MAKES ABOUT 5 1-CUP SERVINGS

The down-home goodness of black-eyed peas combined with flavorful brown rice makes a hearty, delicious salad. The recipe calls for canned black-eyed peas, but you can also cook your own or use frozen ones that have been cooked according to package directions.

1 15-ounce can black-eyed peas, drained	2 tablespoons finely chopped fresh parsley
1½ cups cooked Brown Rice (page 160)	¼ cup lemon juice
3 green onions, chopped	1 tablespoon olive oil
1 celery stalk, thinly sliced	¼ teaspoon salt
1 tomato, diced	1 or 2 garlic cloves, pressed

Combine black-eyed peas, brown rice, green onions, celery, tomato, and parsley in a salad bowl.

Mix lemon juice, olive oil, salt, and garlic. Pour over salad and toss to mix. Chill 1 to 2 hours before serving if time permits.

Per 1-cup serving: 170 calories; 4 g protein; 30 g carbohydrate; 4 g fat; 6 g fiber; 120 mg sodium; calories from protein: 9%; calories from carbohydrates: 72%; calories from fats: 19%

● ● ●

Couscous Confetti Salad

MAKES ABOUT 8 1-CUP SERVINGS

Couscous is pasta from northern Africa that cooks almost instantly and makes a beautiful and flavorful salad. Whole wheat couscous is sold in natural food stores and some supermarkets.

1½ cups whole wheat couscous
2 cups boiling water
3 or 4 green onions, finely chopped, including tops
1 red bell pepper, seeded and finely diced
1 carrot, grated
1 to 2 cups finely shredded red cabbage

½ cup finely chopped parsley
½ cup golden raisins or chopped dried apricots
juice of 1 lemon
¼ cup seasoned rice vinegar
1 tablespoon olive oil
1 teaspoon curry powder
½ teaspoon salt

In a large bowl, combine couscous and boiling water. Stir to mix, then cover and let stand until all the water has been absorbed, 5 to 10 minutes. Fluff with a fork.

Add onions, bell pepper, carrot, cabbage, parsley, and raisins.

In a small bowl mix lemon juice, vinegar, oil, curry powder, and salt. Add to salad and toss to mix. Serve at room temperature or chilled.

Per 1-cup serving: 152 calories; 4 g protein; 30 g carbohydrate; 2 g fat; 2 g fiber; 412 mg sodium; calories from protein: 9%; calories from carbohydrates: 79%; calories from fats: 12%

● ● ●

Aztec Salad

MAKES 8 1-CUP SERVINGS

This delicious salad is also a visual feast. It may be made in advance, and keeps well for several days.

2 15-ounce cans black beans, drained and rinsed
½ cup finely chopped red onion
1 green bell pepper, seeded and diced
1 red or yellow bell pepper, seeded and diced
1 15-ounce can corn kernels, drained or 1 10-ounce bag frozen corn, thawed
2 tomatoes, diced
¾ cup chopped fresh cilantro (optional)

2 tablespoons seasoned rice vinegar
2 tablespoons distilled vinegar or apple cider
juice of 1 lemon or lime
2 garlic cloves, pressed or finely minced
2 teaspoons ground cumin
1 teaspoon coriander
½ teaspoon red pepper flakes or a pinch of cayenne

In a large bowl, combine beans, onion, bell peppers, corn, tomatoes, and cilantro.

In a small bowl, whisk together vinegars, lemon juice, garlic, cumin, coriander, and red pepper flakes. Pour over salad and toss gently to mix.

Per 1-cup serving: 140 calories; 8 g protein; 28 g carbohydrate; 1.4 g fat; 8 g fiber; 470 mg sodium; calories from protein: 20%; calories from carbohydrates: 71%; calories from fats: 9%

● ● ●

Red Cabbage Salad
MAKES 12 ½-CUP SERVINGS

This salad may be served warm or cold. It is delicious with buckwheat groats or kasha.

1 small head red cabbage	¼ cup apple juice concentrate
1 red onion	1 teaspoon thyme
2 teaspoons toasted sesame oil	½ teaspoon salt
1 garlic clove, minced	1 apple, grated
¼ cup balsamic vinegar	2 tablespoons Sesame Salt (page
¼ cup raspberry vinegar (or addi-	181)
tional balsamic vinegar)	

Cut cabbage in half, then into very thin slices. You should have about 6 cups.

Peel onion and cut it in half from top to bottom, then slice each half into thin crescents.

Heat sesame oil in a large nonstick skillet. Add onion and garlic. Cook 3 minutes.

Add sliced cabbage along with the vinegars, apple juice concentrate, thyme, and salt. Continue cooking over high heat, stirring fairly constantly until cabbage begins to soften and turns bright pink, 3 to 5 minutes.

Stir in grated apple and Sesame Salt. Serve warm or chill and serve cold.

Per ½-cup serving: 82 calories; 1 g protein; 17 g carbohydrate; 2 g fat; 2 g fiber; 192 mg sodium; calories from protein: 6%; calories from carbohydrates: 76%; calories from fats: 18%

DIPS, DRESSINGS, AND SAUCES

Simple Vinaigrette
MAKES ½ CUP

Seasoned rice vinegar makes a delicious salad dressing all by itself, or enhanced with mustard and garlic.

½ cup seasoned rice vinegar
1 to 2 teaspoons stone-ground or
 Dijon mustard

1 garlic clove, pressed

Whisk all ingredients together. Use as a dressing for salads and for steamed vegetables.

Per 1 tablespoon: 27 calories; 0.1 g protein; 6 g carbohydrate;
0.1 g fat; 0 g fiber; 562 mg sodium; calories from protein: 2%;
calories from carbohydrates: 94%; calories from fats: 4%

• • •

Balsamic Vinaigrette
MAKES ¼ CUP

The mellow flavor of balsamic vinegar is delicious on salads.

2 tablespoons balsamic vinegar
2 tablespoons seasoned rice
 vinegar

1 tablespoon ketchup
1 teaspoon stone-ground mustard
1 garlic clove, pressed

Whisk vinegars, ketchup, mustard, and garlic together.

Per 1 tablespoon: 20 calories; 0.1 g protein; 4.5 g carbohydrate;
0.08 g fat; 0.05 g fiber; 229 mg sodium; calories from protein: 3%;
calories from carbohydrates: 93%; calories from fats: 4 %

• • •

Tofu Mayo

MAKES ABOUT 1½ CUPS

Use this low-fat mayonnaise substitute on sandwiches and salads.

1 12.3-ounce package Mori-Nu
 Lite Silken Tofu (firm or extra
 firm)
¾ teaspoon salt
½ teaspoon sugar

1 teaspoon Dijon mustard
1½ tablespoons lemon juice
1½ tablespoons seasoned rice
 vinegar

Combine tofu, salt, sugar, mustard, lemon juice, and vinegar in a food processor or blender, and process until completely smooth, 1 to 2 minutes. Chill thoroughly before using.

Per 1 tablespoon: 6 calories; 1 g protein; 0.4 g carbohydrate;
0.1 g fat; 0 g fiber; 93 mg sodium; calories from protein: 48%;
calories from carbohydrates: 29%; calories from fats: 23%

• • •

Salsa Fresca

MAKES ABOUT 6 CUPS

This fresh and chunky salsa is quite mild. For a hotter salsa, increase the jalapeños or red pepper flakes.

4 large ripe tomatoes, chopped
 (about 4 cups)
1 small onion, finely chopped
1 bell pepper, finely chopped
1 jalapeño pepper, seeded and
 finely chopped or 1 teaspoon red
 pepper flakes

4 garlic cloves, minced
1 cup chopped cilantro leaves
1 15-ounce can tomato sauce
2 tablespoons cider vinegar
1½ teaspoons cumin

Combine all ingredients in a mixing bowl. Stir to mix. Let stand 1 hour before serving.

Note: Salsa will keep in the refrigerator for about 2 weeks. It also freezes well.

Per 1 tablespoon: 4 calories; 0.1 g protein; 1 g carbohydrate;
0.03 g fat; 0.2 g fiber; 27 mg sodium; calories from protein: 14%;
calories from carbohydrates: 79%; calories from fats: 7%

• • •

Sesame Salt
MAKES ½ CUP

Sesame Salt is a delicious alternative to butter or margarine on cooked grains, baked potatoes, or steamed vegetables. Unhulled sesame seeds (sometimes called "brown sesame seeds") are sold in natural food stores and some supermarkets.

½ cup unhulled sesame seeds ½ teaspoon salt

Toast sesame seeds in a dry skillet over medium heat, stirring constantly until they begin to pop and brown slightly, about 5 minutes. Transfer to a blender. Add salt and grind into a uniform powder. Transfer to an airtight container. Store in refrigerator.

Per 1 tablespoon: 52 calories; 2 g protein; 2 g carbohydrate;
4 g fat; 1 g fiber; 134 mg sodium; calories from protein: 12%;
calories from carbohydrates: 15%; calories from fats: 73%

● ● ●

Sesame Seasoning
MAKES ½ CUP

Sesame Seasoning is delicious with steamed vegetables, cooked grains, and legumes. Unhulled sesame seeds are light brown in color and are sold in natural food stores and some supermarkets.

½ cup unhulled sesame seeds 2 tablespoons nutritional yeast
½ teaspoon salt

Toast sesame seeds in a dry skillet over medium heat. Stir constantly until seeds begin to pop and brown slightly, about 5 minutes.

Transfer to a blender, add salt and nutritional yeast and grind into a fine powder.

Transfer to an airtight container. Store in refrigerator.

Per 1 tablespoon: 57 calories; 2 g protein; 3 g carbohydrate;
4 g fat; 1 g fiber; 137 mg sodium; calories from protein: 15%;
calories from carbohydrates: 19%; calories from fats: 66%

● ● ●

Cucumber Sauce

MAKES ABOUT 1½ CUPS

Serve this cool creamy sauce with Falafel Sandwiches (page 172) or any other spicy foods.

1 medium cucumber, peeled
1 12.3-ounce package Mori-Nu Lite Silken Tofu, firm or extra firm
2 tablespoons lemon juice

2 garlic cloves, pressed
¼ teaspoon salt
¼ teaspoon coriander
¼ teaspoon cumin

Cut cucumber in half, scoop out seeds, and cut into chunks.

Place cucumber, tofu, lemon juice, garlic, salt, and spices in food processor and puree until completely smooth, about 3 minutes.

Per 1 tablespoon: 8 calories; 1 g protein; 0.2 g carbohydrate;
0.4 g fat; 0.2 g fiber; 23 mg sodium; calories from protein: 35%;
calories from carbohydrates: 21%; calories from fats: 44%

• • •

Pineapple Apricot Sauce

MAKES ABOUT 3 CUPS

Use this sauce as a spread on toast or as a topping for cake. It is delicious with Quick and Easy Brown Bread (page 215). It is thickened with agar, a sea vegetable thickener that is sold in natural food stores and Asian markets.

1 cup apple juice concentrate
1½ teaspoons agar powder
1 cup water
1 cup chopped apricots, fresh, frozen, or canned

1 8-ounce can crushed pineapple, packed in pineapple juice
¼ teaspoon ginger

Combine apple juice and agar with the water in a saucepan. Let stand 5 minutes. Bring to a simmer, stirring occasionally, and cook 3 minutes.

Add apricots, pineapple with its juice, and ginger. Stir to mix. Remove from heat and chill thoroughly, 3 to 4 hours.

Per 1 tablespoon: 13 calories; 0.08 g protein; 3 g carbohydrate;
0 .05 g fat; 0.1 g fiber; 2 mg sodium; calories from protein: 3%;
calories from carbohydrates: 94%; calories from fats: 3%

• • •

Corn Butter

MAKES ABOUT 2 CUPS

This creamy yellow spread is a low-fat alternative to margarine. Emes Jel and agar powder are thickening agents that are sold in natural food stores.

¼ cup cornmeal
2 teaspoons Emes Jel (see Glossary) or 1½ teaspoons agar powder
1 cup boiling water
2 tablespoons raw cashews

½ teaspoon salt
2 teaspoons lemon juice
1 tablespoon finely grated raw carrot
1 teaspoon nutritional yeast (optional)

Combine cornmeal with 1 cup water in a small saucepan. Simmer, stirring frequently, until very thick, about 10 minutes. Set aside.

Combine Emes Jel or agar powder with ¼ cup cold water in a blender. Let stand at least 3 minutes. Add the boiling water and blend to mix. Add cooked cornmeal, cashews, salt, lemon juice, grated carrot, and yeast, if using. Cover and blend until totally smooth (this is essential and will take several minutes). Transfer to a covered container and chill until thickened, 2 to 3 hours.

Per 1 tablespoon: 7 calories; 0.2 g protein; 1 g carbohydrate;
0.2 g fat; 0.1 g fiber; 34 mg sodium; calories from protein: 11%;
calories from carbohydrates: 57%; calories from fats: 32%

● ● ●

Brown Gravy

MAKES ABOUT 2 CUPS

This traditional-tasting gravy is low in fat and delicious on potatoes, rice, or vegetables.

2 cups water or vegetable broth
1 tablespoon cashews
1 tablespoon onion powder
½ teaspoon garlic granules or powder

2 tablespoons cornstarch
3 tablespoons reduced-sodium soy sauce

Combine all ingredients in blender container. Blend until completely smooth, 2 to 3 minutes.

Transfer to a saucepan and cook over medium heat, stirring constantly, until thickened.

Per ¼-cup serving: 23 calories; 1 g protein; 4 g carbohydrate;
0.5 g fat; 0.1 g fiber; 190 mg sodium; calories from protein: 15%;
calories from carbohydrates: 65%; calories from fats: 20%

• • •

Peanut Sauce
Makes ½ cup

Peanut sauce is delicious on cooked vegetables and grains. Be aware that it is high in fat and sodium and should be used sparingly.

¼ cup peanut butter
1 tablespoon seasoned rice vinegar
1 tablespoon reduced-sodium soy sauce
1 teaspoon sugar or other sweetener

¾ teaspoon powdered ginger
¼ teaspoon cayenne
¼ cup water

Whisk all ingredients together. Sauce should be thick but pourable. If it is too thick, add water, a teaspoon at a time, until desired consistency is reached.

Per 1 tablespoon: 54 calories; 2 g protein; 3 g carbohydrate;
4 g fat; 0.5 g fiber; 131 mg sodium; calories from protein: 15%;
calories from carbohydrates: 22%; calories from fats: 63%

SOUPS AND STEWS

Vegetable Broth
Makes about 2 quarts

A steamy cup of this broth makes a warm and comforting meal. It may also be used as an ingredient in recipes that call for broth or stock.

1 onion, chopped
1 carrot, chopped
1 celery stalk, chopped
¼ cup chopped fresh parsley
6 cups water
2 teaspoons onion powder
½ teaspoon thyme

¼ teaspoon turmeric
¼ teaspoon garlic powder
¼ teaspoon marjoram
½ teaspoon salt
1 15-ounce can garbanzo beans, including liquid

Combine onion, carrot, celery, parsley, water, onion powder, thyme, turmeric, garlic powder, marjoram, and salt in a large pot. Cover and simmer 20 minutes.

Stir in garbanzo beans with their liquid. Transfer to a blender in small batches and process until completely smooth, about 1 minute per batch. Be sure to hold the lid on tightly and start the blender on the lowest speed.

Per 1-cup serving: 80 calories; 3 g protein; 16 g carbohydrate;
1 g fat; 3 g fiber; 302 mg sodium; calories from protein: 15%;
calories from carbohydrates: 77%; calories from fats: 8%

● ● ●

Curried Lentil Soup
MAKES ABOUT 2½ QUARTS (10 1-CUP SERVINGS)

Serve this soup with Braised Collards or Kale (page 192) or a green salad and whole grain bread or chapatis.

1 cup lentils, rinsed	½ cup uncooked couscous
1 onion, chopped	1 cup crushed tomatoes
2 celery stalks, sliced	1½ teaspoons curry powder
4 garlic cloves, minced	⅛ teaspoon black pepper
1 teaspoon whole cumin seed or ½ teaspoon ground cumin	1 teaspoon salt
8 cups water or Vegetable Broth (page 184)	

Combine lentils, onion, celery, garlic, cumin seed, and water in a large pot. Bring to a simmer, then cover loosely and cook until lentils are tender, about 50 minutes.

Stir in couscous, crushed tomatoes, curry powder, and black pepper. Continue cooking until couscous is tender, about 10 minutes. Add salt to taste.

Per 1-cup serving: 122 calories; 7 g protein; 23 g carbohydrate;
0.4 g fat; 4 g fiber; 264 mg sodium; calories from protein: 24%;
calories from carbohydrates: 73%; calories from fats: 3%

● ● ●

Navy Bean Soup

MAKES ABOUT 2 QUARTS (8 1-CUP SERVINGS)

Serve this hearty soup with Roasted Broccoli (page 192) and Quick and Easy Brown Bread (page 215).

2 cups dry navy beans or other small white beans	1 large yam, peeled and diced
6 cups water	2 bay leaves
1 onion, chopped	$\frac{1}{4}$ cup chopped fresh parsley
2 garlic cloves, pressed or minced	$\frac{1}{4}$ teaspoon dried thyme
1 large carrot, sliced	$\frac{1}{4}$ teaspoon black pepper
3 celery stalks, sliced	$\frac{1}{4}$ teaspoon liquid smoke (optional)
1 large potato, scrubbed and diced	$1\frac{1}{2}$ teaspoons salt

Rinse beans, then soak in 4 cups of water for 6 to 8 hours or overnight.

Pour off soaking water, rinse beans, and place in a pot with 6 cups of fresh water. Add onion, garlic, carrot, celery, potato, yam, and bay leaves. Bring to a simmer and cook, loosely covered, until beans are tender, about $1\frac{1}{2}$ hours.

Remove bay leaves and discard. Transfer about 3 cups of the soup to a blender. Add parsley, thyme, black pepper, and liquid smoke, if using. Starting on low speed and holding lid on tightly, blend until completely smooth, about 1 minute. Transfer to a bowl and repeat with remaining soup. Return to pot, add salt to taste, and heat until steamy.

Per 1-cup serving: 94 calories; 3.5 g protein; 20 g carbohydrate;
0.2 g fat; 4 g fiber; 288 to 422 mg sodium; calories from protein: 14%;
calories from carbohydrates: 83%; calories from fats: 3%

● ● ●

Autumn Stew

MAKES $2\frac{1}{2}$ QUARTS (10 1-CUP SERVINGS)

This colorful stew is a true celebration of the autumn's abundance. For special occasions, serve it in a pumpkin that has been hollowed-out and baked until just tender.

1 tablespoon reduced-sodium soy
 sauce
1 onion, chopped
1 red bell pepper, seeded and
 diced
4 large garlic cloves, minced
1 butternut squash (about 1
 pound)
1 15-ounce can crushed tomatoes

1½ teaspoons dried oregano
1 teaspoon chili powder
½ teaspoon cumin
¼ teaspoon black pepper
1 15-ounce can kidney beans,
 undrained
1 15-ounce can corn, undrained or
 2 cups frozen corn

Heat ½ cup water and soy sauce in a large pot. Add onion, bell pepper, and garlic. Cook over medium heat until onion is soft and most of the water has evaporated, about 5 minutes.

Peel squash, then cut it in half. Scoop out seeds and discard. Cut squash into ½-inch cubes (you should have about 4 cups). Add to cooked onions along with crushed tomatoes, 1 cup water, oregano, chili powder, cumin, and black pepper.

Cover and simmer until squash is just tender when pierced with a fork, about 20 minutes. Add kidney beans and corn with their liquids and cook 5 minutes longer.

Per 1-cup serving: 138 calories; 5 g protein; 31 g carbohydrate;
1 g fat; 7 g fiber; 276 mg sodium; calories from protein: 14%;
calories from carbohydrates: 81%; calories from fats: 5%

● ● ●

Garbanzo Cabbage Soup
MAKES ABOUT 2 QUARTS (8 1-CUP SERVINGS)

This soup is surprisingly quick to make and delicious with with Crostini with Roasted Red Peppers (page 214).

2 teaspoons olive oil
1 onion, chopped
2 garlic cloves, pressed
1 cup chopped tomato, fresh or
 canned
2 cups chopped cabbage
1 large potato, diced
¼ cup finely chopped fresh parsley

4 cups water or Vegetable Broth
 (page 184)
1 15-ounce can garbanzo beans,
 drained
1 teaspoon paprika
¼ teaspoon black pepper
½ to 1 teaspoon salt

Heat oil in a large pot. Add onion and cook until soft, stirring often, about 3 minutes.

Add garlic, tomato, cabbage, potato, parsley, water or vegetable broth, garbanzo beans, paprika, and black pepper. Simmer until potato and cabbage are tender, about 15 minutes.

Ladle approximately 3 cups of soup into a blender. Blend until smooth, holding lid on tightly and starting on low speed.

Return to pot and stir to mix, adding salt to taste.

Per 1-cup serving: 119 calories; 5 g protein; 21 g carbohydrate;
2 g fat; 4 g fiber; 145 to 278 mg sodium; calories from protein: 15%;
calories from carbohydrates: 68%; calories from fats: 17%

• • •

Spicy Thai Soup
MAKES 6 1-CUP SERVINGS

What a delicious way to enjoy healthy green vegetables!

4 cups Vegetable Broth (page 184)
1 tablespoon finely chopped fresh ginger
2 teaspoons minced garlic
½ to 1 jalapeño pepper, seeded and finely chopped (or more to taste)
1 cup sliced mushrooms

1 cup broccoli, cut into bite-size florets
1 cup (packed) finely chopped bok choy
1 green onion, finely chopped, including top
1 tablespoon finely chopped cilantro

Mix vegetable broth, ginger, garlic, and jalapeño pepper in a pot and bring to a boil.

Add mushrooms and simmer 2 minutes.

Add broccoli and bok choy. Simmer until broccoli is tender but still bright green and crisp, 3 to 4 minutes. Do not overcook!

Stir in green onion and cilantro. Serve immediately.

Per 1-cup serving: 30 calories; 3 g protein; 5 g carbohydrate;
1 g fat; 1 g fiber; 480 mg sodium; calories from protein: 26%;
calories from carbohydrates: 55%; calories from fats: 19%

• • •

Golden Mushroom Soup

MAKES ABOUT 2 QUARTS (8 1-CUP SERVINGS)

This soup is delicious with toasted French bread. Add a tossed green salad for a perfectly marvelous meal.

2 onions, chopped
1 pound mushrooms, sliced
1 tablespoon paprika
1½ teaspoons dill weed
1 teaspoon caraway seeds (optional)
⅛ teaspoon black pepper
3 tablespoons reduced-sodium soy sauce

1 cup water or Vegetable Broth (page 184)
1 tablespoon olive oil
2 tablespoons whole wheat pastry flour or unbleached flour
2 cups unsweetened fortified soy milk or rice milk
2 tablespoons lemon juice
3 tablespoons red wine (optional)

Heat ½ cup water in a large pot and add onions. Cook over high heat, stirring often, until onions are soft and dry, about 5 minutes. Add ¼ cup of water, stir to loosen any bits of onion, and continue cooking until most of the water has evaporated, about 3 minutes.

Add sliced mushrooms, paprika, dill weed, caraway seeds (if using), and black pepper. Lower heat slightly, cover and cook 5 minutes, stirring frequently.

Add soy sauce and water or broth. Cover and simmer 10 minutes.

In a separate pan, mix olive oil and flour to form a thick paste. Cook, stirring constantly, 1 minute, then whisk in milk and cook over medium heat, stirring constantly, until steamy and slightly thickened. Stir into the soup.

Stir in lemon juice and red wine just before serving.

Per 1-cup serving: 89 calories; 4 g protein; 12 g carbohydrate;
3 g fat; 3 g fiber; 145 to 278 mg sodium; calories from protein: 15%;
calories from carbohydrates: 68%; calories from fats: 17%

● ● ●

Split Pea Barley Soup

MAKES ABOUT 3 QUARTS (12 1-CUP SERVINGS)

Barley adds great texture to this simple one-pot soup.

2 cups split peas
½ cup hulled or pearled barley
8 cups water or Vegetable Broth
 (page 184)
1 medium onion, chopped
2 celery stalks, sliced

1 teaspoon ground cumin
1 teaspoon dried basil
1 teaspoon dried thyme
¼ teaspoon black pepper
1½ teaspoons salt

In a large pot combine peas, barley, water or broth, onion, celery, cumin, basil, thyme, and black pepper. Cover loosely and simmer, stirring occasionally, until peas are tender, about 1 hour.

Transfer 2 cups of soup to a blender and process until smooth. Be sure the blender container is no more than half full and hold lid on firmly. Return to pot. Repeat with another 2 cups. Add salt, and serve.

Per 1-cup serving: 180 calories; 11 g protein; 34 g carbohydrate;
1 g fat; 6 g fiber; 337 mg sodium; calories from protein: 24%;
calories from carbohydrates: 72%; calories from fats: 4%

• • •

Summer Stew

MAKES 10 1-CUP SERVINGS

Celebrate the bounty of summer with this thick, flavorful stew. Serve it with French bread and a crisp green salad.

1 tablespoon olive oil
2 onions, chopped
3 Japanese eggplants, cut into
 ¼-inch-thick slices (4 to 6 cups)
1 green bell pepper, seeded and
 diced
5 large garlic cloves, minced
1 12-ounce jar water-packed
 roasted red peppers, including
 liquid

3 small zucchini, sliced (about 3
 cups)
2 cups chopped fresh basil
1 cup water or Vegetable Broth
 (page 184)
1 15-ounce can cannelini beans or
 navy beans, undrained
½ teaspoon salt
¼ teaspoon black pepper

Heat oil in a large pot and add onions. Cook over medium-high heat, stirring often, until onions are lightly browned, about 8 minutes. Add a small amount of water if onions begin to stick.

Add eggplant, bell pepper, and garlic, then cover and cook 5 minutes, stirring occasionally.

Coarsely chop red peppers and add, with their liquid.

Add zucchini, basil, and water or broth. Cover and cook over medium heat, stirring occasionally, for 3 minutes.

Stir in beans and their liquid, salt, and black pepper. Cover and cook until zucchini is just tender, about 3 minutes.

> Per 1-cup serving: 95 calories; 4 g protein; 17 g carbohydrate;
> 2 g fat; 5 g fiber; 200 mg sodium; calories from protein: 15%;
> calories from carbohydrates: 68%; calories from fats: 17%

● ● ●

Brazilian Black Beans
MAKES 10 1-CUP SERVINGS

Serve this colorful bean stew with Brown Rice (page 160) and Braised Collards or Kale (page 192).

½ cup water	1 cup chopped fresh cilantro
1 onion, chopped	1 cup chopped tomato, fresh or
3 garlic cloves, minced	canned
1 small jalapeño pepper, minced	2 oranges, peeled and finely
(more or less to taste)	chopped
1 carrot, thinly sliced	2 15-ounce cans black beans
1 celery stalk, sliced	1 teaspoon coriander
1 yam, diced (about 2 cups)	1 teaspoon cumin
1 red bell pepper, seeded and diced	

Heat the water in a large pot, then add onion, garlic, jalapeño pepper, carrot, celery, and yam. Cook over high heat, stirring often, until onion is soft, about 5 minutes.

Stir in bell pepper and cilantro and cook 3 minutes, stirring often.

Add chopped tomato, oranges, black beans with their liquid, coriander, and cumin. Cover loosely and simmer 15 to 20 minutes.

> Per 1-cup serving: 111 calories; 6 g protein; 22 g carbohydrate;
> 1 g fat; 6 g fiber; 274 mg sodium; calories from protein: 20%;
> calories from carbohydrates: 74%; calories from fats: 6%

VEGETABLES

Roasted Broccoli

MAKES 4 1-CUP SERVINGS

Broccoli, the vegetable superstar, always gets rave reviews when it's oven-roasted.

4 cups broccoli florets	black pepper
2 teaspoons olive oil	juice of 1 lemon
salt	

Preheat oven to 400°F.

Toss broccoli florets with olive oil. Spread in a single layer on a baking sheet, and sprinkle with salt and pepper.

Bake until tender, about 20 minutes. Drizzle with lemon juice and serve.

Per 1-cup serving: 46 calories; 2 g protein; 6 g carbohydrate;
2 g fat; 2 g fiber; 156 mg sodium; calories from protein: 19%;
calories from carbohydrates: 40%; calories from fats: 41%

● ● ●

Braised Collards or Kale

MAKES 3 1-CUP SERVINGS

Collard greens and kale are rich sources of calcium and beta-carotene as well as other minerals and vitamins. One of the tastiest—and easiest— ways to prepare them is with a bit of soy sauce and plenty of garlic. Try to purchase young tender greens, as these have the best flavor and texture.

1 bunch collard greens or kale (6 to 8 cups chopped)	1 teaspoon balsamic vinegar
1 teaspoon olive oil	2 to 3 garlic cloves, minced
2 teaspoons reduced-sodium soy sauce	¼ cup water

Wash greens, remove stems, then cut leaves into ½-inch-wide strips.

Combine olive oil, soy sauce, vinegar, garlic, and the water in a large pot or skillet. Cook over high heat about 30 seconds. Reduce heat to

medium-high, add chopped greens, and toss to mix. Cover and cook, stirring often, until greens are tender, about 5 minutes.

Per 1-cup serving: 106 calories; 6 g protein; 18 g carbohydrate;
2 g fat; 6 g fiber; 132 mg sodium; calories from protein: 20%;
calories from carbohydrates: 60%; calories from fats: 20%

● ● ●

Bok Choy
MAKES 3 1-CUP SERVINGS

Bok choy is another calcium-rich dark leafy green. The stems are crisp and tender, and can be sliced and cooked with the leaves.

2 bunches bok choy (about 6 cups chopped)
1 teaspoon olive oil
2 teaspoons reduced-sodium soy sauce

¼ cup water
2 to 3 garlic cloves, minced
1 teaspoon balsamic vinegar

Wash bok choy, then slice leaves and stems into ½-inch strips.

Combine olive oil, soy sauce, garlic, and water in a large pot or skillet. Cook over high heat about 30 seconds, then add bok choy and toss to mix.

Reduce heat to medium-high, then cover and cook, stirring often, until tender, about 5 minutes. Sprinkle with balsamic vinegar and toss to mix.

Per 1-cup serving: 60 calories; 4 g protein; 8 g carbohydrate;
2 g fat; 2 g fiber; 306 mg sodium; calories from protein: 23%;
calories from carbohydrates: 41%; calories from fats: 36%

● ● ●

Oven-Roasted Asparagus
MAKES 3 1-CUP SERVINGS

This is a deliciously easy way to prepare asparagus.

1 pound fresh asparagus
1 teaspoon sesame seeds
1 teaspoon reduced-sodium soy sauce

1 teaspoon seasoned rice vinegar
1 teaspoon toasted sesame oil
1 garlic clove, pressed

Preheat oven to 450°F.

Snap off tough ends of asparagus and discard. Cut or break stalks into 1-inch pieces. Place in a large bowl.

Toast sesame seeds in a dry skillet over high heat, stirring constantly, until they begin to pop. Transfer to a small bowl and add soy sauce, vinegar, toasted sesame oil, and garlic. Stir to mix, then pour over asparagus. Toss to coat evenly.

Spread in a single layer in a 9-by-13-inch baking dish. Bake until tender, about 15 minutes.

Per 1-cup serving: 54 calories; 4 g protein; 8 g carbohydrate; 2 g fat; 4 g fiber; 118 mg sodium; calories from protein: 23%; calories from carbohydrates: 51%; calories from fats: 26%

• • •

Green Beans with Braised Onions
MAKES 3 1-CUP SERVINGS

Green beans take on a slightly Asian flair in this simple recipe.

1 pound fresh green beans	1 tablespoon soy sauce
1 small onion	1 tablespoon seasoned rice vinegar
⅓ cup water	

Trim beans and break them into bite-sized pieces (you should have about 3 cups). Steam until just tender, about 10 minutes. Cut onion in half lengthwise, then cut each half into thin crescent slices.

In a large skillet heat the water, then add onion. Cook over medium heat until soft, 3 to 5 minutes. Lower the heat and add soy sauce and vinegar. Continue cooking until most of the liquid has evaporated and onion slices are lightly browned. Add steamed beans, toss to mix, and serve.

Per 1-cup serving: 56 calories; 3 g protein; 12 g carbohydrate; 0.2 g fat; 4 g fiber; 266 mg sodium; calories from protein: 17%; calories from carbohydrates: 80%; calories from fats: 3%

• • •

Grilled Summer Vegetables
MAKES ABOUT 4 1½-CUP SERVINGS

Easy-to-prepare grilled vegetables are delicious as a side dish with polenta, pasta, or rice. The vegetables can be varied according to the

*season and your taste. For example, use fresh asparagus when it is avail-
able in spring, and zucchini during summer and fall.*

1 red onion	2 teaspoons olive oil
1 red bell pepper, seeded	2 teaspoons garlic granules or
1 medium zucchini or other	powder
summer squash	2 teaspoons mixed Italian herbs
2 ears fresh corn, husked and cut	2 teaspoons chili powder
into 1-inch lengths	½ teaspoon salt
2 cups button mushrooms	

Preheat grill.

Cut onion, bell pepper, and zucchini into generous chunks and place in a large mixing bowl. Add corn. Clean mushrooms and add.

Sprinkle vegetables with olive oil and toss to coat. Sprinkle with garlic granules, Italian herbs, chili powder, and salt. Toss to mix.

Spread vegetables in a single layer on a grilling rack and place over medium-hot coals. Cover and cook 5 minutes. Turn with a spatula and cook until tender when pierced with a sharp knife, about 5 more minutes. Repeat with remaining vegetables.

Variation: Preheat oven to 450°F. Arrange vegetables in a single layer in one or two large baking dishes and bake until tender when pierced with a sharp knife, about 20 minutes.

Per serving (¼ of recipe): 107 calories; 5 g protein; 17 g carbohydrate;
4 g fat; 4 g fiber; 351 mg sodium; calories from protein: 15%;
calories from carbohydrates: 56%; calories from fats: 29%

• • •

Red Potatoes with Kale

MAKES 6 1-CUP SERVINGS

This dish is a colorful and delicious way to enjoy kale.

4 red potatoes	½ teaspoon black pepper
1 small bunch kale	½ teaspoon paprika
2 teaspoons toasted sesame oil	5 teaspoons reduced-sodium soy
1 onion, thinly sliced	sauce
2 garlic cloves, minced	2 tablespoons water

Scrub potatoes and cut into ½-inch cubes (you should have about 4 cups). Steam over boiling water until just tender when pierced with a fork, about 10 minutes. Rinse with cold water then drain and set aside.

Rinse kale and remove stems. Chop leaves into small pieces (about 4 cups).

Heat oil in a large nonstick skillet. Add onion and garlic and sauté 5 minutes, stirring often.

Add cooked potatoes, black pepper, and paprika. Continue cooking until potatoes begin to brown, about 5 minutes. Use a spatula to turn the mixture gently as it cooks.

Spread chopped kale leaves over potato mixture. Sprinkle with the soy sauce and water. Cover and cook, turning occasionally, until kale is bright green and tender, 5 to 7 minutes.

> Per 1-cup serving: 176 calories; 6 g protein; 36 g carbohydrate;
> 2 g fat; 4 g fiber; 214 mg sodium; calories from protein: 12%;
> calories from carbohydrates: 77%; calories from fats: 11%

• • •

Yams with Cranberries and Apples
MAKES ABOUT 6 1-CUP SERVINGS

This colorful blend of sweet and tart flavors is a perfect addition to any autumn meal.

2 yams	1 cup cranberries, fresh or frozen
1 tablespoon olive oil	2 tablespoons maple syrup
1 large green apple, peeled and diced	½ cup orange juice

Preheat oven to 350°F.

Peel yams and cut into ½-inch cubes (you should have about 4 cups). Toss with olive oil and spread in a 9-by-13-inch baking dish. Top with diced apple and cranberries.

Mix maple syrup and orange juice and pour over casserole. Cover and bake until yams are tender when pierced with a fork, about 1 hour.

> Per 1-cup serving: 208 calories; 2 g protein; 44 g carbohydrate;
> 2 g fat; 4 g fiber; 18 mg sodium; calories from protein: 5%;
> calories from carbohydrates: 83%; calories from fats: 12%

Cooking Potatoes, Sweet Potatoes, Yams, and Winter Squash

Potatoes, sweet potatoes, and winter squash are traditionally baked, but steaming and microwaving are also excellent methods for cooking these nutritious vegetables. In addition to being quick and easy, the vegetables stay moist and flavorful.

Steaming

To steam potatoes, yams, or sweet potatoes, simply scrub them (or peel them if you prefer) and arrange them on a steamer rack. Cook in a covered pot over simmering water until tender when pierced with a fork. This will take between 15 and 40 minutes, depending on their size. For quicker cooking, cut them into cubes or slices before steaming.

To steam winter squash, cut it in half and scoop out the seeds with a spoon. Cut it into wedges or other conveniently sized pieces and arrange on a steamer rack. Place in a pot, then cover and cook over medium heat until the squash is tender when pierced with a fork, between 15 and 30 minutes, depending on the size and freshness of the squash.

Microwave cooking

Russet Potatoes

2 medium potatoes

Pierce potato in several places with a fork. Place in microwave on rotating surface or turn midway during cooking. Microwave 7 to 8 minutes on high. Pierce with a fork to test for doneness. Crisp potato skins by placing in a toaster oven for a short time.

Sweet Potatoes or Yams

2 medium yams

Place yams in shallow covered casserole. Do not add water. Microwave 6 minutes on high, then turn yams over and microwave another 4 minutes. Test for doneness with a fork.

Butternut or Acorn Squash

1 squash

Cut squash in half and remove seeds. Place cut side down in a shallow dish. Do not add water. Microwave on high for 8 minutes. Turn squash right side up and cook another 6 minutes on high.

Roasted Red Peppers

Roasted red peppers are delicious additions to salads, sauces, and soups. You can purchase water-packed roasted peppers in most grocery stores, or you can roast your own as described below.

1 (or more) large, firm red bell
 peppers

Wash pepper and place it over an open flame (such as a gas burner on the stove) or under the oven broiler. Turn pepper with tongs until skin is evenly charred on all sides.

Transfer to a bowl and cover with a plate. Let stand 15 minutes, then rub off charred skin. Cut pepper in half, saving any juice, and remove seeds. Use immediately or refrigerate or freeze for later use.

Per pepper: 20 calories; 0.6 g protein; 5 g carbohydrate;
0.1 g fat; 1 g fiber; 1 mg sodium; calories from protein: 11%;
calories from carbohydrates: 83%; calories from fats: 6%

● ● ●

Roasted Garlic

Roasted garlic is a delicious appetizer or accompaniment to a meal. Serve it spread onto crusty French bread or mash it and add it to salad dressings. Store in a sealed container in the refrigerator for up to 2 weeks.

1 or more whole garlic heads

Preheat oven or toaster oven to 375°F.

Select heads of garlic with large cloves. Place entire bulb in a small baking dish and bake until cloves feel soft when pressed, about 35 minutes.

Microwave variation: Place 1 large head of garlic in microwave. Cook on high for 2 minutes, 10 seconds. Test for doneness with a fork.

Per bulb: 45 calories; 2 g protein; 10 g carbohydrate;
0.1 g fat; 0.6 g fiber; 5 mg sodium; calories from protein: 16%;
calories from carbohydrates: 81%; calories from fats: 3%

• • •

Ratatouille

MAKES 10 1-CUP SERVINGS

Ratatouille is a perfect dish for late summer and early autumn when tomatoes, peppers, and eggplants are at their peak. Serve with bread or pasta and a crisp green salad.

½ cup water
2 onions, chopped
3 garlic cloves, minced
1 large eggplant, diced
1 to 2 pounds tomatoes, peeled, seeded, and chopped, or 1 15-ounce can crushed tomatoes

½ teaspoon dried basil
½ teaspoon dried oregano
½ teaspoon dried thyme
½ teaspoon salt
¼ teaspoon black pepper
1 bell pepper, seeded and diced
2 medium zucchini, sliced

Heat the water in a large pot and add onions and garlic. Cook over medium heat, stirring often, until onions are soft, about 5 minutes.

Stir in eggplant, tomatoes, basil, oregano, thyme, salt, and black pepper. Cover and simmer, stirring frequently, until eggplant is just tender when pierced with a fork, about 15 minutes.

Stir in bell pepper and zucchini. Cover and cook until tender, about 5 minutes.

Per ½-cup serving: 104 calories; 4 g protein; 24 g carbohydrate;
0.8 g fat; 6 g fiber; 362 mg sodium; calories from protein: 14%;
calories from carbohydrates: 80%; calories from fats: 6%

• • •

Mashed Potatoes

MAKES ABOUT 10 ½-CUP SERVINGS

Serve with Brown Gravy (page 183) and enjoy this traditional favorite to your heart's content!

4 russet potatoes, peeled and diced
2 cups water
1 cup unsweetened fortified soy
 milk or rice milk
¼ teaspoon onion powder
¼ teaspoon garlic powder

½ teaspoon salt
1½ tablespoons rice flour
2 tablespoons potato flour
½ cup Corn Butter (page 183) or
 1 tablespoon nonhydrogenated
 margarine

Put potatoes the water in a saucepan. Simmer until potatoes are tender when pierced with a fork, about 10 minutes. Drain, reserving liquid. Mash potatoes.

Pour milk, onion powder, garlic powder, salt, rice flour, potato flour, and Corn Butter or margarine into a blender. Blend until completely smooth, about 1 minute. Add to mashed potatoes and stir to mix.

Per ½-cup serving: 85 calories;
2 g protein; 18 g carbohydrate; 1 g fat; 2 g fiber;
140 mg sodium; calories from protein: 11%;
calories from carbohydrates: 81%; calories from fats: 8%

• • •

Curried Cauliflower with Peas
MAKES 6 1-CUP SERVINGS

The spices in this curry are toasted for extra flavor. Be careful to add the liquid slowly to avoid spattering.

1 teaspoon coriander
1 teaspoon whole mustard seed
½ teaspoon turmeric
½ teaspoon cumin
¼ teaspoon cinnamon
¼ teaspoon ground ginger
¼ teaspoon ground cardamom
¼ teaspoon cayenne

½ cup Vegetable Broth (page 184)
 or water
1 to 2 tablespoons reduced-sodium
 soy sauce
1 large onion, chopped
1 cauliflower, cut or broken into
 florets (about 4 cups)
1 10-ounce bag frozen peas

Combine coriander, mustard seed, turmeric, cumin, cinnamon, ginger, cardamom, and cayenne in a large skillet. Heat, stirring constantly, until spices darken slightly and just begin to smoke, about 1 minute. Remove from heat and cool slightly.

Add vegetable broth, soy sauce, and onion. Cook until onion is soft, stirring occasionally, about 5 minutes.

Stir in cauliflower, then cover and cook over medium heat until tender when pierced with a fork, about 5 minutes. Stir in peas and cook until hot, another minute or two.

Per 1-cup serving: 72 calories; 4 g protein; 14 g carbohydrate;
0.2 g fat; 4 g fiber; 146 to 230 mg sodium; calories from protein: 23%;
calories from carbohydrates: 73%; calories from fats: 4%

● ● ●

Broccoli with Sesame Seasoning
MAKES ABOUT 4 1-CUP SERVINGS

Here is a simple and delicious way to prepare broccoli. Serve it with your favorite cooked rice, grain, or pasta.

1 bunch broccoli	1 tablespoon Sesame Seasoning (page 181)

Rinse broccoli and remove stems. Cut or break into bite-size florets. Peel stems and cut into ¼-inch-thick rounds. Steam until bright green and tender-crisp, about 5 minutes. Transfer to a serving bowl and sprinkle with Sesame Seasoning. Toss to mix.

Per 1-cup serving: 40 calories; 4 g protein; 6 g carbohydrate;
2 g fat; 4 g fiber; 58 mg sodium; calories from protein: 27%;
calories from carbohydrates: 46%; calories from fats: 27%

● ● ●

Zucchini Corn Fritters
MAKES 16 FRITTERS

Serve these golden fritters with Chili Beans (page 202) or with Ratatouille (page 199).

1⅓ cups fortified soy milk or rice milk	½ teaspoon baking soda
1 tablespoon cider vinegar	½ teaspoon salt
1 cup cornmeal	1 medium zucchini
¼ cup unbleached flour	1 cup corn (fresh, frozen, or canned)
½ teaspoon baking powder	vegetable oil cooking spray

Combine milk and vinegar. Set aside.

In a mixing bowl, combine cornmeal, flour, baking powder, baking soda, and salt.

Chop or grate zucchini (you should have about 1 cup), then add to cornmeal mixture. Add milk mixture and corn. Stir to mix.

Lightly oil-spray a nonstick griddle or skillet and heat until a drop of water dances on the surface. Pour on small amounts of batter and cook until edges are dry, about 2 minutes. Carefully turn with a spatula and cook second side until golden brown, about 1 minute. Serve immediately.

Per fritter: 55 calories; 2 g protein; 11 g carbohydrate; 0.6 g fat;
1 g fiber; 142 mg sodium; calories from protein: 13%;
calories from carbohydrates: 77%; calories from fats: 10%

ENTRÉES

Chili Beans

MAKES ABOUT 6 1-CUP SERVINGS

Serve these chili beans with Zucchini Corn Fritters (page 201), warm corn tortillas, or brown rice. A crisp green salad will round out the meal. If you have leftover beans, use them to make Mexican Corn Pone (page 212).

1½ cups dry pinto beans	1 15-ounce can tomato sauce
3½ cups water	1 15-ounce can corn or 2 cups
3 large garlic cloves, minced	fresh or frozen corn
½ teaspoon ground cumin	2 teaspoons chili powder
1 onion, chopped	¼ teaspoon cayenne (more for
1 green bell pepper, seeded and	spicier beans)
diced	½ to 1 teaspoon salt

Sort through beans, then rinse and soak in about 6 cups of cold water for 6 to 8 hours or overnight.

Discard soaking water and rinse beans. Place in a pot with 3 cups fresh water, garlic, and cumin. Cover loosely and simmer until tender, about 1 hour.

Heat ½ cup water in a large skillet and cook onion and bell pepper until soft, about 5 minutes. Add to beans, along with tomato sauce, corn, chili powder, and cayenne. Simmer at least 30 minutes. Add salt to taste.

Crock-Pot method: Soak beans as described, then transfer to a Crock-Pot along with garlic, cumin, onion, bell pepper, chili powder, cayenne, and 3 cups boiling water. Cook on high until beans are tender, 2 to 3 hours. Add tomato sauce and corn. Continue cooking on high for at least 1 hour. Add salt to taste.

Per 1-cup serving: 125 calories; 6 g protein; 26 g carbohydrate;
1 g fat; 7 g fiber; 209 to 387 mg sodium; calories from protein: 18%;
calories from carbohydrates: 76%; calories from fats: 6%

● ● ●

Middle Eastern Lentils and Rice with Salad
MAKES 8 SERVINGS

This traditional Middle Eastern dish of flavorful lentils and rice topped with a cool green salad and tangy lemon vinaigrette makes a delicious meal.

Lentils and rice:
2 teaspoons olive oil
2 large onions, coarsely chopped
¾ cup brown rice
1½ teaspoons salt
1½ cups lentils, rinsed
4 cups boiling water

Salad:
4 to 6 cups leaf lettuce or salad mix
1 tomato, cut into wedges

2 or 3 green onions, chopped
1 cucumber, thinly sliced
½ avocado, sliced
1 tablespoon olive oil
2 tablespoons lemon juice
1 garlic clove, pressed
1 teaspoon sugar or other sweetener
½ teaspoon paprika
¼ teaspoon dry mustard
¼ teaspoons salt

To prepare lentils and rice, heat olive oil in a large pot and sauté onions until soft, about 5 minutes. Add rice and salt and cook 3 minutes, stirring often.

Stir in lentils and boiling water. Cover and simmer until rice and lentils are tender, about 1 hour.

While lentil mixture cooks, prepare a generous green salad with leaf lettuce or salad mix, tomatoes, green onions, cucumber, and avocado. Add any other ingredients you enjoy in a salad.

Whisk together the olive oil, lemon juice, garlic, sugar, paprika, dry mustard, and salt. Mix well.

Pour dressing over salad and toss to mix. For each serving place 1 cup of the lentil mixture on each plate and top with salad.

Per serving (1 cup lentils and 1 cup salad): 278 calories;
13 g protein; 44 g carbohydrate; 6 g fat; 8 g fiber;
480 mg sodium; calories from protein: 19%;
calories from carbohydrates: 62%; calories from fats: 19%

● ● ●

Indonesian Stir-fry

MAKES 10 1-CUP SERVINGS

Once the vegetables are all prepared, this dish cooks in a flash. Udon is Japanese pasta available in many supermarkets and natural food stores. If you cannot find it, use spaghetti.

8 ounces udon or spaghetti
2 teaspoons toasted sesame oil
1 onion, sliced
1 teaspoon turmeric
½ teaspoon cumin
¼ teaspoon red pepper flakes
2 cups sliced mushrooms (about
 ½ pound)
2 celery stalks, sliced

½ pound firm tofu, cut into cubes
2 cups shredded green cabbage
1 red bell pepper, seeded and cut
 into strips
2 tablespoons reduced-sodium soy
 sauce
2 cups bean sprouts (optional)
Peanut Sauce for serving (page
 184)

Cook noodles until tender. Rinse, drain, and set aside.

Heat sesame oil in a large nonstick skillet. Add onion, turmeric, cumin, and red pepper flakes. Cook over high heat, stirring often, until onion is soft, about 5 minutes.

Add mushrooms, celery, and tofu. Reduce heat to medium-high and cook 5 minutes, stirring often.

Add cabbage and bell pepper, then cover and cook 4 minutes, stirring occasionally.

Add cooked noodles and soy sauce and toss gently to mix. Remove from heat and stir in bean sprouts, if using. Serve with Peanut Sauce.

Per 1-cup serving: 142 calories; 7 g protein; 23 g carbohydrate;
3 g fat; 4 g fiber; 123 mg sodium; calories from protein: 18%;
calories from carbohydrates: 64%; calories from fats: 18%

● ● ●

Lasagna Roll-ups

MAKES 16 ROLL-UPS

In this recipe, creamy spinach filling is rolled up in lasagne noodles and baked with a seasoned mushroom marinara.

8 wide lasagna noodles

Marinara Sauce:
½ cup red wine or water
1 small onion, chopped
3 garlic cloves, pressed or minced
1½ cups sliced mushrooms (about ⅓ pound)
¼ cup chopped fresh parsley
1 15-ounce can crushed or ground tomatoes
1½ tablespoons apple juice concentrate
½ cup water
½ teaspoon dried basil
½ teaspoon dried oregano

¼ teaspoon fennel seeds (optional)
¼ teaspoon black pepper

Filling:
1 garlic clove
1 pound firm reduced-fat tofu
2 10-ounce packages frozen chopped spinach, thawed
½ cup finely chopped parsley
1 teaspoon dried basil
½ teaspoon dried oregano
½ teaspoon dried thyme
½ teaspoon grated nutmeg
½ teaspoon salt
¼ teaspoon black pepper

Cook noodles in boiling water until just tender. Drain and rinse in cold water. Set aside.

Prepare the sauce: Heat wine or water in a large pot. Add onion and garlic and cook over high heat until soft, about 5 minutes.

Add mushrooms and parsley. Lower heat slightly, cover and cook, stirring occasionally, for 5 minutes.

Stir in tomatoes, apple juice concentrate, water, basil, oregano, fennel seeds (if using), and black pepper. Cover and simmer 15 to 20 minutes. Spread evenly in a 9-by-13-inch baking dish.

To prepare filling, finely chop garlic in a food processor, then add tofu and process until completely smooth. Squeeze spinach dry then add it to the processor with parsley, basil, oregano, thyme, nutmeg, salt, and black pepper. Mix completely.

Preheat oven to 350°F.

Cut a noodle in half so it is about 5 inches long and spread each half with about ¼ cup of filling. Roll into a pinwheel and place in baking dish (seam side down or standing on end). Repeat with remaining noodles.

Cover and bake 20 minutes.

Per roll-up: 103 calories; 6 g protein; 16 g carbohydrate; 2 g fat;
2 g fiber; 146 mg sodium; calories from protein: 23%;
calories from carbohydrates: 62%; calories from fats: 15%

• • •

Pasta e Fagioli
MAKES 5 2-CUP SERVINGS

Pasta and beans make a delicious and satisfying meal.

½ cup water or Vegetable Broth
(page 184)
1 onion, chopped
1 small bell pepper, seeded and
diced
1 carrot, sliced
1 celery stalk, sliced
2 cups sliced mushrooms (about
½ pound)
1 15-ounce can chopped tomatoes

1 15-ounce can kidney beans,
drained
1 teaspoon dried thyme
1 teaspoon paprika
½ teaspoon black pepper
1 tablespoon low-sodium soy
sauce
4 ounces uncooked rigatoni or
other pasta

Heat water or broth in a large pot. Cook onions over high heat, stirring
often, for 3 minutes.

Add bell pepper, carrots, and celery. Reduce heat to medium and cook
for 5 minutes, stirring often.

Add mushrooms. Cover and cook 7 minutes, stirring occasionally.

Add tomatoes, kidney beans, thyme, paprika, black pepper, and soy
sauce. Cover and simmer 10 to 15 minutes.

In a separate pot, cook pasta until tender. Rinse and drain. Stir into
vegetables just before serving.

Per 2-cup serving: 255 calories; 13 g protein; 50 g carbohydrate;
2 g fat; 8 g fiber; 882 mg sodium; calories from protein: 19%;
calories from carbohydrates: 75%; calories from fats: 6%

• • •

Black-Eye Refries
MAKES ABOUT 4 1-CUP SERVINGS

*Eating black-eyed peas on New Year's Day brings good luck, according to
a Southern tradition. Here's an interesting way to serve them.*

1½ cups dry black-eyed peas

1 teaspoon ground cumin

¼ teaspoon dried red pepper flakes

2 garlic cloves, minced

2 teaspoons olive oil

1 small onion, finely chopped

½ teaspoon salt

Rinse peas, then soak overnight in about 4 cups of water.

Drain peas, then place in a pot with 4 cups water, cumin, red pepper flakes, and half the garlic. Cover and simmer until very tender, about 45 minutes.

Heat oil in a large skillet or pot. Add onion and remaining garlic. Cook until soft, about 3 minutes. Stir in cooked peas with their liquid. Use a potato masher to mash peas, leaving some chunks. Cook uncovered over medium heat, stirring often, until most of the liquid has evaporated. Add salt.

Per 1-cup serving: 256 calories; 16 g protein; 22 g carbohydrate; 4 g fat; 8 g fiber; 278 mg sodium; calories from protein: 24%; calories from carbohydrates: 66%; calories from fats: 10%

● ● ●

Pueblo Pie

MAKES 12 SERVINGS

Pueblo Pie is like a Southwestern lasagna, with layers of corn tortillas, tangy garbanzo spread, chili beans, corn, and a spicy tomato sauce. Serve it with a green salad for a very satisfying meal.

½ cup plus ⅔ cup water

1 large onion, chopped

1 tablespoon minced garlic (about 4 large cloves)

1 28-ounce can crushed tomatoes

4 teaspoons chili powder

2 teaspoons cumin

1 12-ounce package Yves Veggie Ground Round or similar product

1 15-ounce can garbanzo beans, drained

½ cup roasted red pepper (about 2 peppers)

3 tablespoons tahini (sesame butter)

3 tablespoons lemon juice

12 corn tortillas, torn in half

2 15-ounce cans vegetarian chili beans

1 cup chopped green onions

1 to 2 cups corn, fresh or frozen

Heat ½ cup water in a large pot or skillet. Add onion and garlic and cook until soft, about 5 minutes. Add tomatoes, chili powder, cumin, Veggie

Ground Round, and another ⅔ cup water. Simmer over medium heat 5 minutes.

Place garbanzo beans, roasted peppers, tahini, and lemon juice in a food processor or blender and process until very smooth.

Preheat oven to 350°F.

Spread about ½ cup of the tomato sauce in the bottom of a 9-by-13-inch baking dish. Cover with a layer of tortillas, then spread with a third of the garbanzo bean mixture, holding tortillas in place with your fingers. Sprinkle with a third of the chili beans, green onions, and corn. Spread about 1 cup of tomato sauce over the top.

Repeat layers twice, ending with tomato sauce. Make sure all the tortillas are covered. Bake 20 minutes, until hot and bubbly.

Per serving (¹⁄₁₂ of casserole): 230 calories;
15 g protein; 35 g carbohydrate; 4 g fat; 9 g fiber;
225 mg sodium; calories from protein: 26%;
calories from carbohydrates: 60%; calories from fats: 14%

● ● ●

Zucchini Skillet Hash

Makes 6 1-cup servings

This hearty hash is made with delicious meatless burgers that are sold in natural food stores and many supermarkets.

½ cup water
1 onion
2 garlic cloves
1½ cups sliced mushrooms (about ⅓ pound)
1 celery stalk, thinly sliced

2 medium zucchini, diced (about 2 cups)
3 vegan burger patties, chopped (see box, page 168)
½ teaspoon salt
½ teaspoon black pepper

Heat the water in a large nonstick skillet. Add onion and garlic and cook over high heat until onion begins to soften, 3 minutes.

Add mushrooms and celery. Continue cooking, stirring frequently, until onion is soft and mushrooms are brown, about 5 minutes. Add a small amount of additional water if vegetables begin to stick.

Add zucchini, chopped burgers, salt, and pepper. Reduce heat to medium. Cover and cook, stirring often, until zucchini is just tender, about 3 minutes.

Per 1-cup serving: 93 calories; 12 g protein; 11 g carbohydrate;
0.2 g fat; 5 g fiber; 234 mg sodium; calories from protein: 52%;
calories from carbohydrates: 46%; calories from fats: 2%

• • •

Vegetable Curry
MAKES 8 1-CUP SERVINGS

*This colorful curry is delicious with brown rice or couscous, or rolled in
a warm tortilla.*

½ cup plus ⅓ cup water
3 tablespoons reduced-sodium soy
 sauce
1 onion, sliced
2 small sweet potatoes or yams,
 peeled and diced (about 2 cups)
1 large carrot, thinly sliced
1 celery stalk, thinly sliced

1 red or green bell pepper, seeded
 and diced
1 15-ounce can crushed tomatoes
1 15-ounce can garbanzo beans
½ cup chopped fresh cilantro
2 tablespoons peanut butter
2 teaspoons curry powder

Heat ½ cup water and soy sauce in a large pot. Add onion and sweet pota-
toes. Cook over high heat, stirring occasionally, for 5 minutes.

Stir in carrot, celery, and bell pepper. Cover and continue cooking 3
minutes, stirring occasionally.

Add tomatoes, garbanzo beans, and cilantro. Blend peanut butter with
⅓ cup water, then add it along with the curry powder.

Cover and simmer, stirring often, until vegetables are tender, about 10
minutes.

Per 1-cup serving: 174 calories; 6 g protein; 32 g carbohydrate;
3 g fat; 5 g fiber; 451 mg sodium; calories from protein: 13%;
calories from carbohydrates: 72%; calories from fats: 15%

• • •

Spinach and Mushroom Fritatta
MAKES 8 SERVINGS

*This fritatta is like a crustless quiche. It is made with Mori-Nu silken tofu,
which is available in most grocery stores.*

½ cup water
1 onion, chopped
2 garlic cloves, minced
2 cups sliced mushrooms (about ½ pound)
2 teaspoons dried basil
½ teaspoon salt
¼ teaspoon black pepper
¼ teaspoon grated nutmeg
¼ teaspoon celery seed

1 10-ounce package frozen spinach, thawed
1 12.3-ounce package Mori-Nu Lite Silken Tofu (firm or extra firm)
2 tablespoons couscous
¼ cup fortified soy milk or rice milk
vegetable oil cooking spray
1 ripe tomato, thinly sliced

Heat the water in a large pot or skillet. Add onion and garlic and cook until soft, about 5 minutes.

Add mushrooms, basil, salt, pepper, nutmeg, and celery seed. Cook over medium-high heat, stirring often, until mushrooms are soft, about 5 minutes.

Stir in spinach and cook over medium heat, stirring often, until mixture is very dry. Remove from heat.

Preheat oven to 350°F.

In a food processor or blender, process tofu until very smooth. Add to spinach mixture along with couscous and milk.

Pour into an oil-sprayed 9-inch pie pan. Arrange tomato slices around the outside edge. Bake 25 minutes. Let stand 10 minutes before serving.

Per slice (⅛ of fritatta): 55 calories; 6 g protein; 8 g carbohydrate;
2 g fat; 2 g fiber; 194 mg sodium; calories from protein: 32%;
calories from carbohydrates: 55%; calories from fats: 13%

● ● ●

Stuffed Portobello Mushrooms
MAKES 4 SERVINGS

These "meaty" mushrooms, stuffed with savory polenta and vegetables make an elegant entree. If you make your own Polenta (page 162), it should be cooked a day in advance and thoroughly chilled. For quicker preparation, use a 1-pound package of ready-to-slice polenta, available in most supermarkets.

Stuffing:
2 teaspoons olive oil
1 small yellow onion, chopped
10 small white mushrooms, sliced
½ red or green bell pepper, seeded
 and diced
1 teaspoon dried basil
½ teaspoon dried oregano
½ teaspoon dried thyme
½ teaspoon salt
¼ teaspoon black pepper
2 cups cooked, chilled polenta, cut
 into ¼-inch cubes

1 6-ounce bag prewashed spinach,
 coarsely chopped

Portobellos:
4 large portobello mushrooms
2 teaspoons olive oil
2 tablespoons red wine, water, or
 vegetable broth
2 tablespoons reduced-sodium soy
 sauce
1 tablespoon balsamic vinegar
2 garlic cloves, minced
¼ cup finely chopped pecans
 (optional)

To prepare polenta stuffing, heat olive oil in a nonstick skillet and add onion, sliced white mushrooms, and bell pepper. Cook over medium heat, stirring often, for 3 minutes. Stir in basil, oregano, thyme, salt, and black pepper. Continue cooking until flavors are blended, about 5 minutes.

Use a spatula to gently fold the polenta into the mixture. Spread chopped spinach evenly over polenta. Cover pan and cook over medium heat until spinach is wilted and mixture is very hot, about 5 minutes. Use a spatula to turn the mixture occasionally. Add a tablespoon or two of water if necessary to prevent sticking.

To prepare portobellos, trim stems flush and discard. Mix oil, wine, soy sauce, vinegar, and garlic in a large skillet. Heat until mixture bubbles, then add mushrooms with tops down. Reduce heat to medium, cover and cook 3 minutes, adding 1 to 2 tablespoons of water if pan becomes dry. Flip mushrooms, cover and cook second side until tender when pierced with a sharp knife, about 3 minutes. Transfer to a baking dish. Add any cooking juices to dish.

Preheat broiler.

Top each mushroom with a generous mound of polenta mixture. If using pecans, spread on a baking sheet and toast under broiler until fragrant and lightly browned, about 4 minutes, then sprinkle over polenta. Place under preheated broiler until tops just begin to brown, about 3 minutes.

Per portobello (with pecans): 224 calories; 7 g protein; 28 g carbohydrate;
11 g fat; 5 g fiber; 299 mg sodium; calories from protein: 12%;
calories from carbohydrates: 48%; calories from fats: 40%

Per portobello (without pecans): 174 calories; 6 g protein;
26 g carbohydrate; 6 g fat; 5 g fiber; 299 mg sodium;
calories from protein: 14%; calories from carbohydrates:
58%; calories from fats: 28%

• • •

Mexican Corn Pone
MAKES 12 SERVINGS

When you make Chili Beans (page 202), cook a double batch so you'll have enough for this delicious Corn Pone. You'll love the spicy beans topped with a golden cornbread crust. You could also use canned vegetarian chili beans for this recipe.

6 cups Chili Beans with their juice (page 202), or 3 15-ounce cans vegetarian chili beans	2 tablespoons vinegar
	2 cups cornmeal
	2 teaspoons baking soda
2 cups fortified soy milk or rice milk	½ teaspoon salt
	2 tablespoons oil

Preheat oven to 400°F. Spread chili beans evenly in a 9-by-13-inch baking dish and place in oven as it preheats.

Mix milk and vinegar and set aside.

In a separate bowl, mix cornmeal, baking soda, and salt. Add oil and milk-vinegar mixture. Stir to dissolve any lumps, then pour over hot beans.

Bake until cornbread is set and golden brown, about 30 minutes.

Per serving (¹⁄₁₂ of casserole): 180 calories;
6 g protein; 32 g carbohydrate; 4 g fat; 6 g fiber;
409 mg sodium; calories from protein: 13%;
calories from carbohydrates: 68%; calories from fats: 19%

• • •

Hungarian Goulash
MAKES 8 1-CUP SERVINGS

This hearty goulash is served over cooked pasta; try tomato basil fettucine or red pepper pasta for added flair. It is made with seitan ("saytan"), a high-protein wheat product with a meaty taste and texture. It also contains light miso ("mee-so"), a soybean product that is sold in natural food stores.

1 tablespoon toasted sesame oil
1 large onion, thinly sliced
3 cups sliced mushrooms (about
 ¾ pound)
1 green bell pepper, seeded and
 diced
1 red bell pepper, seeded and
 diced
3 tablespoons light miso
1½ cups water

1 28-ounce can crushed tomatoes
¾ cup sauerkraut (low-sodium, if
 possible)
8 ounces seitan, cut into bite-size
 pieces
4 teaspoons paprika
½ teaspoon dried basil
¼ teaspoon black pepper
8 ounces your favorite pasta

Heat oil in a large pot or skillet. Cook onion until soft and lightly browned, about 8 minutes. Add mushrooms and bell peppers. Lower heat slightly, then cover and cook 8 to 10 minutes, stirring occasionally.

Combine miso and water, stirring until smooth. Add to vegetable mixture, along with tomatoes, sauerkraut, seitan, paprika, basil, and black pepper. Cover and simmer 20 minutes.

Cook pasta in boiling water according to package directions. Drain, then rinse with hot water and spread on a platter. Top with goulash and serve.

Per 1-cup serving: 147 calories; 12 g protein; 20 g carbohydrate;
3 g fat; 4 g fiber; 357 mg sodium; calories from protein: 31%;
calories from carbohydrates: 53%; calories from fats: 16%

● ● ●

Rice and Beans with Greens
MAKES 8 SERVINGS

If you enjoy simple, down-home food, you'll love this combination of seasoned pinto beans served with brown rice and braised kale.

Beans:
1½ cups dry pinto beans
4 cups water
4 large garlic cloves, minced
1½ teaspoons cumin seed (or 1
 teaspoon ground cumin)
½ teaspoon red pepper flakes
¾ teaspoon salt

Rice:
8 cups water

2 cups brown rice
1 teaspoon salt

Greens:
1 bunch kale or collard greens
 (6 to 8 cups chopped)
½ cup water
2 teaspoons reduced-sodium soy
 sauce
2 large garlic cloves, minced

Rinse beans and soak overnight in about 6 cups of water.

Drain and rinse, then place in a pot with 4 cups water, garlic, cumin, and red pepper flakes. Simmer until tender, about 1 hour. Add salt to taste.

Bring 8 cups of water to a boil, then add rice and salt. Cover loosely and simmer until rice is tender, about 40 minutes. Pour off excess water.

Wash greens, remove stems, and chop leaves into ½-inch-wide strips. Heat the water and soy sauce in a large pot, then add garlic and cook 1 minute. Stir in chopped greens. Cover and cook over medium heat until tender, about 5 minutes.

To serve, place ¾ cup rice on each plate, then top with about ½ cup of beans. Add some of the cooking liquid, then top with ½ cup cooked greens.

Per serving (½ cup beans, ¾ cup rice, ½ cup greens): 231 calories;
7 g protein; 48 g carbohydrate; 2 g fat; 6 g fiber;
520 mg sodium; calories from protein: 12%;
calories from carbohydrates: 82%; calories from fats: 6%

BREADS AND DESSERTS

Crostini with Roasted Red Peppers
Makes about 20 slices

In this fat-free version of crostini, slices of toasted baguette are topped with a flavorful blend of tomatoes and roasted red peppers. Sun-dried tomatoes and roasted red peppers packed in water are sold in most supermarkets.

1 cup boiling water
10 sun-dried tomato halves
⅔ cup chopped roasted red peppers
 (about 2 peppers)
1 garlic clove, pressed

2 tablespoons finely chopped fresh
 basil, or 1 teaspoon dried basil
⅛ teaspoon black pepper
1 small baguette, cut into ½-inch-
 thick slices

Pour boiling water over tomatoes in a small bowl and set aside until softened, about 10 minutes.

Drain and chop coarsely.

Mix red peppers and tomatoes, along with garlic, basil, and black pepper. Let stand 30 minutes.

Preheat oven to 350°F.

Arrange baguette slices in a single layer on one or two baking sheets.

Toast in oven until outsides are crisp, 10 to 15 minutes. Remove from oven and cool slightly, then spread each piece with 1 to 2 tablespoons of tomato mixture.

Per slice: 40 calories; 1 g protein; 8 g carbohydrate; 0.4 g fat;
1 g fiber; 104 mg sodium; calories from protein: 13%;
calories from carbohydrates: 77%; calories from fats: 10%

• • •

Garlic Bread
MAKES ABOUT 20 SLICES

Roasted garlic makes a delicious, fat-free garlic bread. Choose heads with nice big cloves for easy peeling.

2 heads Roasted Garlic (page 198)
1 to 2 teaspoons mixed Italian herbs

½ teaspoon salt
1 baguette or loaf of French bread, sliced into 20 pieces

Preheat oven to 350°F.
 Peel roasted cloves, or squeeze flesh from skin, and place in a bowl.
 Mash with a fork, then mix in Italian herbs and salt.
 Spread on sliced bread. Wrap tightly in foil and bake for 20 minutes.

Per slice: 88 calories; 3 g protein; 17 g carbohydrate;
1 g fat; 1 g fiber; 229 mg sodium; calories from protein: 13%;
calories from carbohydrates: 76%; calories from fats: 11%

• • •

Quick and Easy Brown Bread
MAKES 1 LOAF (ABOUT 20 SLICES)

This bread is made with healthy whole wheat and contains no added fat or oil. Serve it plain or with Pineapple Apricot Sauce (page 182).

1½ cups fortified soy milk or rice milk
2 tablespoons vinegar
3 cups whole wheat pastry flour

2 teaspoons baking soda
½ teaspoon salt
½ cup molasses
½ cup raisins

Preheat oven to 325°F.
 Mix milk with vinegar and set aside.

In a large bowl, combine flour, baking soda, and salt. Stir to mix.

Add milk mixture and molasses. Stir to mix, then stir in raisins. Do not overmix.

Spread evenly in 5-by-9-inch nonstick or oil-sprayed loaf pan (pan should be about half full). Bake 1 hour.

Per slice (¹⁄₂₀ of loaf): 100 calories; 3 g protein; 22 g carbohydrate;
1 g fat; 2 g fiber; 186 mg sodium; calories from protein: 12%;
calories from carbohydrates: 82%; calories from fats: 6%

• • •

Double Bran Muffins

MAKES 12 MUFFINS

The combination of oat and wheat brans makes these wholesome, fruity muffins doubly healthy. Oat bran helps lower blood cholesterol, while wheat bran promotes a healthy digestive tract. Prune puree makes the muffins moist without added fat. They will be quite moist when they first come out of the oven, so let them stand a few minutes before serving.

vegetable oil cooking spray	1 apple, finely chopped or grated
2 cups whole wheat flour or whole wheat pastry flour	½ cup raisins
¾ cup wheat bran	1½ cups fortified soy milk or rice milk
¾ cup oat bran	1½ tablespoons white or cider vinegar
½ teaspoon salt	
1 teaspoon baking soda	1 4-ounce jar prune baby food or other prune puree
1 teaspoon cinnamon	
¼ teaspoon grated nutmeg	⅓ cup molasses

Preheat oven to 350°F. Spray a 12-cup muffin pan with cooking spray.

Mix flour, brans, salt, baking soda, cinnamon, and nutmeg.

In a separate bowl, combine apple, raisins, milk, vinegar, prune puree, and molasses.

Combine wet and dry ingredients and stir to mix. Spoon batter into muffin pan, filling the cups nearly to the top. Bake until tops bounce back when lightly pressed, about 25 minutes. Let stand 1 to 2 minutes, then remove from pan and let stand 5 minutes before serving.

Per muffin: 159 calories; 5.5 g protein; 37 g carbohydrate; 2 g fat;
6 g fiber; 203 mg sodium; calories from protein: 12%;
calories from carbohydrates: 80%; calories from fats: 8%

• • •

Summer Fruit Cobbler

MAKES 9 SERVINGS

This cobbler is a delicious way to enjoy peaches and strawberries when they are at their peak. Barley flour, which makes it tender without adding a lot of fat, is sold in natural food stores and some supermarkets.

¼ cup plain or fortified vanilla soy milk or rice milk
2 tablespoons maple syrup
1 tablespoon canola oil
2 teaspoons white or cider vinegar
4 medium-size fresh peaches (about 1 pound)
2 cups fresh strawberries

½ cup apple juice concentrate
2 teaspoons cornstarch
1 cup plus 3 tablespoons barley flour
¼ teaspoon baking soda
1 teaspoon baking powder
¼ teaspoon salt

Preheat oven to 350°F.

Mix milk, maple syrup, oil, and vinegar. Set aside.

Rinse fruit. Remove strawberry stems. Peel peaches if desired, then slice. Combine fruit in a saucepan with apple juice concentrate and cornstarch. Bring to a simmer, stirring constantly, until fruit begins to soften and liquid thickens slightly, about 5 minutes. Transfer to a 9-by-9-inch baking dish.

Combine 1 cup flour, baking soda, baking powder, and salt. Add milk mixture and stir until dough forms a ball. Transfer to a flat surface that has been dusted with the remaining 3 tablespoons barley flour. Flatten dough to a thickness of about ¼ inch. Cut into pieces and arrange on top of fruit.

Bake until top is slightly browned and firm, about 30 minutes.

Per serving (⅑ of cobbler): 172 calories; 3 g protein; 36 g carbohydrate; 2 g fat; 5 g fiber; 103 mg sodium; calories from protein: 8%; calories from carbohydrates: 81%; calories from fats: 11%

● ● ●

Gingerbread

MAKES 12 SERVINGS

You'll find it hard to believe that this delicious gingerbread contains no added fat. Try serving it with hot applesauce for a real treat.

½ cup raisins
½ cup chopped pitted dates
1¾ cup water
¾ cup sugar or other sweetener
½ teaspoon salt
2 teaspoons cinnamon
1 teaspoon ground ginger

¾ teaspoon grated nutmeg
¼ teaspoon ground cloves
2 cups whole wheat pastry flour
1 teaspoon baking soda
1 teaspoon baking powder
vegetable oil cooking spray

Combine raisins and dates with the water in a saucepan. Add sugar, salt, cinnamon, ginger, nutmeg, and cloves. Boil for 2 minutes, then remove from heat and cool completely—this is essential!

Preheat oven to 350°F.

Stir flour, baking soda, and baking powder together in a large bowl. Add cooled fruit mixture and stir just enough to mix.

Spread evenly into a 9-by-9-inch oil-sprayed pan. Bake until a toothpick inserted into the center comes out clean, about 30 minutes.

Per serving (¹⁄₁₂ of cake): 155 calories; 3 g protein; 37 g carbohydrate; 0.4 g fat; 3 g fiber; 194 mg sodium; calories from protein: 8%; calories from carbohydrates: 90%; calories from fats: 2%

● ● ●

Fruit Gel

MAKES 8 ½-CUP SERVINGS

This is an all natural alternative to Jell-O! Agar powder and kudzu ("kood-zoo") are natural plant-based thickeners available in natural food stores.

1½ cups strawberries, fresh or
 frozen
¾ cups apple juice concentrate
½ cup water

½ teaspoon agar powder
1 tablespoon kudzu powder
2 cups blueberries, fresh or frozen

Chop strawberries by hand or in a food processor.

Place in a pan with apple juice concentrate, the water, agar, and kudzu powder. Stir to mix.

Bring to a simmer and cook 3 minutes, stirring often. Remove from heat and chill completely.

Fold in blueberries and transfer to serving dishes.

Variations: Two cups of fresh or frozen blackberries or raspberries, or chopped peaches or mango may be substituted for the blueberries.

Per ½-cup serving: 77 calories; 0.5 g protein; 19 g carbohydrate;
0.2 g fat; 2 g fiber; 9 mg sodium; calories from protein: 2%;
calories from carbohydrates: 95%; calories from fats: 3%

● ● ●

Chocolate Tofu Pudding
MAKES 4 ½-CUP SERVINGS

Soft tofu makes it easy to prepare a smooth and creamy chocolate pudding. Be sure the tofu is fresh by checking the date on the package.

1 pound soft tofu	⅓ to ½ cup maple syrup
2 tablespoons cocoa	1 teaspoon vanilla
¼ teaspoon salt	

Place all ingredients in a blender and process until completely smooth. Spoon into small bowls and chill before serving.

Per ½-cup serving: 114 calories; 7 g protein; 20 g carbohydrate;
2 g fat; 1 g fiber; 144 mg sodium; calories from protein: 23%;
calories from carbohydrates: 65%; calories from fats: 12%

● ● ●

Fresh Fruit Compote
MAKES 6 ½-CUP SERVINGS

Enjoy this compote with Quick and Easy Brown Bread (page 215).

2 cups fresh peaches or nectarines	½ cup white grape juice
2 cups fresh blueberries	concentrate or apple juice
	concentrate

Rinse fruit. Peel peaches if desired, then slice.

Combine fruit in a saucepan with grape juice concentrate. Bring to a simmer and cook until fruit just becomes soft, about 5 minutes. Serve warm or cold.

Per ½-cup serving: 78 calories; 1 g protein; 20 g carbohydrate;
0.2 g fat; 2 g fiber; 9 mg sodium; calories from protein: 3%;
calories from carbohydrates: 94%; calories from fats: 3%

● ● ●

Baked Bananas
MAKES 2 SERVINGS

For a real treat, top these warm bananas with a scoop of vanilla nondairy frozen dessert.

2 bananas
1 tablespoon maple syrup

½ teaspoon vanilla
¼ teaspoon cinnamon

Preheat oven to 350°F.

Peel bananas, slice lengthwise and arrange in a single layer in a small baking dish. Drizzle with maple syrup and sprinkle with vanilla and cinnamon.

Bake until tender and creamy, 15 to 20 minutes.

> Per serving (1 banana): 131 calories; 1 g protein; 33 g carbohydrate;
> 0.5 g fat; 2 g fiber; 2 mg sodium; calories from protein: 3%;
> calories from carbohydrates: 93%; calories from fats: 4%

● ● ●

Ginger Peachy Bread Pudding
MAKES 9 SERVINGS

Chunks of golden peaches dress up this traditional dessert.

1 28-ounce can sliced peaches, packed in juice
1 tablespoon cornstarch
6 cups whole grain bread cubes (about 8 slices)
¾ cups fortified soy milk or rice milk
⅓ cup apple juice concentrate

¾ cup golden raisins
½ teaspoon ground ginger
½ teaspoon cinnamon
¼ teaspoon grated nutmeg
¼ teaspoon salt
1 teaspoon vanilla
vegetable oil cooking spray

Preheat oven to 350°F.

Drain liquid from peaches into a large mixing bowl. Add cornstarch. Stir to dissolve any lumps, then add bread cubes, milk, apple juice concentrate, raisins, ginger, cinnamon, nutmeg, salt, and vanilla. Mix well.

Chop peaches and stir into bread mixture. Spread in an oil-sprayed 9-by-9-inch baking dish. Bake 35 minutes. Serve warm or cooled.

> Per serving (⅑ of pudding): 193 calories; 4 g protein; 43 g carbohydrate;
> 2 g fat; 3 g fiber; 197 mg sodium; calories from protein: 8%;
> calories from carbohydrates: 83%; calories from fats: 9%

● ● ●

Quick Indian Pudding
MAKES 4 ½-CUP SERVINGS

This quick, delicious version of Indian Pudding bakes for just 30 minutes.

½ cup cornmeal
2½ cups fortified vanilla soy milk
2 tablespoons molasses
⅓ cup maple syrup

½ teaspoon ground ginger
½ teaspoon cinnamon
¼ teaspoon salt

Whisk together cornmeal, 2 cups of soy milk, molasses, maple syrup, ginger, cinnamon, and salt in a saucepan.

Bring to a slow simmer and cook, stirring fairly constantly, for 5 minutes.

Remove from heat, stir in remaining ½ cup of soy milk and transfer to a bread pan or similar-size baking dish. Place in oven and turn oven to 350°F. Bake for 35 minutes. Let stand 15 minutes before serving.

Per ½-cup serving: 188 calories; 3 g protein; 41 g carbohydrate;
1 g fat; 2 g fiber; 140 mg sodium; calories from protein: 6%;
calories from carbohydrates: 88%; calories from fats: 6%

● ● ●

Poached Pears with Butterscotch Sauce
MAKES 4 SERVINGS

Poached pears are attractive, delicious, and deceptively easy to prepare. They are especially good with Butterscotch Sauce.

2 large ripe pears
½ cup apple juice concentrate
½ cup white wine or water
½ teaspoon cinnamon

Butterscotch Sauce:
1 cup fortified soy milk or rice milk
3 tablespoons maple syrup

⅛ teaspoon salt
½ teaspoon natural butterscotch flavor, such as Frontier Naturals
1½ tablespoons rice flour
2 tablespoons potato flour
½ cup Corn Butter (page 183) or 1 tablespoon nonhydrogenated margarine

Peel pears, cut in half, and remove cores. Place in a pan with apple juice concentrate, wine, and cinnamon. Simmer until tender when pierced with a fork, 15 to 20 minutes.

Remove pears from pan and place in serving dishes.

Return pan to stove and boil juice until it is quite thick, about 5 minutes. Pour over pears.

For the sauce, combine milk, maple syrup, salt, and butterscotch flavor in a blender. With blender running, add rice flour, potato flour, and Corn Butter or margarine. Blend until completely smooth.

Pour one fourth of sauce over each pear half.

Per serving (½ pear and ⅓ cup sauce): 234 calories;
3 g protein; 48 g carbohydrate; 2 g fat; 4 g fiber;
155 mg sodium; calories from protein: 6%;
calories from carbohydrates: 85%; calories from fats: 9%

● ● ●

Tropical Freeze
MAKES 3 1-CUP SERVINGS

Pureed frozen fruit makes a wonderful dessert, without the fat or refined sugar of ice cream. Look for frozen mango pieces in your supermarket, or you can make your own using fresh mangoes. To freeze bananas, peel, break into chunks, and place loosely in a covered container in the freezer.

1 orange (preferably navel), peeled
1 cup frozen banana chunks
1 cup frozen mango chunks
½ to 1 cup fortified soy milk or rice milk

Cut orange in half and remove any seeds. Place in a blender with banana, mango, and milk. Blend until thick and very smooth, 2 to 3 minutes. Serve immediately.

Per 1-cup serving: 130 calories; 3 g protein; 28 g carbohydrate;
2 g fat; 4 g fiber; 12 mg sodium; calories from protein: 10%;
calories from carbohydrates: 78%; calories from fats: 12%

Glossary

Foods That May Be New to You

The majority of ingredients in the recipes are common and widely available in grocery stores. A few that may be unfamiliar are described below.

agar a sea vegetable used as a thickener and gelling agent instead of gelatin, an animal by-product. Available in natural food stores and Asian markets. Also may be called "agar agar." Agar comes in several forms, including powder and flakes. The powder is the easiest to measure and the most concentrated form of agar. If a recipe calls for agar flakes and you are using powder, you will have to adjust the amount you use as follows: for each teaspoon of powder called for in the recipe, use approximately 1½ tablespoonfuls of flakes to substitute.

apple juice concentrate frozen concentrate for making apple juice. May be used full strength as a sweetener.

arrowroot a natural thickener that may be substituted for cornstarch.

baked tofu tofu that has been marinated and baked until it is very firm and flavorful. Baked tofu is usually available in a variety of flavors. Sold in natural food stores and many supermarkets (check the deli and produce sections).

Bakkon yeast a type of nutritional yeast with a smoky flavor. Also called "torula yeast." Sold in natural food stores.

balsamic vinegar mellow-flavored wine vinegar that makes delicious salad dressings and marinades. Available in most food stores.

barley flour can be used in baked goods in place of part or all of the wheat flour for a light, somewhat crumbly product. Available in natural food stores and many supermarkets.

Bob's Red Mill products whole grain flours, multigrain cereal, and baking mixes. Contact the manufacturer to locate a source near you.

Bob's Red Mill Natural Foods, Inc.
5209 S.E. International Way
Milwaukee, OR 97222
800-553-2258
www.bobsredmill.com

Boca Burger a low-fat vegetarian burger with a meaty taste and texture. Available in natural food stores, usually in the freezer case.

brown rice an excellent source of protective soluble fiber as well as protein, vitamins, and minerals that are lost in milling white rice. Available in long-grain and short-grain varieties. Long-grain, which is light and fluffy, includes basmati, jasmine, and other superbly flavorful varieties. Short-grain is more substantial and perfect for hearty dishes. Nutritionally there is very little difference between the two. Brown rice is sold in natural food stores and in many supermarkets.

bulgur hard red winter wheat that has been cracked and toasted. Cooks quickly and has a delicious, nutty flavor. May be sold in supermarkets as "Ala."

carob powder the roasted powder of the carob bean that can be used in place of chocolate in many recipes. Sold in natural food stores and some supermarkets.

couscous although it looks like a grain, couscous is actually a very small pasta. Some natural food stores and supermarkets sell a whole wheat version. Look for it in the grain section.

date pieces pitted, chopped dates that are coated with cornstarch to keep them from sticking together. They are sold in natural food stores and some supermarkets.

diced green chilies refers to diced Anaheim chilies, which are mildly hot. These are available canned (Ortega is one brand) or fresh. When using fresh chilies, remove the skin by charring it under a broiler and rubbing it off once it has cooled.

Emes Jel a natural gelling agent made from vegetable ingredients. May be combined with fruit juice to make a natural gelatin.

Fat-Free Nayonaise a fat-free, cholesterol-free mayonnaise substitute that contains no dairy products or eggs. Sold in natural food stores and some supermarkets.

Fines Herbs a herb blend that usually features equal parts of tarragon, parsley, and chives, and also may contain chervil. Look for it in the spice section.

garlic granules another term for garlic powder.

Harvest Burger for Recipes ready-to-use, ground beef substitute made from soy. Ideal for tacos, pasta sauces, and chili. Made by Green Giant (Pillsbury) and available in supermarket frozen food sections.

instant bean flakes precooked black or pinto beans that can be quickly reconstituted with boiling water and used as a side dish, dip, sauce, or burrito filling. Fantastic Foods (707-778-7801) and Taste Adventure (Will-Pak Foods, 800-874-0883, www.tasteadventure.com) are two brands available in natural food stores and some supermarkets.

Italian Herbs a commercially prepared mixture of Italian herbs: basil, oregano, thyme, marjoram, etc. Also may be called "Italian Seasoning." Look for it in the spice section of your market.

jicama ("hick-ama") a crisp, slightly sweet root vegetable. Usually used raw in salads and with dips, but also may be added to stir-fries. Usually sold in the unrefrigerated area of the produce section.

kudzu ("kood-zoo") a thickener made from the roots of the kudzu vine, which grows rampantly in the southeastern United States. It is used much like arrowroot or cornstarch and makes a creamy sauce or gel.

miso ("mee-so") a salty fermented soybean paste used to flavor soup, sauces, and gravies. Available in light, medium, and dark varieties. The lighter-colored versions having the mildest flavor, while the dark are more robust. Sold in natural food stores and Asian markets.

nonhydrogenated margarine margarine that does not contain hydrogenated oils. Hydrogenated oils raise blood cholesterol and can increase heart disease risk. Three brands of nonhydrogenated margarine are Earth Balance, Canoleo Soft Margarine, and Spectrum Spread.

nori ("nor-ee") flat sheets of seaweed used for making sushi and nori rolls.

nutritional yeast a good-tasting yeast that is richly endowed with nutrients, especially B vitamins. Certain nutritional yeasts, such as Red Star Vegetarian Support Formula Nutritional Yeast, are good sources of vitamin B_{12}. Check the label to be sure. Nutritional yeast may be added to foods for its flavor, sometimes described as "cheeselike," as well as for its nutritional value. Look for nutritional yeast in natural food stores.

Pacific Cream Flavored Sauce Base a nondairy cream soup base made by Pacific Foods of Oregon and sold in natural food stores and many supermarkets.

potato flour used as a thickener in sauces, puddings, and gravies. One common brand sold in natural food stores and many supermarkets is Bob's Red Mill.

prewashed salad mix, prewashed spinach mixtures of lettuce, spinach, and other salad ingredients. Because they have been cleaned and dried, they store well and are easy to use. Several different mixes are available in the produce department of most food stores. "Spring mix" is particularly flavorful.

prune puree may also be called "prune butter." Can be used in place of fat in baked goods. Commercial brands are WonderSlim and Lekvar. Prune baby food or pureed stewed prunes also may be used.

quinoa ("keen-wah") a highly nutritious grain that cooks quickly and may be served as a side dish, pilaf, or salad. Sold in natural food stores.

red pepper flakes dried, crushed chili peppers, available in the spice section or with the Mexican foods.

reduced-fat tofu contains about a third of the fat of regular tofu. Three brands are Mori-Nu Lite, White Wave, and Tree of Life. Sold in natural food stores and supermarkets.

reduced-sodium soy sauce also may be called "lite" soy sauce. Compare labels to find the brand with the lowest sodium content.

Rice Dream see "rice milk."

rice flour a thickener for sauces, puddings, and gravies. Choose white rice flour for the smoothest results. Bob's Red Mill is one common brand sold in natural food stores and many supermarkets.

rice milk a beverage made from partially fermented rice that can be used in place of dairy milk on cereals and in most recipes. Available in natural food stores and some supermarkets.

roasted red peppers red bell peppers that have been roasted over an open flame for a sweet, smoky flavor. Roast your own (see page 198) or purchase them already roasted, packed in water, in most grocery stores. Usually located near the pickles.

seasoned rice vinegar a mild vinegar made from rice and seasoned with sugar and salt. Great for salad dressings and on cooked vegetables. Available in most grocery stores. Located with the vinegar or in the Asian foods section.

seitan ("say-tan") also called "wheat meat," seitan is a high-protein, fat-free food with a meaty texture and flavor. Available in the deli case or freezer of natural food stores.

silken tofu a smooth, delicate tofu that is excellent for sauces, cream soups, and dips. Often available in reduced-fat or "lite" versions. One popular brand, Mori-Nu, is widely available in convenient shelf-stable packaging—special packaging that may be stored without refrigeration for up to a year.

soba noodles spaghetti-like pasta made with buckwheat flour. Has a delicious, distinctive flavor. Sold in natural food stores and in the Asian food section of some supermarkets.

sodium-free baking powder made with potassium bicarbonate instead of sodium bicarbonate. Sold in natural food stores and some supermarkets. Featherweight is one brand.

soy milk nondairy milk made from soybeans that can be used in recipes or as a beverage. May be sold fresh, powdered, or in convenient shelf-stable packaging. Choose calcium-fortified varieties. Available in natural food stores and supermarkets.

soy milk powder can be used in smoothies, baked goods, or mixed with water for a beverage. Choose calcium-fortified varieties. Available in natural food stores and some supermarkets.

Spike a seasoning mixture of vegetables and herbs. Comes in a salt-free version, as well as the original version, which contains salt. Sold in natural food stores and many supermarkets.

spreadable fruit natural fruit preserves made of 100 percent fruit with no added sugar.

stone-ground mustard mustard containing whole mustard seeds. Often contains horseradish.

tahini ("ta-hee-nee") sesame seed butter. Comes in raw and toasted forms (either will work in the recipes in this book). Sold in natural food stores, ethnic grocery stores, and some supermarkets. Look for it near the peanut butter or with the natural or ethnic foods.

teff the world's smallest whole grain. Cooks quickly and has a rich, nutty flavor. Delicious as a breakfast cereal. Sold in natural food stores.

textured vegetable protein (TVP) meatlike ingredient made from defatted soy flour. Rehydrate with boiling water to add protein and meaty texture to sauces, chili, and stews. TVP is sold in natural food stores and in the bulk section of some supermarkets.

tofu a mild-flavored soy food that is adaptable to many different recipes. Texture varies greatly, from very smooth "silken" tofu to very dense "extra-firm" tofu. Flavor is best when it is fresh, so check freshness date on package.

torula yeast see "Bakkon yeast."

turbinado sugar also called "raw sugar" because it is less processed than white sugar.

unbleached flour white flour that has not been chemically whitened. Available in most grocery stores.

vegetable broth ready-to-use brands include Pacific Foods, Imagine Foods, and Swanson's. Other brands available in dry form as powder or cubes. Sold in natural food stores and many grocery stores.

wasabe ("wa-sah-bee") horseradish paste traditionally served with sushi. Sometimes sold fresh, but more commonly sold as a powder to be reconstituted. Look for it where Asian foods are sold.

whole wheat pastry flour milled from soft spring wheat. Has the nutritional benefits of whole wheat and produces lighter-textured baked goods than regular whole wheat flour. Available in natural food stores.

Yves Veggie Cuisine meatlike vegetarian products that are fat-free, including burgers, hot dogs, cold cuts, sausages, and Veggie Ground Round. Sold in natural food stores and many supermarkets.

Resources

Cookbooks

Golbitz, Peter. *Tofu & Soyfoods Cookery*. Summertown, Tenn.: Book Publishing Company, 1998.

Grogan, Bryanna Clark. *20 Minutes to Dinner*. Summertown, Tenn.: Book Publishing Company, 1997.

Hagler, Louise. *Soyfoods Cookery*. Summertown, Tenn.: Book Publishing Company, 1996.

McDougall, Mary, and McDougall, John. *The McDougall Quick & Easy Cookbook*. New York: Penguin Group, 1999.

Melina, Vesanto, and Forest, Joseph. *Cooking Vegetarian*. New York: John Wiley & Sons and Scarborough, Ont.: Macmillan Canada, 1998.

Raymond, Jennifer. *The Peaceful Palate*. Summertown, Tenn.: Book Publishing Company, 1996.

Solomon, Jay. *150 Vegan Favorites*. Rocklin, Calif.: Prima, 1998.

Stepaniak, Joanne. *Delicious Food for a Healthy Heart*. Summertown, Tenn.: Book Publishing Co., 1999.

———. *Vegan Vittles*. Summertown, Tenn.: Book Publishing Co., 1996.

Nutrition

Barnard, Neal D. *Eat Right, Live Longer*. New York: Three Rivers Press, 1995.

———. *Food for Life*. New York: Three Rivers Press, 1993.

———. *Foods That Fight Pain*. New York: Three Rivers Press, 1998.

———. *Turn Off the Fat Genes*. New York: Harmony Books, 2001.

Davis, Brenda, and Melina, Vesanto. *Becoming Vegan*. Summertown, Tenn.: Book Publishing Company, 2000.

McDougall, John. *The McDougall Program: Twelve Days to Dynamic Health*. New York: Penguin Group, 1991.

Melina, Vesanto; Davis, Brenda; and Harrison, Victoria. *Becoming Vegetarian*. Summertown, Tenn.: Book Publishing Company, 1996.

Physicians Committee for Responsible Medicine
 http://www.pcrm.org
Vegetarian Resource Group
 http://www.vrg.org

While Traveling

Airplane travel
 http://www.ivu.org/faq/travel.html
Directories on the Internet
 http://www.vegdining.com and http://www.vegeats.com/restaurants
*The Vegetarian Journal's Guide to Natural Foods Restaurants in the U.S. and
 Canada.* Wayne, N.J.: Avery Publishing Group, 1998; updated every few
 years.

References

Chapter 1: Understanding Diabetes

American Diabetes Association. "Clinical Practice Recommendations 2000." *Diabetes Care* 23 (2000): S1–S116.

Human Nutrition and Diet Therapy. Belmont, Calif.: Wadsworth, 1983.

Resnicow, K.; Barone, J.; Engle, A.; et al. "Diet and Serum Lipids in Vegan Vegetarians: A Model for Risk Reduction." *Journal of the American Dietetic Association* 91 (1991): 447–453.

Chapter 2: The Power of Food: A New Dietary Approach to Overcoming Diabetes

American Academy of Pediatrics Work Group on Cow's Milk Protein and Diabetes Mellitus. "Infant Feeding Practices and Their Possible Relationship to the Etiology of Diabetes Mellitus." *Pediatrics* 94, no. 5 (1994): 752–754.

Anderson, J. W.; Gustafson, N. J.; Bryant, C. A.; et al. "Dietary Fiber and Diabetes: A Comprehensive Review and Practical Application." *Journal of the American Dietetic Association* 87 (1987): 1189–1197.

Foster-Powell, K., and Miller, J. B. "International Tables of Glycemic Index." *American Journal of Clinical Nutrition* 62 (1995): 871S–893S.

Gannon, M. C.; Nuttall, F. Q.; Neil, B. J.; et al. "The Insulin and Glucose Responses to Meals of Glucose plus Various Proteins in Type II Diabetic Subjects." *Metabolism* 37 (1988): 1081–1088.

Karjalainen, J.; Martin, J. M.; Knip, M.; et al. "A Bovine Albumin Peptide as a Possible Trigger of Insulin-Dependent Diabetes Mellitus." *New England Journal of Medicine* 327 (1992): 302–307.

Kostraba, J. N.; Cruickshanks, K. J.; Lawler-Heavner, J.; et al. "Early Exposure to Cow's Milk and Solid Foods in Infancy, Genetic Predisposition, and Risk of IDDM." *Diabetes* 42 (1993): 288–295.

Lappé, F. M. *Diet for a Small Planet.* New York: Ballantine Books, 1982.

Monte, W. C.; Johnston, C. S.; and Roll, L. E. "Bovine Serum Albumin Detected in Infant Formula is a Possible Trigger for Insulin-Dependent

Diabetes Mellitus." *Journal of the American Dietetic Association* 94 (1994): 314–316.

Nicholson, A. D.; Sklar, M.; Barnard, N. D.; et al. "Toward Improved Management of NIDDM: A Randomized, Controlled, Pilot Intervention Using a Lowfat, Vegetarian Diet." *Preventive Medicine* 29 (1999): 87–91.

Pennington, J. A. T. *Bowes and Church's Food Values of Portions Commonly Used.* 17th ed. Philadelphia: J. B. Lippincott, 1998.

Snowdon, D. A., and Phillips, R. I. "Does a Vegetarian Diet Reduce the Occurrence of Diabetes?" *American Journal of Public Health* 75 (1985): 507–512.

Vaarala, O.; Knip, M.; Paronen, J.; et al. "Cow's Milk Formula Feeding Induces Primary Immunization to Insulin in Infants at Genetic Risk for Type 1 Diabetes." *Diabetes* 48 (1999): 1389–1394.

Vaarala, O.; Paronen, J.; Otonkoski, T.; et al. "Cow Milk Feeding Induces Antibodies to Insulin in Children—A Link between Cow Milk and Insulin-Dependent Diabetes Mellitus?" *Scandinavian Journal of Immunology* 47 (1998): 131–135.

Chapter 3: Healthy Eating Basics

American Heart Association, 2000. http://www.americanheart.org/Heart and_Stroke_A_Z_Guide

Carlson, E., et al. "A Comparative Evaluation of Vegan, Vegetarian, and Omnivore Diets." *Journal of Plant Foods* 6 (1985): 89–100.

Littlefield, D. "Chromium Decreases Blood Glucose in a Patient with Diabetes" (letter). *Journal of the American Dietetic Association* 94 (1994): 1368.

Malter, M. "Natural Killer Cells, Vitamins, and Other Blood Components of Vegetarian and Omnivorous Men." *Nutrition and Cancer* 12 (1989): 271–278.

Masarei, J. R.; Rouse, I. L.; Lynch, W. J.; Robertson, K.; Vandongen, R.; and Beilin, L. J. "Vegetarian Diet, Lipids and Cardiovascular Risk." *Australian and New Zealand Journal of Medicine* 14 (1984): 400–404.

Offenbacher, E. G. "Promotion of Chromium Absorption by Ascorbic Acid." *Journal of Trace Elements and Electrolytes in Health and Disease* 11 (1994): 178–191.

Phillips, R. L. "Role of Lifestyle and Dietary Habits in Risk of Cancer among Seventh-Day Adventists." *Cancer Research* 35 (1975): 3513S–3522S.

Rouse, I. L., and Beilin, L. J. "Editorial Review: Vegetarian Diet and Blood Pressure." *Journal of Hypertension* 2 (1984): 231–240.

Chapter 4: Preventing Diabetes

Dahlquist, G. "The Aetiology of Type 1 Diabetes: An Epidemiologic Perspective." *Acta Paediatrica Supplement* 425 (1998): 5S–10S

Green, A. "Prevention of IDDM: The Genetic Epidemiologic Perspective." *Diabetes Research and Clinical Practice* 34 (1996): 101 S–106S.

Marrero, D. G., and Kraft, S. K. "Prevention of IDDM: A Public Health Perspective." *Diabetes Research and Clinical Practice* 34 (1996): 181S–184S.

Resnicow, K.; Barone, J.; Engle, A.; et al. "Diet and Serum Lipids in Vegan Vegetarians: A Model for Risk Reduction." *Journal of the American Dietetic Association* 91 (1991): 447–453.

Schatz, D. A.; Rogers, D. G.; and Brouhard, B. H. "Prevention of Insulin-Dependent Diabetes Mellitus: An Overview of Three Trials." *Cleveland Clinical Journal of Medicine* 63 (1996): 270–274.

Chapter 5: Achieving and Maintaining a Healthy Weight

American Diabetes Association. "Clinical Practice Recommendations 2001." *Diabetes Care* 24 (2001): S1–S33; http://journal.diabetes.org/CareSup1Jan01.htm

Esselstyn, C. B.; Ellis, S. T.; Medendorp, S. V.; and Crowe, T. D. "A Strategy to Arrest and Reverse Coronary Artery Disease: A 5-year Longitudinal Study of a Single Physician's Practice." *Journal of Family Practice* 41 (1995): 560–568.

Flatt, J. P. "Diet, Lifestyle, and Weight Maintenance." *American Journal of Clinical Nutrition* 62 (1995): 820–836.

Hill, J. O.; Drougas, H.; and Peters, J. C. "Obesity Treatment: Can Diet Composition Play a Role?" *Annals of Internal Medicine* 119 (1993): 694–697.

Kendall, A.; Levitsky, D. A.; Strupp, B. J.; and Lissner, L. "Weight Loss on a Low-Fat Diet: Consequence of the Imprecision of the Control of Food Intake in Humans." *American Journal of Clinical Nutrition* 53, no. 5 (1991): 1124–1129.

Melby, C. I.; Goldflies, D. G.; Hyner, G. C. I.; and Lyle, R. M. "Relations between Vegetarian/Non-Vegetarian Diets and Blood Pressure in Black and White Adults." *American Journal of Public Health* 79 (1989): 1283–1288.

Ornish, D.; Scherwitz, L. W.; Billings, J. H.; Brown, S. E.; Gould, K. L.; Merritt, T. A.; Sparler, S.; Armstrong, W. T.; Ports, T. A.; Kirkeeide, R. L.; Hogeboom, C.; and Brand, R. J. "Intensive Lifestyle Changes for Reversal of Coronary Heart Disease." *Journal of the American Medical Association* 280, no. 23 (1998): 2001–2007.

Shintani, T. T.; Hughes, C. K.; Beckham, S.; and O'Connor, H. K. "Obesity and Cardiovascular Risk Intervention through the *ad libitum* Feeding of Traditional Hawaiian Diet." *American Journal of Clinical Nutrition* 53 (1991): 1647S–1651S.

Snowdon, D. A., and Phillips, R. L. "Does a Vegetarian Diet Reduce the Occurrence of Diabetes?" *American Journal of Public Health* 75 (1985):

507–512.

Chapter 6: Managing Your Diabetes with Food

American Diabetes Association. "Clinical Practice Recommendations 2000." *Diabetes Care* 23 (2000): S1–S116.

Chandalia, M.; Garg, A.; Lutjohann, D.; et al. "Beneficial Effects of High Dietary Fiber Intake in Patients with Type 2 Diabetes Mellitus." *New England Journal of Medicine* 342 (2000): 1392–1398.

Rafkin-Mervis, L. E. "Counting Carbohydrates." *Diabetes Forecast* 1995 (1): 30–36.

Chapter 7: Managing Your Diabetes with Medicine

American Diabetes Association. "Clinical Practice Recommendations 2000." *Diabetes Care* 23 (2000): S1–S116.

Chapter 8: Healthy Blood Vessels, Healthy Heart

Barnard, N. D.; Scialli, A. R.; Bertron, P.; Hurlock, D.; Edmonds, K.; and Taley, L. "Effectiveness of a Low-Fat Vegetarian Diet in Altering Serum Lipids in Healthy Premenopausal Women." *American Journal of Cardiology* 85, no. 8 (2000): 969–972.

Castelli, W. P. "Epidemiology of Coronary Heart Disease." *American Journal of Medicine* 76, no. 2A (1984): 4–12.

Lindahl, O.; Lindwall, L.; Spangberg, A.; Stenram, A.; and Ockerman, P. A. "A Vegan Regimen with Reduced Medication in the Treatment of Hypertension." *British Journal of Nutrition* 52 (1984): 11–20.

Ornish, D.; Brown, S. E.; Scherwitz, L. W.; et al. "Can Lifestyle Changes Reverse Coronary Heart Disease?" *Lancet* 336 (1990): 129–133.

Ornish, D.; Scherwitz, L.W.; Billings, J. H.; Brown, S. E.; Gould, K. L.; Merritt, T. A.; Sparler, S.; Armstrong, W. T.; Ports, T. A.; Kirkeeide, R. S.; Hogeboom, C.; and Brand, R. J. "Intensive Lifestyle Changes for Reversal of Coronary Heart Disease." *Journal of the American Medical Association* 280, no. 23 (1998): 2001–2007.

Chapter 9: Preventing Complications

American Diabetes Association. "Clinical Practice Recommendations 2000." *Diabetes Care* 23 (2000): S1–S116.

Bernstein, A. L. "Vitamin B_6 in Clinical Neurology." *Annals of the New York Academy of Sciences* 585 (1990): 250–260.

Ceriello, A.; Quatraro, A.; and Guigliano, D. "New Insights on Non-Enzymatic Glycosylation May Lead to Therapeutic Approaches for the Prevention of Diabetic Complications." *Diabetic Medicine* 9 (1992): 297–299.

Crane, M. G., and Sample, C. "Regression of Diabetic Neuropathy with Total

Vegetarian (Vegan) Diet." *Journal of Nutritional Medicine* 4 (1994): 431–439.

Ellis, J. M.; Folkers, K.; Minadeo, M.; et al. "A Deficiency of Vitamin B$_6$ Is a Plausible Molecular Basis of the Retinopathy of Patients with Diabetes Mellitus." *Biochemical and Biophysical Research Commununications* 179 (1991): 615–619.

Head, K. A. "Natural Therapies for Ocular Disorders Part One: Diseases of the Retina." *Alternative Medicine Review* 4, no. 5 (1999): 342–359.

Max, M. B.; Lynch, S. A.; Muir, J.; et al. "Effects of Desipramine, Amitriptyline, and Fluoxetine on Pain in Diabetic Neuropathy." *New England Journal of Medicine* 326 (1992): 1250–1256.

McNair, P.; Christiansen, C.; Madsbad, S.; et al. "Hypomagnesemia, a Risk Factor in Diabetic Retinopathy." *Diabetes* 27 (1978): 1075–1077.

Morley, G. K.; Mooradian, A. D.; Levine, A. S.; et al. "Mechanism of Pain in Diabetic Peripheral Neuropathy." *American Journal of Medicine* 77 (1984): 79–82.

Pennington, J. A. T. *Bowes and Church's Food Values of Portions Commonly Used.* 17th ed. Philadelphia: J. B. Lippencott, 1998.

Rema, M.; Mohan, V.; Bhaskar, A.; et al. "Does Oxidant Stress Play a Role in Diabetic Retinopathy?" *Indian Journal of Ophthalmology* 42 (1995): 17–21.

Rouse, I. L., and Beilin, L. .J. "Editorial Review: Vegetarian Diet and Blood Pressure." *Journal of Hypertension* 2 (1984): 231–240.

Sinclair, A. J.; Girling, A. J.; Gray, L.; et al. "An Investigation of the Relationship between Free Radical Activity and Vitamin C Metabolism in Elderly Diabetic Subjects with Retinopathy." *Gerontology* 38, no. 5 (1992): 268–274.

Chapter 10: Exercise Matters

American Diabetes Association. "Clinical Practice Recommendations 2000." *Diabetes Care* 23 (2000): S1–S116.

Guyton, A. C. *Textbook of Medical Physiology.* 8th ed. Philadelphia: W. B. Saunders, 1991.

Laaksonen, D. E.; Atalay, M.; Niskanen, L. K.; et al. "Aerobic Exercise and the Lipid Profile in Type 1 Diabetic Men: A Randomized Controlled Trial." *Medicine and Science in Sports and Exercise* 32, no. 9 (2000): 1541–1548.

Maughan, R. J.; Shirreffs, S. M.; and Leiper, J. B. "Rehydration and Recovery after Exercise." *Sport Science Exchange* 9, no. 62; (1996): 1–5.

Rosenbloom, C. A. *Sports Nutrition: A Guide for the Professional Working with Active People,* 3rd ed. Chicago: American Dietetic Association, 2000.

Chapter 11: Diabetes during Pregnancy

Carlson, E., et al. "A Comparative Evaluation of Vegan, Vegetarian, and Omnivore Diets." *Journal of Plant Foods* 6 (1985): 89–100.

Prentice, A. "Maternal Calcium Requirements during Pregnancy and Lactation." *American Journal of Clinical Nutrition* 59 (1994): 477S–483S.

Index

Note: An Index of Recipe Titles can be found on pages ix–x.